THE AFRICAN ANCESTORS GARDEN

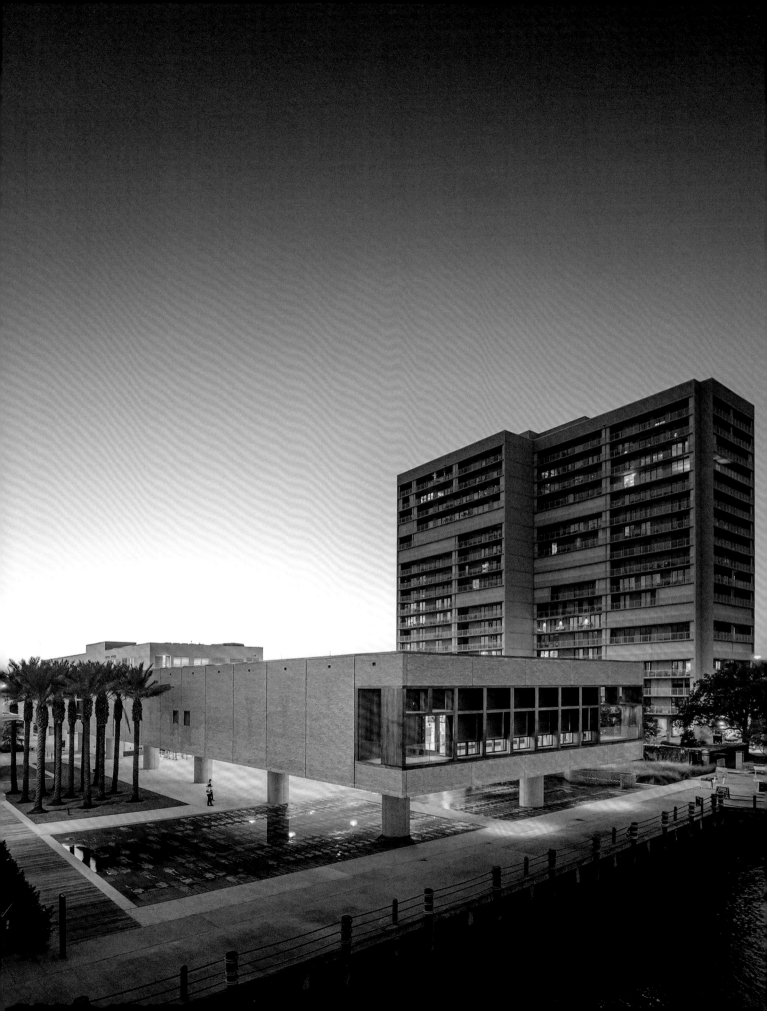

THE AFRICAN ANCESTORS GARDEN

History and Memory at the International African American Museum

WALTER HOOD

Foreword by

Tonya M. Matthews, PhD

Essays and contributions by

Michael Allen, Louise Bernard, Jonathan Green, Rhoda Green,
Robert R. Macdonald, Jonathan Moody, Matteo Milani, Guy Nordenson,
Chinwe Ohajuruka, Paul Peters, Bernard Powers, Dell Upton,
Nathaniel Robert Walker, Lewis Watts, and Mabel O. Wilson

Edited by
Grace Mitchell Tada

ℳ

CONTENTS

ON THIS SITE: PHOTOGRAPHS FROM THE AFRICAN ANCESTORS GARDEN

03 HISTORY AND MEMORY AT THE INTERNATIONAL AFRICAN AMERICAN MUSEUM

Reckoning:
A Time to Fly

Tonya M. Matthews, PhD

Black Angel Haiku #6

It wasn't slavery
That stopped us from flying
It was amnesia

I want the Ancestors Memorial Garden at the International African American Museum in Charleston, South Carolina, to be a space for reckoning, rather than a place to be reckoned with. We have indeed reckoned with the history of this place.

That is to say, we called it by its name: Gadsden's Wharf, one of our nation's most prolific slave ports. We've noted the wharf's edge and inlaid a steel band that makes clear to all: As every enslaved African man or woman or child crossed from ocean to land across this line, they stepped into a space that demanded the surrender of their humanity. That is to say, through the archaeological dig required to build on this site, we reckoned some more. We unearthed foundations of a storage shed, the place where more than 700 captive Africans were held—waiting for separation, waiting for auction, waiting for their price to increase—and died while waiting when an unexpected chill came through the Lowcountry that winter.

That is to say, the museum has applied for local, national, and international acknowledgments to show we have reckoned. We have placed official markers, written reminders, and stories of the history of this place—and the magnitude of what happened here.

The gardens are filled with nods to the languages, names, and places that belonged to captured Africans, asserting that humanity denied, deferred, is not humanity surrendered.

So yes, this place has been reckoned.

We often make the mistake of stopping here. We often end the arduous journey of reckoning after a place or moment in time has been reckoned with, after it has been named. Perhaps there's a tearful commemoration or song-filled service in which the story is told and the name is declared. And then we all exhale and move on. We miss the fact that though naming is a critical and necessary part of reckoning, it is only the first step. If our ultimate goal is reconciliation and healing and, perhaps, not being doomed to repeat history or live in its darkest shadows, after naming a place or a moment, we must move on to the next step. We must do the heavy lifting of reckoning with impact and legacy.

Here at Gadsden's Wharf in the African Ancestors Memorial Garden, the rest of our work can now begin: The claiming of space for reckoning with the legacy of slavery, its systems and echoes, and the brilliant, steadfast resilience of African Americans through slavery and beyond.

This will be no easy task. Claiming space is never an easy task. Space is sacred and expensive, and often comes with the illusion of ownership. Most people do not easily relinquish what they believe they own. In its day, the entirety of Gadsden's Wharf—the crossing point of tens of thousands of enslaved people—was much larger than the footprint of the African Ancestors Memorial Garden. As the Lowcountry community of Charleston grew in the twentieth and twenty-first centuries, the former Gadsden's Wharf became home to parks, modern condominiums, and business offices. Today, the site even touches the edges of a stately and state-of-the-art performing arts center. A historic marker or two has been placed; a few buildings even took on historic names. Indeed, it is a space transformed. But none of these new places provide space for reckoning with this history, with these truths. In fact, some argue, these places amplify the lack of reckoning and reconciliation in our community, if not our country.

But what is reckoning? Reckoning is personal. Reckoning requires its own space. "Reckoning" is the bolder version of "me time."

These gardens don't do the work of reckoning—but they do provide space for the work. The rest is up to you.

What I most appreciated about working with Walter Hood in the final stages of the garden design and installation was his acknowledgement of the layers and complexity in the African American journey, and his refusal to simplify or omit. I often say that one of the gifts of the African American story is our hard-won ability to simultaneously hold the sensations of trauma and joy.

I like to joke that this is not "trauma on Tuesday" and "joy on Thursday;" rather it's woven together as intricately as a water-tight sweetgrass basket! Similarly, there is tension in the layers of reckoning that can now happen at this place in this space. And that tension is beautifully—if not courageously—manifested in Hood Design Studio's gardens-within-gardens design.

One of my favorite examples of this in the garden is the black granite mirror wall installation. In this artistic installation, a one-dimensional brick outline of the storage house intersects two polished black granite walls as the walls themselves cut across the brick outline, both surrounding sculpted kneeling figures. I can imagine those who will lean against the outside of the black granite wall installation to pose proudly next to the quote, "And Still I Rise," even as others lean against the inside of it and weep softly next to the kneeling figures. I have imagined myself doing both.

And this journey continues throughout the space. I can envision some who will look at the plantings from the west coast of Africa and think "kidnapping" while others will think "connection"—and many will think both simultaneously. Directly next to this space, some will be confused by the rawness of the stelae monuments, and some will be inspired to imagine all the memories of those to whom the monuments could be dedicated.

Everyone will be drawn to the infinity pool. And for every ten people who stand at its edges, there are three times as many impressions, reflections, and follow-on conversations as they contemplate the impressions of bodies—rising? sinking?—beneath the water while the harbor breeze powers a constant ripple effect.

So then what? Is the process of reckoning simply being able to recognize and acknowledge complex art in a complex space in community? That is a step

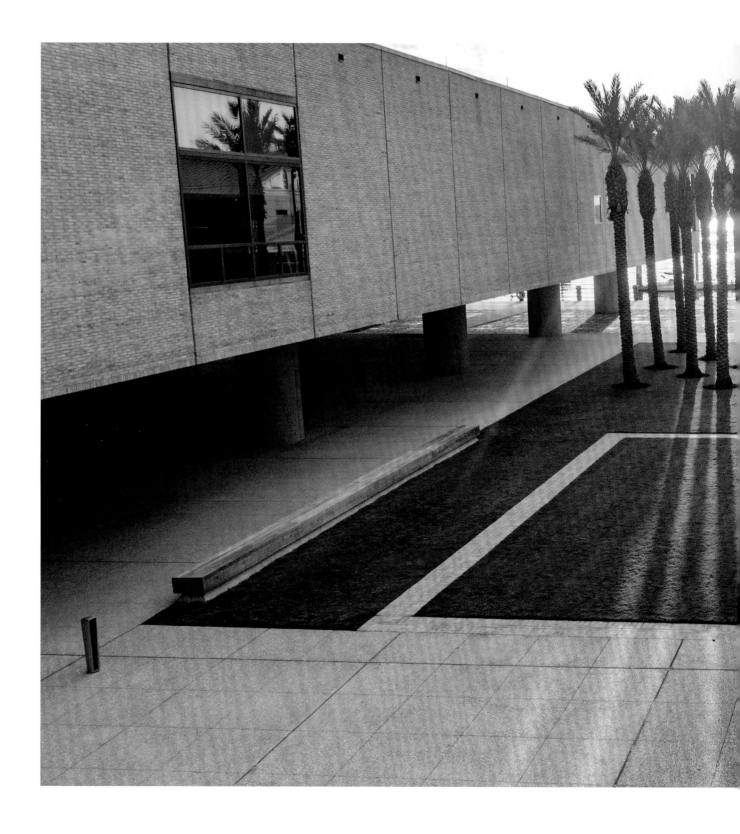

The African Ancestors Memorial Garden at the International African American Museum serves as a profound act of reconciliation, offering a space where the truth about the past is embraced and shared. The design of the gardens balances the necessity for truth in a specific moment, while recognizing slavery as a point in time along a much longer journey of the African Diaspora.

in the process but still, the physical place has never been the point—only the instigator.

Reckoning is the courage to ask what the complexities of our past have to do with the inequities of our present—and what we must do to reconcile both. Reckoning is the courage to do the work of finding the answer in public, in community. Reckoning requires us to be brave enough to apply the answer to ourselves, to the communities we love, and to the communities we have been taught to fear. When it comes to the African American journey, reckoning also requires that authentic history must be acknowledged and that stories long held in quiet must be told out loud.

This is not about sightseeing. It's about conversation; it's about listening; it's about interrogating what we think we know; it's about gathering in ways that create brave community. And all of that requires space. The goal of the International African American Museum is to present the African Ancestors Memorial Garden as such a space.

This book and these essays represent just a fraction of the reckoning that these gardens have the potential to nurture—a reckoning of one of the most important crises of our time, if not all time.

The 2020s have become a time of unprecedented conversation about race in America, if not all over the world. I am often asked, "Doesn't it make you hopeful to be able to build this kind of museum, curate this kind of memorial garden, and claim this kind of space in a time like this?" Inevitably, I try to find a polite and encouraging way of shrugging my shoulders. In fact, I do the same when the question is reversed, and I'm asked if times like these make it more difficult for me to be hopeful.

Today, conversations on race and history in America are loud, constant, and out in the open. Overall, the conversations are a bit more truthful than they have been, and there is extraordinary power in that truth. There is even enough power in these moments to soothe and satiate the fear that has become just as loud, just as constant, and just as out in the open. Indeed, I am hopeful that we will all grab onto this power and move through this time as deliberately and as artfully as a serpentine wall through an Ancestors Memorial Garden.

Yes, I am hopeful. But I prefer to focus on my joy—and my joy is not dependent on hope. That's the secret of the African American journey when told in its fullness. Our journey tells the story of a people's relentless refusal to

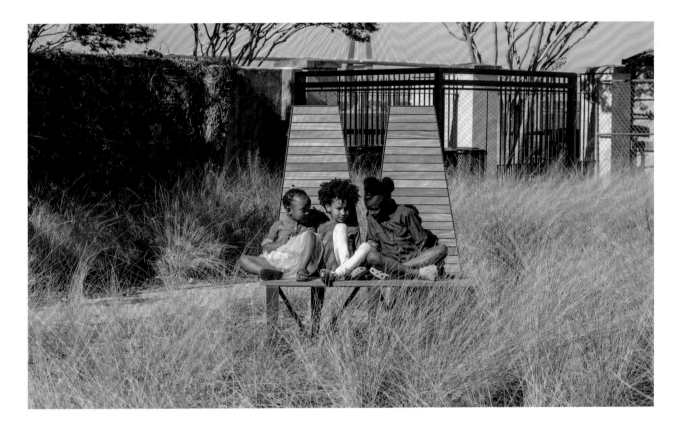

relinquish our joy. I am a product of that lesson—and so is the reclaiming of a former slave port as a site of future reconciliation.

A critical part of my work, of Hood Design Studio's work, and of the work of all who have supported this endeavor is rooted in authentically telling and empathetically commemorating what happened at this place called Gadsden's Wharf. Yes, my work is grounded in telling what enslaved Africans and descendent African Americans have endured. But embracing the why of that relentless endurance constantly waters the deep roots of my joy.

The quote from Toni Morrison that opens Walter Hood's introduction is meant to give us pause: "There is no suitable memorial. . . . There's no 300-foot tower, there's no small bench by the road." But while Morrison meant it in the moment, I embrace it in perpetuity: The proper remembrance is not in what we build; it's in who we build it for—the ones who came, and the ones who will come—and the why they will embrace to nurture their own courage, hope, and joy to continue along this path of reckoning.

Children create space for themselves in the Sweetgrass Field of the African Ancestors Garden at the International African American Museum.

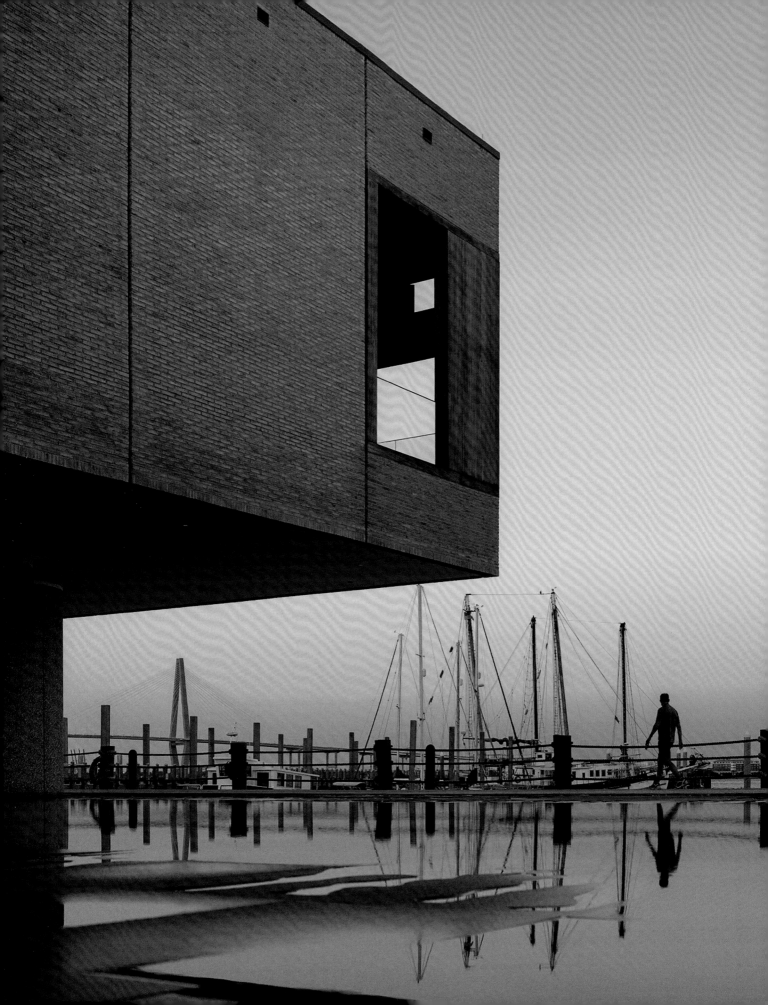

The why may come with a quiet visceral reckoning as you sit atop the garden mounds and watch a cargo ship go by. The why may come at finally pausing to look long enough at the tabby to understand the genius required to crush shells into building material. The why may even come in the sneeze that follows the tickle of sweetgrass pollen or an unexpected understanding of another's perspective when overhearing chatter at the badge frame installation.

The why will certainly come when some young Black girl dances in the middle of the reflection pool and her little brother runs in after with a bit of broken palmetto bark stuck in his hair, while the father laughs and brushes away hidden tears that fell at the granite wall, and the mother yells for them to get out of there! while sneaking a photo at the triumph of descendants recon-secrating bloody ground with unapologetic joy.

Or perhaps when a descendant who finally found the name of the ancestor who stepped off that ship at this place comes to pour a little libation at the edge of the gardens, and quietly smiles through a silent, *Well done, we have survived*.

Somehow, yes, the why will certainly come.

In this place of Gadsden's Wharf, at this site of the International African American Museum, on these grounds that have been reckoned, I know the Ancestors Garden opens our space for the tough, complex, forward-moving work of reckoning. Not at the beginning of it, not the ending of it, but—much like the stories we will tell here—in the middle of it.

If you are reading this foreword, thumbing through this book, inhaling this tense beauty, then you, too, are part of our why. Thank you.

The southeastern corner of the International African American Museum hovering above the Tide Tribute. The east edge of the building directly faces the harbor opening to the Atlantic Ocean. The museum building is raised on eighteen pillars, each six feet in circumference and covered in tabby concrete made from broken oyster shells, ash, and sand. Visible in this photo is one of four balconies that adorn the four corners of the building.

Overleaf: The African Ancestors Memorial Garden at the International African American Museum serves as a profound act of reconciliation, offering a space where the truth about the past is embraced and shared.

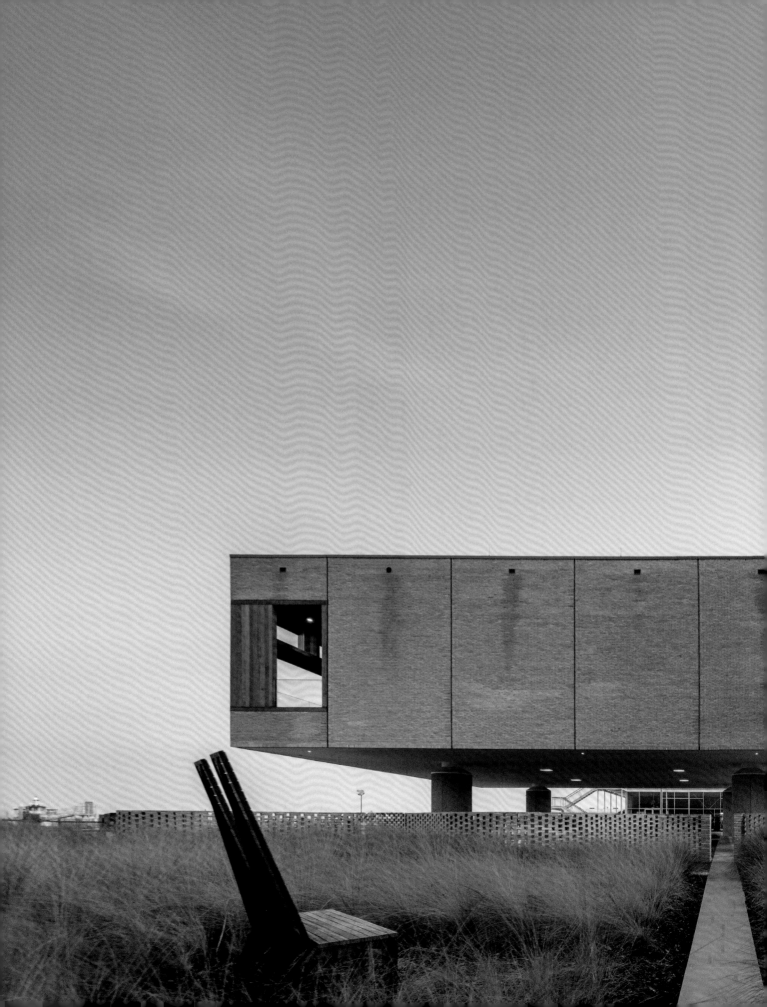

Visualizing Truth
by Walter Hood

In 1989, a year after she won a Pulitzer Prize for her novel *Beloved*, Toni Morrison articulated why she wrote the story:

> There is no place you or I can go, to think about or not think about, to summon the presences of, or recollect the absences of slaves. . . . There is no suitable memorial, or plaque, or wreath, or wall, or park, or skyscraper lobby. There's no 300-foot tower, there's no small bench by the road. There is not even a tree scored, an initial that I can visit or you can visit in Charleston or Savannah or New York or Providence or better still on the banks of the Mississippi. And because such a place doesn't exist . . . the book had to.[1]

So, on Morrison's 75th birthday, she launched the "Bench by the Road Project," with the Toni Morrison Society. Since then, they have placed twenty benches, from Sullivan's Island, South Carolina; in Walden Woods in Massachusetts; at the Schomberg Center in Harlem, and as far away as Martinique and Paris's 20th Arrondissement. These are places where slaves crossed into bondage, and places where Black people celebrated culture. These are places of trauma, and places of happiness.

Some thirty years later, a memorial in Lower Manhattan pays homage to a slave burial ground (the African Burial Ground National Monument). Lynching is scrutinized and made visible in Alabama, the cradle of the South (the National Memorial of Peace and Justice in Montgomery). A monument in Providence, Rhode Island, confesses to an institution's complicities with slavery (Bell). A national museum in our country's capital honors our achievements and history (the National Museum of African American History and Culture). And most recently, a museum dedicated to the diasporic African American history and experience in Charleston, South Carolina (the International African American Museum).

Arguably most compelling in Morrison's comments was the recognition of the absence of Black space in the American landscape. She advocates Black space not only as places of injustice or commemoration or celebration, but also as essential landscapes that define America, as do our public parks. As well as the aforementioned commemorative monuments and sculptures, they encompass ordinary landscapes all around us, and the mundane elements that comprise them—trees, walls, benches, and the like.

Yet, despite these landscapes, we are simply not present in this country in ways that give our heritage a visual and physical truth. Black existence in the landscape is one of constant erasure. When our built spaces and landscapes are appropriated, a new ostensible past is invented. Seneca Village, a free Black town in Manhattan, is lost to the narrative that invents the new "natural" space of Central Park. Without more encompassing contextual commemorative narratives and spaces, Morrison's benches sit in the landscape in a context that, without her words on plaques to mark the bench's meaning, become just another benign element in the landscape. The exterior landscape of the Sullivan Island's Visitor Center is ordinary, featuring a lawn and path leading to a boat dock.

On a cold winter's morning in 2016, as the design committee for the IAAM toured Fort Moultrie's visitor center on Sullivan's Island, Morrison's Bench by the Road took on new meaning for me. We exited the meager exhibit at the rear of the center that described the Atlantic slave trade and Charleston, and stepped out onto a grassy space overlooking the marsh. I was struck by how ordinary the bench was. But in a powerful display of wanting, the entire committee gathered around the bench as if it were artifact, all of us taking pictures of this ordinary thing.

Chinwe Ohajuruka, Matteo Milani, and Michael Allen visiting the inaugural Bench by the Road placed by the Toni Morrison Society on Sullivan's Island, South Carolina, on the first site tour for the International African American Museum in January, 2016.

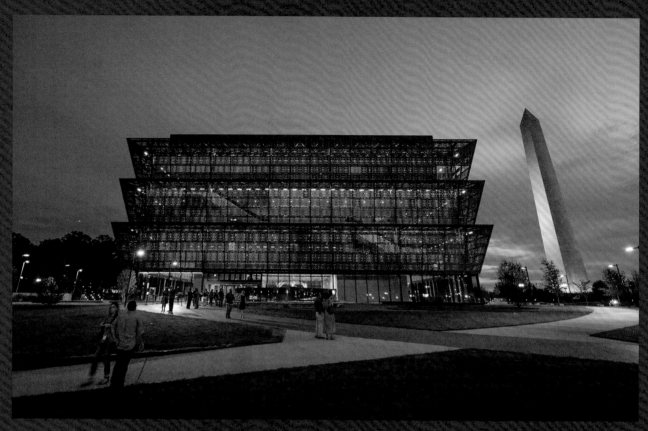

Above: The Smithsonian
National Museum of African
American History and Culture,
Washington DC. Adjaye
Associates, 2016.

Right: African Burial Ground
National Monument, New York
City. Rodney Léon, AARRIS
Architects, Elizabeth Kennedy
Landscape Architects, 2007.

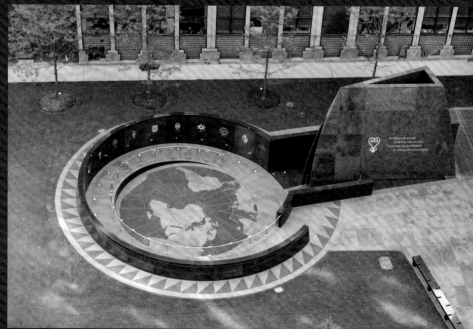

Above: Slavery Memorial, Brown University, Providence, Rhode Island. Martin Puryear, 2014.

Left: Memorial Corridor at the National Memorial for Peace and Justice, Montgomery, Alabama. MASS Design Group, 2018.

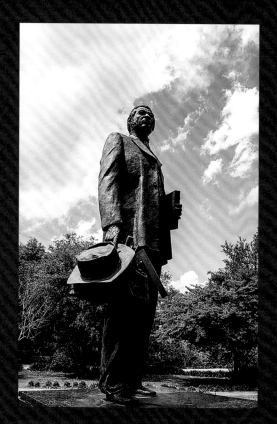

Statue of Denmark Vesey,
Hampton Park, Charleston.
Ed Dwight, 2014.

That moment was prophetic: there was no space to contemplate or remember our ancestral history. Why are the military exploits at Fort McHenry more important to celebrate than the thousands of Black lives that perished and passed through this site? As I stood in the landscape of Sullivan's Island—a national park, charged with preserving, conserving, and reserving our nation's stories—Morrison's words on the plaque resonated in a very different way.

We need parks, gardens, streets, towers, and trees that celebrate, commemorate, and preserve our diasporic contributions in this country. Not abstract places, but real sites of memory. We need to imbue them with a visual truth: One that is not romantic and pastiche, but a visual truth that helps heal the trauma and divide, a prophetic aesthetic that emanates from our experiences as diverse and different Americans.

The designation and placement of the Denmark Vesey statue in 2014 at Hampton Park in Charleston elucidates the possibilities of this aesthetic. Vesey, an enslaved carpenter, was accused and convicted of the "rising," a potential slave revolt slated for Bastille Day in 1822. The plan leaked, and 131 men were arrested and charged with conspiracy—sixty-seven were convicted, and thirty-five were hanged, including Vesey. Black Charlestonians nurtured stories about Vesey's plot well into the twentieth century. But to the white community, he was considered the bogeyman—someone who stepped out of line and challenged the institution. To tell his truth as a martyr would challenge the ostensible past that the city had chosen to write. As attempts to memorialize him in statue were repeatedly thwarted, Vesey was memorialized in portrait inside the Gaillard Municipal Auditorium (now Charleston Gaillard Center) in 1976. Dr. Bernard Powers summed up the power of a prophetic aesthetic when he commented on Vesey's statue and grove in Hampton Park, stating, "The monument changes the landscape by now offering a counterpoint to those other monuments to white supremacy … that populate Charleston's streets."[2]

Charleston is one of those cities that you have to visit multiple times before it makes sense. The peninsula that reaches south—called "the neck"—is the best characterization of its geography. King Street, the central spine of the city, runs

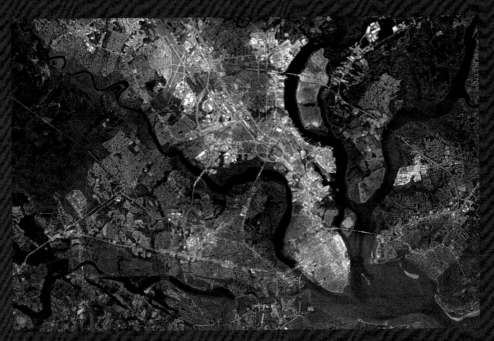

Charleston Neck, the tongue of land between the Ashley and Cooper Rivers. Courtesy Google Earth; map data: GoogleLandsat/ CopernicusData SIO, NOAA, U.S. Navy, NGA, GEBCO.

southeast down the neck, turning abruptly south at Beaufain Street. Continuing along either King or Beaufrain, you descend to the Ashley River. Calhoun and Meeting Streets form the crossroads where the Citadel marks the center of town, and Meeting Street stretches, parallel to King Street, along a high ridge. Fittingly for this present postcolonial moment, Calhoun Street—whose namesake, John C. Calhoun, was an ardent states' rights congressman, advocate of slavery, and vice president of the US under two different presidents—is the street where Mother Emanuel AME Church is located and connects directly to the IAAM. Yet Charleston is still a city of memory and monuments, its economy bolstered by marketing the "genteel"—a loaded word—culture of old. It is a white city of classical colonial architecture and cobbled streets, its skyline punctuated with church steeples. It is a construction of an ostensible past reflected in the preservation efforts and narratives that hold on to a conflicted history. It is a contradiction.

The Black public spaces in Charleston that have been built to commemorate the African slave presence are the aforementioned Denmark Vesey statue in Hampton Park, and Morrison's bench by the road, at Fort Moultrie. Both are major contributions to the changing tide in Charleston that includes the African American narrative in the city's memory and past; they are but two sites in the 150-plus years since emancipation.

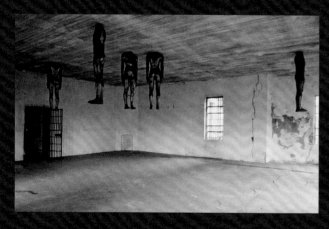

Places with a Past, Spoleto Festival, Charleston, 1991, curated by Mary Jane Jacob. Top images: David Hammons and Albert Alston, *House of the Future*, 1991; Middle left: Narelle Jubelin, *Foreign Affairs*, 1991. United States Custom House, 200 East Bay Street, Charleston; Middle right: Lorna Simpson and Alva Rogers, *Five Rooms*, 1991. Dependency Governor Thomas Bennett House, 69 Barre Street, Charleston; Bottom left: Antony Gormley, *Learning to Think*, 1991. Old City Jail, Charleston; Bottom right: Barbara Steinman, *Ballroom*, 1991. Pump House, Market Street between East Bay and Concord Streets, Charleston.

Winds of change began to permeate the city in 1989. Hurricane Hugo rocked South Carolina's eastern coastal plain and delivered billions of dollars in damage to Charleston. As the city recovered, the annual Spoleto festival, under director Nigel Redden, invited curator Mary Jane Jacob to develop an exhibition around the festival. She modeled it after the 1987 Skulptur Projekte Münster, where the curators Kaspar König and Klaus Bussman solicited fifty artists to engage with the historic and contemporary nature of the city. Jacob organized *Places with a Past*, working closely with twenty-three artists. Spilling out from the Gibbes Museum of Art across the city, artists in the exhibition focused on buried histories: Narelle Jubelin at the United States Customs House, Barbara Steinman at the Pump House; Elizabeth Newman at the 1796 Middle-Pinckney House; Ronald Jones at the Emanuel AME Church; Lorna Simpson at the slave quarters of the Governor Thomas Bennett House; and David Hammons at the corner of America and Reid Streets. The exhibition challenged the festival's conventionally picturesque notion of the art experience. Previously, art in Charleston had entailed colorful syrupy paintings of the city's genteel life, flower-filled windows, beautiful piazza houses with lush plantings, and gaiety of music and drama performances. On this occasion, instead, the festival empowered artists to work across disciplines to challenge Charleston's history of slavery, the Civil War, and the military industrial complex.

The exhibition caused a stir. Curators Jacob and Redden were not invited back the next year, and Menotti eventually resigned:

Menotti did not want this exhibition. On May 30 Allan Kozinn reported in the *Times* that "in an extraordinarily fiery statement, delivered to the board on Monday, Mr. Menotti attacked the show again, describing it as 'nothing more than silly, sophomoric stunts, justified by even sillier explanations.' When a member of the board quoted Michael Brenson's favorable review of the exhibition in the *New York Times* on Monday as part of a resolution in support of the curator, Mary Jane Jacob, Mr. Menotti stormed out of the meeting." Two years later, Menotti resigned from the Festival.[4]

What transpired from those winds that blew into Charleston with *Places of the Past?* Not much changed in how the city presented itself to the world. The pendulum may have even swung in the opposite direction. Instead of embracing the challenging past as presented by the art installations, Charleston chose to double down on the genteel, to return to the white city of the past. Planning with a strong historic preservation ethic dominated the post-Hugo era, and the downtown thrived, transforming the population along the way. From 1980 to 2010, the downtown population went from two-thirds Black to two-thirds white; a massive demographic shift. Maybe this was why, when Jacob returned over a decade later, she shifted the theme to the future.

Ten years passed before Redden returned as director to the festival, as the politics of the festival gradually changed. He launched *Art and Landscape* in Charleston and the Lowcountry, curated by John Beardsley in 1999. In reaction to the *Art and Landscape* program, between 2004 and 2008, Spoleto sponsored *Places of the Future*, curated by Mary Jane Jacob. In 2003, Jacob—with Reading from Spoleto—brought together artist Suzanne Lacy and Tumelo Mosaka, and Rick Lowe and Miller in 2004. Both festivals highlighted the plight of the African American community in Ansenborough through installations in houses that presented hidden histories, current inequalities, and the impact of redevelopment on the African American neighborhood. In 2004, in an adjacent field, a temporary porch marked the yards of the erased middle-class houses that had defined this precinct of the Ansenborough. During an evening performance, 150 Charlestonians from all walks came together to voice their concerns and opinions over redevelopment, race, and equity in South Carolina.

The next year began my introduction to Charleston. Under the curation of Jacob, I was selected as one of four artists, chosen for our Southern upbringings and experience, to spend weeks researching how Black people live next to water in the Lowcountry. Of particular interest were the African American experience and heritage. Examining the histories wherein people worked enslaved in the rice fields, maintaining autonomy in isolated Gullah communities, we asked how the collective trauma of assaults on African American land tenure and the jeopardy of heirs' property rights could be addressed in the future. It was during this time that I was introduced to my ancestors.

In Charleston, at Market and Beaufain Streets, the city grid shifts abruptly about forty-five degrees clockwise. On the southwest side of Beaufain is one

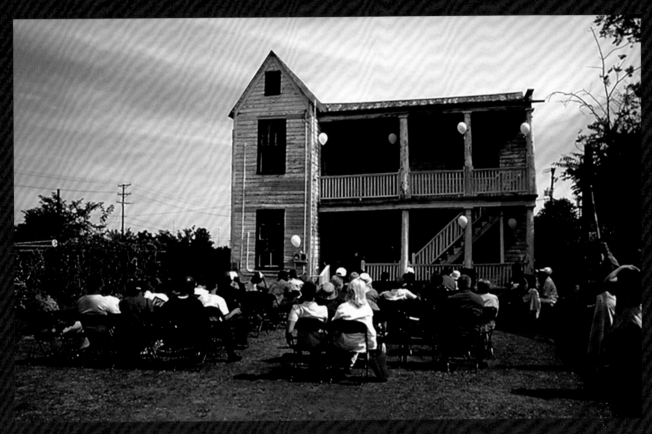

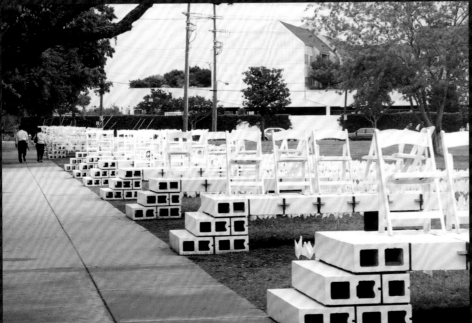

Above: Suzanne Lacy and Tumelo Mosaka, *The Borough Project*, Spoleto Festival, Charleston, 2002.

Left: Rick Lowe and Rob Miller, *Latitude 32 Degrees*, Spoleto Festival, Charleston, 2003.

Right: Hood Design Studio, *Water Table*, Spoleto Festival, Charleston, 2004.

Bottom left: Hood Design Studio, *Philips Lifeways Plan*, Spoleto Festival, Charleston, 2006.

Bottom right: Hood Design Studio, *Blue Chairs*, Spoleto Festival, Charleston, 2004.

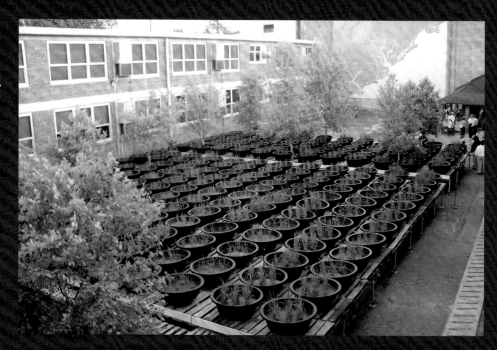

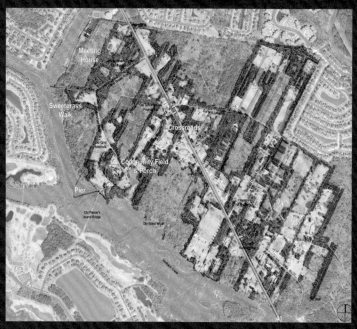

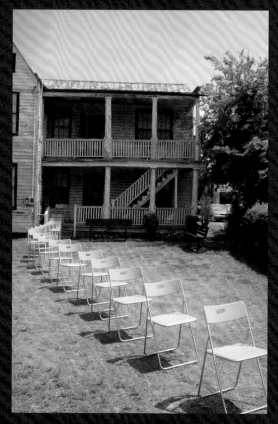

of the oldest public housing projects, the Robert Mills Homes from the Public Works Administration in 1939, and to the north on Beaufain is Memminger Auditorium, a neoclassical structure that opened that same year. There, in an abandoned asphalt schoolyard—as part of the artist team that featured Ernesto Pujol, Francis Whitehead, and Kendra Hamilton—we introduced *Water Table*, an installation piece that cultivated rice. Market Street, like Spring Street, another of the city's thoroughfares, sits atop underground springs, which exacerbate flooding. Old maps and archeological data showed the school was near the site of one of the earlier city's fortified walls. We focused the installation on Charleston's relationship to water, particularly its use for production. Historically, wetlands existed beyond the walls, today made invisible by urban development. It was here we wanted to conceptually call attention to Charleston's precarious cultural history and relationship with water. We cultivated three thousand living Carolina Gold rice plants, mounting them on recycled wood pallets, and planting them in three hundred circular black ponds elevated three to four feet above the ground. As they matured over six weeks, we welcomed green shoots sprouting at eye level—a true transformation of the asphaltic school yards. Within weeks of installing the rice-filled ponds, a wetland emerged. At night there were ritualistic dances and table talks with Charlestonians, frogs croaking, and herons circling overhead.

While we developed *Water Table*, we visited multiple Black communities in Charleston, particularly those who lived next to water: Mosquito Beach, Ashleyville, Phillips, and Hamlin, to name a few. These communities, still predominately Black, reminded me of the segregated landscapes of my childhood in North Carolina. But more importantly, as I learned more about rice culture and the African Diaspora in the Lowcountry, they demystified the differences we had associated with Black people from South Carolina (Gullah Geechee). Within the African American community, hierarchy exists; we looked down on those in South Carolina as being "country"—that is, not as sophisticated as those of us in the north.

Richard Habersham, a Gullah community leader, had spoken at the 2003 festival about the North Charleston Phillips settlement and their issues with land tenure. More particularly, he discussed the plight of their dwindling 1,000 acres at the hands of suburban development. The Phillips community descends from the Phillips Plantation. The original settlement was divided into 10-acre

ribbon lots that connected to Holbeck Creek. A small two-lane road bifurcated the development connecting it to North Charleston. Over time, families subdivided the lots and sold others. Today, houses sit in open lots shared by extended family members. Residents experience the constant threat of roadway widening due to increased development, which has changed the cultural landscape from a rural amenity to an urban domestic front.

Over the next three years, I came to know the community of Phillips and assisted them in developing a "Lifeways Plan." It featured a concept called the "overgrown," a validation of the Gullah approach to settlement: you only cultivate what you need in your yard or garden, and the rest becomes the overgrown. As I write this essay, Phillips is, again, almost fifteen years later, under threat of road widening and suburban development. In these new developments, every part of the landscape is controlled aesthetically, lawns and specimen plantings shaping the new landscape.

I preface these experiences and events as setting the table for the International African American Museum. It is important to develop a prophetic aesthetic for the Vesey story, along with all the other events that have shaped Charleston's history but have been left out of the narrative. A prophetic aesthetic tells the truth. In places where an ostensible past is present, as we see in most of the landscapes across the US, the truth is the mode for reconciliation. These places create dualities that must be worked out in the same landscape, in the same place. The early *Places with a Past* exhibition was powerful in foregrounding lost narratives spanning from gruesome to celebratory. They highlighted the necessary work to do. But even in the ten years following *Places of the Future*, the figure of Calhoun still sat above on his pedestal and the rebel flag flew at the state's capitol.

During the design development of IAAM, the winds of change swept through Charleston again. On June 17, 2015, a young white supremacist participated in an evening Bible study at the Mother Emanuel AME Church and then massacred nine people as they bowed their heads in prayer. This event reverberated nationally and made historic change at the state capitol, which, finally, removed the Confederate flag.

This book describes a personal and collective journey to create a landscape and building that honors our Black ancestors on hallowed ground in one of the most celebrated colonial cities in the United States. It describes the journey to

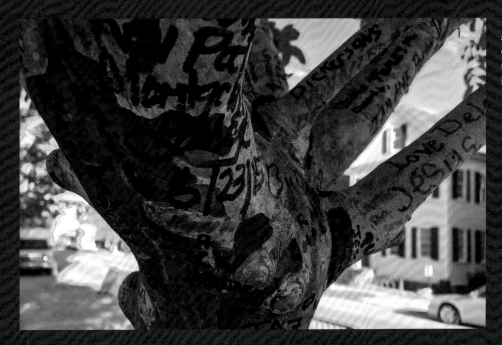

Memorial messages painted on a tree at Mother Emanuel AME Church honor the lives lost in the 2015 massacre (photo taken in 2016).

make the IAAM, pulling together the many voices that came together to realize the museum, notably those who worked for years to see their dream for this institution come to fruition. There, through prophecy and a newly enabled community, a landscape where the past is exhumed will stir our souls. Here, through design, we can create a place of sorrow, but also a place of joy! Black joy! That is the "double-consciousness" that enables African American culture to be resilient. We carry our history with us, we are told who we are and where we came from at birth—and still we move forward, becoming.

Design concepts and themes emerged from a two-day workshop and tour of the Lowcountry with International African American Museum memorial committee members, the design team, and local scholars. As we gathered and toured—designers, scholars, community, and city officials alike—to take on the task of creating a landscape and an institution, the city's experiences with the earlier Spoleto Festivals inspired us to think about the past and future in multi-dimensional and multidisciplinary ways.

Twenty-one conceptual thematic ideas transpired from those two days. These ideas structure the essays and contributions. The theme of the first section, "Journey to Charleston," nods to this passage—geographical, historical, and emancipatory—and the cultural objects of slavery. Its essays speak to the

The African Ancestors Garden is structured into a series of smaller gardens and features, each one celebrating the significant contributions of African Americans to art, craft, and labor throughout history.

imperative of the IAAM. Dr. Bernard Powers—the founding director of the College of Charleston's Center for the Study of Slavery, an emeritus professor at the College, and one of the leading experts and scholars on African American history—contributes an essay that contextualizes the Atlantic crossing and the lives of enslaved people in the US. Three voices follow in short essays: architect Chinwe Ohajuruka; Barbados and the Carolinas Legacy Foundation founder Rhoda Green; and former National Park Service Ranger and community partnership specialist Michael Allen. They each write from personal perspectives and experiences of places across the diaspora: West Africa, Barbados, and South Carolina, respectively.

The second section, "History of Charleston," conjures the landscape as a medium and how it is shaped through labor. Three scholars—Professor Dell Upton, Professor and Chair of Art History, UCLA; Nathaniel Walker, Associate Professor of Architectural History at the Catholic University of America; and historian Robert Macdonald—write of historic Charleston and the plantation, each bringing their respective scholarly research and interest to contextu-

alize the IAAM. They elucidate the mundane and everyday physical detritus of slavery in the Southern plantation and landscape, the African presence within the built environment of Charleston, and an interpretation of the palimpsest cultural landscape of the city.

Within their own disciplines, photographer Lewis Watts—also an archivist and professor emeritus at UC Santa Cruz—and Charleston painter Jonathan Green offer visual and written documentation of the Lowcountry landscape and people. They document the fleeting Gullah communities in and around Charleston through their images and describe their contemporary context in conversation with figurative Black bodies celebrated in full color.

The final section discusses the development and execution of the African Ancestors Garden through the voices of the numerous design collaborators on this long-gestating and multifaceted project.

Morrison's proclamation, "There is no place you or I can go, to think about or not think about, to summon the presences of, or recollect the absences of slaves," will eventually lose its validity here at Gadsden's Wharf. Here, now, there is a museum and a memorial, and there are plaques, walls, and lots of benches set in a former park reclaimed as a Black Space. In the context of this new institution, the International African American Museum, a new collective context is born in Charleston. So as visitors frequent the city's aquarium and ride boats across the Charleston harbor to visit Fort Sumter, this new Black landscape will tell a hidden truth in plain sight. And, finally, there is a landscape to go to recollect and think about our Black ancestors.

References

1. *World Magazine*, 1989
2. Ethan J. Kyle and Blain Roberts, *Denmark Vesey's Garden* (New York: New York Press, 2018), 336.
3. Michael Brenson, "Places with a Past: New Site-Specific Art in Charleston Belongs to its Place and Time," *Brooklyn Rail*, 2013. brooklynrail.org/2013/07/criticspage/places-with-a-pastnew-site-specific-art-in-charleston-belongs-to-its-place-and-time.
4. Brenson, "Places with a Past."

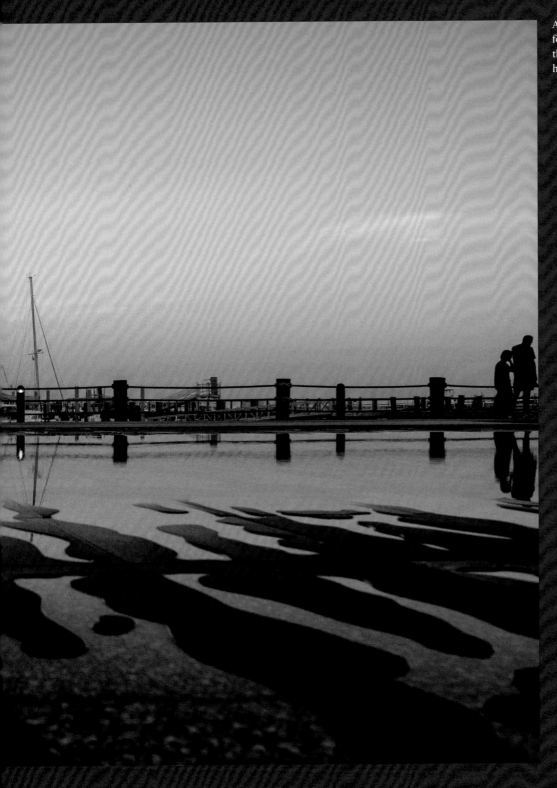

As the water fills the Tide Tribute fountain, the figures symbolizing the lives lost are reflected into heavens.

01 JOURNEY TO CHARLESTON

The Middle Passage
by Bernard E. Powers Jr.

A white Carolinian's observation, in 1738, that "Negroes [were] … the Bait proper for catching a Carolina Planter, as certain as Beef to catch a Shark," illuminated just how uniquely interwoven African lives were with the colony's past and foreseeable future. Carolina's first constitution in 1669 established "Negro Slavery." Rice culture relied on African labor, thus, in 1708, the settlement had a Black majority. More than 40 percent of all Africans brought forcibly to the British mainland colonies entered through Charleston between 1700 and 1775, and when the international trade was ended by federal law in 1808, South Carolina remained the only state still importing Africans.[1] At least 180,000 Africans landed in South Carolina through the Middle Passage—the second leg of the Africa–North America–Europe trade route. Confinement on the slave ship and sailing on the open seas during that voyage were traumatic and culturally transformative for these African captives and laid the foundation for a new cultural and racial identity we today call African American.

The Atlantic slave trade supplied vital labor for the early modern world's multinational system of commodity production. African export slaves were violently procured through military conflicts or systematic kidnapping in West and Central Africa.[2] These unfortunate souls, often injured, were taken to the coast and imprisoned in barracoons, uncertain of their future.

Their anxiety increased immensely once they were sold to European traders, shackled, and forced onto awaiting ships. Because most Africans had never seen a European, they had no cultural framework for understanding this initial encounter. Those from the interior of the continent were astonished by the sight of the ocean and terrified when ferried across roiling waves to the ships. Europeans' appearances were shocking as well; their white skin, sunburned faces, and long, stringy hair suggested they were evil spirits.[3] No wonder many Africans believed these creatures were cannibals who had ravished their own society and now sought new sources of human flesh. Olaudah Equiano was convinced of this fate when coerced aboard a ship, where he "saw a large furnace of copper boiling." Similarly, when Samuel Crowther saw skinned portions of a hog on shipboard, he believed they were the remains of Africans, killed for their flesh.[4]

Once these two and others were imprisoned below the ship's deck, their nightmarish Middle Passage began. The largest slavers could transport hundreds of captives, and vessels often exceeded their prescribed capacities. When a ship left Bonny (in present-day Nigeria) with six to seven hundred persons, an observer noted many "were even obliged to lie one upon another." Half the human cargo perished before reaching the Caribbean.[5] The ship's hold readily incubated disease. Alexander Falconbridge, a ship surgeon, noted the lack of fresh air, open wounds, and "constan[t] lying in ... blood and mucus" produced "fevers and fluxes," making the hold resemble "a slaughter-house." The Portuguese sometimes described slave ships as *tumbeiros*: floating tombs.[6]

Lowcountry planters bought people from along the African littoral, but they preferred those familiar with rice culture from the Upper Guinea Coast (between contemporary Sierra Leone and Senegal). Overall, 35 percent of imported individuals originated there; in the eighteenth century, the figure was 43 percent. Compared to more easterly locations, it took longer to complete a ship's cargo from the Upper Guinea Coast, where small traders dominated the markets and multiple stops were necessary. However, travel between this region and the Caribbean was nearly a month shorter in duration, thus lowering mortality rates.[7]

Surviving the physical challenges of this macabre environment preoccupied the captives, but the cosmic anxieties proved equally disquieting. As historian Stephanie Smallwood determined, "the slave ship was not just a setting

for brutality and death, but also a locus of unparalleled displacement." Africans initially wondered if the whites lived on it and if the crews' navigational abilities were magical.[8] The ship was a mystery, the familiar order of life upended. On the open water, every day and place appeared the same. When the captives were confined to the darkened hold during inclement weather, their means of calculating time was impaired and they easily lost track of the days. This inability had serious *metaphysical* implications because Africans' spiritual lives were regulated by routine rituals to honor deities and ancestral spirits. Captivity prevented them from performing rituals, but even worse, many could no longer determine *when* to do so.[9] Africans became even more vulnerable; they couldn't expect assistance from the spirits they had thus neglected. Physical and metaphysical challenges were mutually reinforcing aboard slavers.

The Middle Passage disrupted Africans' spiritual world in other ways, too. In the cosmology of the Bakongo people of Central Africa, the surface of large bodies of water was called the *kalunga* line, which separated the world of the living above from the world of the dead below. Thus, as ships sailed into open waters, the land behind them disappearing, the captives were thrust into a realm seemingly more appropriate for spirits than for human habitation. After several days aboard ship, Olaudah Equiano began to see amazing things. He witnessed flying fish, and he peered through a mariner's quadrant which made the clouds appear like land. Equiano believed he had entered "another world . . . [where] every thing about me was magic."[10] On this trip though, each source of wonder was quickly overshadowed by another which only produced dread.

Death and derangement pervaded every corner of the slave ship. Some captive Africans became so disturbed the traders called them "raving mad" and "lunatic." Some were driven to suicide and used the ship to aid their designs. On rare occasions, individuals hung themselves with rope. Typically, they jumped overboard; in a dramatic case, eighteen women jumped into the sea through an open gunport as their ship departed Angola. Middle Passage suicides were a radical reaction to profound cultural displacement. Many captives believed death would release the soul to return to their homelands, but there also existed a widespread African taboo against suicide. The decision these individuals faced must have been even more daunting as they considered this clash in values.[11] Most captives who perished died from diseases. Regardless of the cause, every shipboard death was especially horrible for Africans. Those who died were

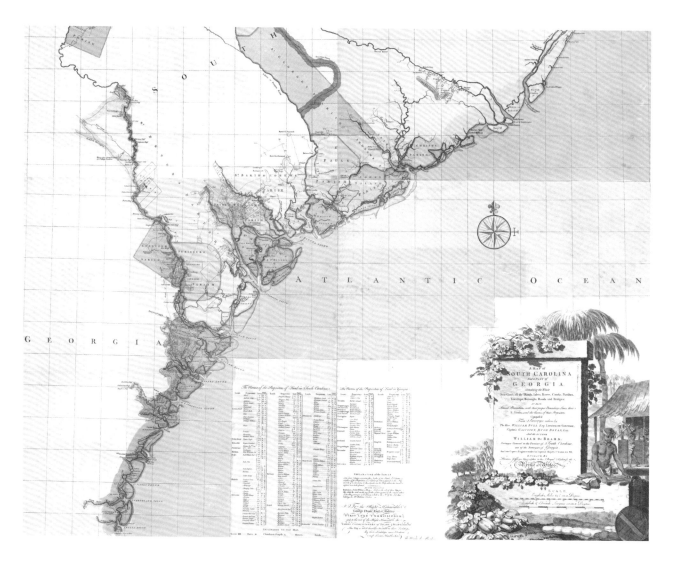

John Gerar William De Brahm, *A map of South Carolina and a part of Georgia. Containing the whole sea-coast; all the islands, inlets, rivers, creeks, parishes, townships, boroughs, roads, and bridges; as also, several plantations, with their proper boundary-lines, their names, and the names of their proprietors.* Published by T. Jefferys, 1757.

unceremoniously cast overboard without the proper rituals and burial, thus "unable fully to die." According to traditional African culture, a "bad death" severed linkages to ancestral protection, and the soul of such a person could become a roving evil spirit who posed dangers to the living.[12]

African captives who did not physically perish nonetheless experienced a metaphorical death as the pressures of the Middle Passage forced them to discard or adapt aspects of their traditional culture for mere survival and preservation of a sense of humanity. This cultural transformation was gradual and influenced by many variables, including the ethnic composition of the human cargo. In the late eighteenth century, Captain John Adams reported that cap-

tives from the Gold Coast brought their ethnic and political rivalries on board the ships. So, when the Ashanti or Fante raised an insurrection, Adams said their weaker traditional enemy, the Chamba, sided with the crew to quash it. However, as the pure racial dynamics of the slave trade became obvious, black skin emerged for the first time as a unifying point that began to supplant ethnic division.[13] A new racial consciousness was being created.

Other experiences also pushed disparate African groups into greater cooperation as they moved tentatively toward new identities. During the passage, captives were routinely brought to the deck and encouraged, sometimes forcibly, to dance for exercise and to drum and sing as diversions. These were complex situations that raise intriguing issues. The surgeon Falconbridge recalled "their songs are generally . . . melancholy lamentations of their exile from their native country." Another man's grandfather told of songs performed in the call-and-response manner and sung in the "language what dey learn in Africa when dey was free!" during his own journey across the Middle Passage.[14] In traditional African culture, drums and dances were part of worship, used to summon spirits for assistance and recount important events, such as victories over one's enemies.

Unbeknownst to the white captors, these shipboard performances might have included acts of resistance. West Africans shared similar dance traditions and performing them might have contributed to the emerging racial consciousness by joining different ethnic groups in a common cultural enterprise. The need to sing songs undoubtedly facilitated language borrowing, which later developed into creolized languages such as Gullah. The plaintive songs of the Middle Passage eventually morphed into slave spirituals. W. E. B. Du Bois called them "Sorrow Songs," which spoke of death and disappointment and contained the "siftings of centuries."[15]

The Middle Passage was one of the most horrific episodes in modern history, and we rightfully associate it with death. The bones from Black bodies littered the wake of slave ships. This aspect of the Middle Passage is most familiar to people. But even if they are unfamiliar, upon learning of it they can envision their own reaction to such confinement and brutality. What is less obvious is how Africans viewed this new and bizarre world into which they were pushed. Applying an African cultural lens to the Middle Passage moves us beyond the physical brutality to begin understanding the psychic and cultural trauma that reinforced

it. Because the Middle Passage forced Africans to recreate themselves, they thus laid the cultural foundation for a new African American people to emerge. The process was gradual and moved ahead in fits and starts. It was slower in South Carolina where the slave trade lasted longer. Yet that slow transformation ensured Gullah Geechee, the African American cultural variant in the Lowcountry, would be unique in its deep and persistent connection to Africa.

References

1. South Carolina *Gazette*, March 9, 1738; Peter Wood, *Black Majority: Negroes in Colonial South Carolina From 1670 Through the Stono Rebellion* (New York: Knopf, 1974), xiv,18–19, 36; W. E. B. Du Bois, *The Suppression of the African Slave-Trade to the United States of America 1638-1870* (New York: Schocken Books, 1969), 238, 240, 245; Philip D. Morgan, *Slave Counterpoint: Black Culture in the Eighteenth-Century Chesapeake and Lowcountry* (Chapel Hill: University of North Carolina, 1998), 61; "Trans-Atlantic Slave Trade – Database," SlaveVoyages, accessed October 25, 2020, www.slavevoyages.org/voyage/database#tables.
2. Philip Curtin, *The Atlantic Slave Trade: A Census* (Madison: University of Wisconsin, 1969), 271-72.
3. Philip Curtin, *Africa Remembered: Narratives by West Africans From the Era of the Slave Trade* (Madison: University of Wisconsin, 1967), 331; Olaudah Equiano, *The Life of Olaudah Equiano, or Gustavus Vassa, the African in Great Slave Narratives*, ed. Arna Bontemps (Boston: Beacon, 1969), 27.
4. Curtin, *Africa Remembered*, 215, 313; Equiano, *Gustavus Vassa*, 27.
5. Cheryl Finley, *Committed to Memory: The Art of the Slave Ship Icon* (Princeton: Princeton University Press, 2018), 34–35; Alexander Falconbridge, *An Account of the Slave Trade on the Coast of Africa* (London: J. Phillips, 1788), 26.
6. Falconbridge, *An Account*, 24–26, 28; Stephanie Smallwood, *Saltwater Slavery: A Middle Passage from Africa to American Diaspora* (Cambridge: Harvard, 2007), 137.
7. "Trans-Atlantic Slave Trade – Database," accessed October 27, 2020; Daniel Littlefield, *Rice and Slaves: Ethnicity and the Slave Trade in Colonial South Carolina* (Urbana: University of Illinois, 1991), 113; Sean Kelley, *The Voyage of the Slave Ship Hare: A Journey into Captivity from Sierra Leone to South Carolina* (Chapel Hill: University of North Carolina, 2016), 1, 78–81, 87, 110–11. Kelley reports that the route between Sierra Leone and Barbados was one of the quicker passages in the eighteenth century, taking on average about forty-three days. The average time for the eighteenth-century crossing was seventy days; Falconbridge, *An Account*, 30.
8. Smallwood, *Saltwater*, 124, 131; Equiano, *Gustavus Vassa*, 29.
9. Smallwood, *Saltwater*, 133, 135.
10. Robert F. Thompson, *Flash of the Spirit: African and Afro-American Art and Philosophy* (New York: Random House, 1983), 106, 109; Smallwood, *Saltwater*, 124–25; Jason Young, *Rituals of Resistance: African Atlantic Religion in Kongo and the Lowcountry South in the Era of Slavery* (Baton Rouge: Louisiana State University, 2007), 156; Equiano, *Gustavus Vassa*, 31.
11. Equiano, *Gustavus Vassa*, 30; Falconbridge, *An Account*, 31–32; Sowande M. Mustakeem, *Slavery at Sea: Terror, Sex, and Sickness in the Middle Passage* (Urbana: University of Illinois, 2016), 122. ethicsofsuicide.lib.utah.edu/tradition/indigenous-cultures/african-traditional-subsaharan-cultures/african-traditional-sub-saharan-cultures/, accessed 10/24/2020; Austin Echema, *Igbo Funeral Rites Today: Anthropological and Theological Perspectives* (Germany: Lit Verlag, 2010), 36–37.
12. Falconbridge, *An Account*, 28; Smallwood, *Saltwater*, 141, 152; Echema, *Igbo Funeral*, 36–37. John S. Mbiti says, "the dying person is being cut off from human beings, and yet there must be continuing ties between the living and the departed. . . . The grave is paradoxically the symbol of separation between

the dead and the living, but turning it into the shrine for the living-dead converts it into the point of meeting between the two worlds." See his *African Religions and Philosophy* (New York: Anchor Books, 1970), 203.

13. Captain John Adams, *Sketches Taken During Ten Voyages to Africa Between the Years 1786 and 1800* (London: Hurst, Robinson and Co. 1822), 8–9; Michael Gomez, *Exchanging Our Country Marks: The Transformation of African Identities in the Colonial and Antebellum South* (Chapel Hill: University of North Carolina, 1998), 165.

14. Falconbridge, *An Account*, 23; T. Aubrey, *The Sea-Surgeon or the Guinea Man's Vade Mecum* (London: John Clarke, 1729), 133; as quoted in Deena Epstein, *Sinful Tunes and Spirituals* (Urbana: University of Illinois, 1977), 15–16.

15. Sterling Stuckey, *Slave Culture: Nationalist Theory & the Foundations of Black America* (New York: Oxford University, 1987), 11, 19–20, 27, 365; Sylviane A. Diouf, *Fighting the Slave Trade: West African Strategies* (Athens: Ohio University, 2003), 128; Mustakeem, *Slavery*, 119–20; W. E. B. Du Bois, *The Souls of Black Folk* (New York: Fawcett, 1961), 183–84.

The Door
of No Return
by Chinwe Ohajuruka

Something stirred within me as I stood at the Door of No Return that balmy afternoon. As I listened to the tour guide explain how captured Africans were led to the door in chains and pushed out to the waiting boats, the boats that would take them to the ships, the ships that would take them to their deaths or cruel destinies, I knew I was forever changed.

We stood for a while in the women's dungeon, and I wondered why the ceiling was so low. Rather, the guide explained, it was that the floor was so high; we stood on centuries of compacted blood, sweat, vomit, urine, and excrement, belonging to the women who waited in chains to be taken through the Door of No Return. The largest of the women's dungeons held up to 150 women who lived there for as long as three months amidst the heat, stench, and suffering. Many died in that room of starvation and sickness, their bodies then thrown into the sea.

We sat mostly in silence on our car ride back to Accra. Earlier that morning, two friends and I had set off from Accra, Ghana, on a tourist jaunt. We had flown in from Lagos, Nigeria, a few days earlier to spend a week in Ghana over Christmas. It was 1998. We planned to first visit the virgin rainforests of Kakum National Park, and St. George's Castle, in Elmina, afterward.

We spent an exhilarating but terrifying couple of hours at Kakum, glimpsing wildlife, then lurching and swaying across the seven canopy bridges that stretched from tree to tree a hundred feet above the ground. At that height we were too scared to appreciate the beauty of the rain forest, wildlife, and exotic birds all around us.

Then, we went to Elmina Castle.

It was supposed to have been a sightseeing tour to explore the history and architecture of one of West Africa's most iconic monuments. The castle had few visitors that day, so we had a knowledgeable guide all to ourselves. As we toured, he recounted its terrible history. Of the many questions we posed and the shocking answers he gave, a particular one remains with me. I asked if the slaves' chains were removed as they boarded the boats. No, the guide responded, their arms remained shackled; they couldn't brace themselves when they inevitably fell to the ground as the traders shoved them forward.

Entering the dungeons, our faces turned grim and our questions faded into silence. The guide shepherded us through the dingy and dark chambers to the door that led out to the boats: The Door of No Return. It was actually a gate—a narrow arched opening with an iron grille that led out to the Atlantic Ocean and the boats that would have been waiting below.

Those who passed through that door never came back.

As we left the Room of No Return where the Door was located, I noticed that my arms were tightly wrapped around my body as if to shield myself from something, I did not know what. I felt cold, even though it was approximately 80 degrees Fahrenheit in there. I had goose bumps. My companions wore sober expressions. As we looked out across the Atlantic, gone was the excitement and jocularity we had shared just hours earlier. The rest of the tour was a blur, as I could not shake the dark, foreboding, helpless, hopeless feeling I felt in that room. As we exited, a marble plaque on the exterior wall read:

IN EVERLASTING MEMORY
OF THE ANGUISH OF OUR ANCESTORS.
MAY THOSE WHO DIED REST IN PEACE.
MAY THOSE WHO RETURN FIND THEIR ROOTS.

MAY HUMANITY NEVER AGAIN PERPETRATE
SUCH INJUSTICE AGAINST HUMANITY.
WE THE LIVING VOW TO UPHOLD THIS.

It had been placed there in the early 1990s by Ghanaian chiefs as a me-morial to generations past and an exhortation to the generations to come.

St. George's Castle is a 91,000-square-foot, whitewashed, European-style behemoth constructed in 1482 as a Portuguese trading settlement and home for missionaries. Initially, it was used primarily to export gold from the Gold Coast to Europe. In the 1500s, it became one of the principal slave de-pots during the centuries-long transatlantic slave trade. Europeans and cer-tain African tribes captured West Africans from across the region and brought them there. If they survived the ordeal, European slave traders shipped them off to a new world. It is estimated that 30,000 Africans passed through the castle every year—for nearly 300 years.[1]

After I returned home to Nigeria, I began to think more deeply about my Nigerian-Jamaican heritage and why my trip to Elmina so profoundly dis-tressed me. My parents had met and married in the UK in the mid-1950s as young students: he from Nigeria and she from Jamaica. In 1957, they sailed, with their young family, to Nigeria, where I was later born and raised. Cur-rently, my parents live in Port Harcourt in the Niger Delta of Nigeria. My father comes from a small village along the Niger River in a region rumored to have participated in the slave trade. Did my paternal ancestors assist in raiding and paddling captives down the Niger River to the waiting traders? Were they among the infamous intermediaries who made a living selling their own peo-ple? I do not know. The history of my ancestral village concerning the slave trade is often blurry and confusing.

What I do know is a less brutal form of slavery existed long before the Europeans came to our shores. To this day, we have an expression that goes: "You cannot sell me; I understand your language." Simply belonging to anoth-er tribe or speaking a different language was a reason one could be betrayed, captured, and sold.

Does my dual heritage trace a lineage of predators or of victims? Or both? What does that make me? Confused? Disorientated?

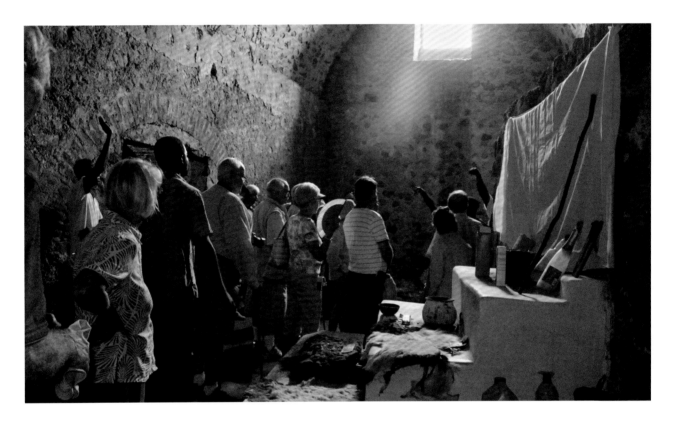

Former holding cell, now serving as a shrine, Elmina Castle. The altar on the right is covered with offerings of wreaths, flowers, animal skins, and animistic fetishes in memory of those who perished there, as well as passed through into enslavement.

Certainly not! It makes me powerful, knowledgeable, and committed to the sacred task of confronting history. My opportunity came nearly ten years later in Charleston, South Carolina, when I was working as an architect at Moody Nolan, Inc. In January 2008, two architectural firms, Moody Nolan and Antoine Predock, were invited to collaborate in designing the International African American Museum. But first we had to win the project bid by competing against other formidable teams.

In preparation for the interview, we collaborated to produce a powerful collage that wove the story of Africans and African Americans in Charleston. I located a picture of Africans in the hold of the slave ships, and we printed it at life-sized scale. Everyone who saw the image backed away from it, horrified by its ghastliness, pain, and rawness. In the end, we tore it into strips and incorporated it into the collage.

At the selection interview, we poured our hearts out. I told of my heritage, describing my experience at St. George's Castle. I don't think anyone else in the room had been there and walked, as I had, through the dungeons and up

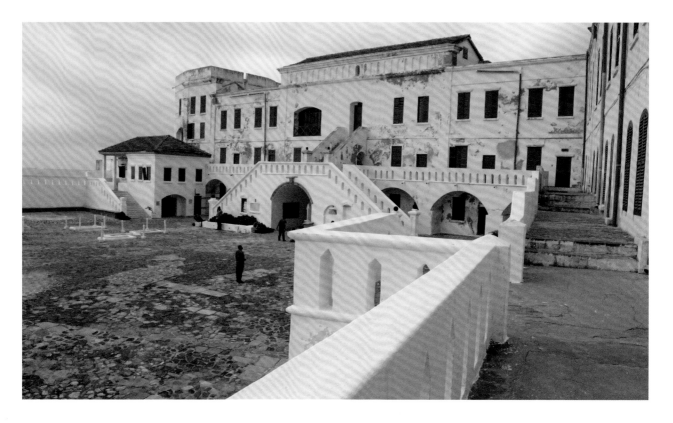

to the Door of No Return. Even though every African American spoke for their ancestors, I spoke for mine from a unique vantage. I spoke from the soil—as witness to the dispossession (of my mother) and brutalization (of my father) that continues to ravage the people of the African continent, who have never recovered from four hundred horrific years of forced migration and evacuation. Our team had to win because it was not just about a project: it was about me standing there; it was about the redemption of my heritage.

And win we did. In the years following, we worked hard. At some point, the project stopped. When it restarted a few years later, Antoine Predock Architect was replaced by Pei Cobb Freed & Partners as the design office, while Moody Nolan remained the architect of record. The teams visited the Lowcountry often, and I felt a deep connection to the place. I walked along the beach on Hunting Island, South Carolina, with Queen Quet, the chieftess of the Gullah Geechee Nation. As I looked across the Atlantic Ocean toward Africa, I remembered standing at Elmina Castle and peering out through the Door of No Return. Now, we were taking action, telling the story in the right

Elmina Castle, founded as Castelo de São Jorge da Mina in 1482, was a former Portuguese, and then Dutch, fortress used as a holding center for enslaved people before departing for the Americas.

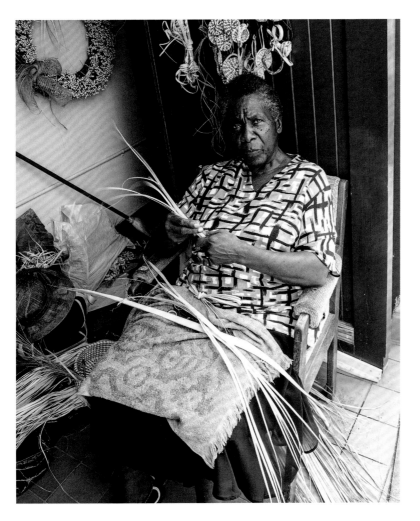

Sweetgrass weaver, Charleston, 2023.

place. I no longer felt hopeless or helpless. I was standing where I needed to be.

My time in the Lowcountry was poignant: gazing out to the Cooper River from Gadsden's Wharf, touring Sullivan's Island, visiting the Old Slave Mart, walking through the lush gardens of Middleton Plantation, experiencing the carefully preserved relics. Strangely enough, my time there was not as distressing as my visit to Elmina Castle. Yet, I wanted to bring a similar poignancy to the work we were doing there. For me, the journey to realizing the IAAM became one of hope and a source of solace and power—not just for myself, but for many who will visit the museum.

My horror at the memorial on the coast of western Ghana was nothing compared to what my mother's ancestors experienced during the slave trade. My trauma mostly came from the helplessness I felt in response to the voices I sensed were crying out to me. Based on ship records, the enslaved Africans taken to Jamaica were mostly Akan people of the Gold Coast (today's Ghana). Akan (then called Coromantee) culture has been the dominant African culture in Jamaica. I grew up listening to my mother telling us stories of Anancy the Cunning Spider, only to find out that Anansi, an important spider character, figures prominently in Akan folklore. This museum is about my mother and for my mother. It is also for me.

As I wandered through the streets of Charleston, I loved to watch the ladies skillfully weave baskets with sweetgrass. It reminded me of home where, in cer-

tain parts of the country, basket weaving is an everyday task. Eventually, I ambled back to Gadsden's Wharf, the sacred space where the memorial would soon be reverently laid out and our story told with deserved gravitas. The silent agony I had experienced at the Door of No Return had begun to slowly dissipate. It will probably never entirely disappear, but with the emergence of the IAAM will come a certain degree of healing, wholeness, and even joy. My soul-searching journey will finally have reached a place of remembrance, with peace.

References

1. Kingsley Ighobor, "Reflecting on the brutal Transatlantic Slave Trade" *United Nations Africa Renewal*, 2013, www.un.org/africarenewal/web-features/reflecting-brutal-transatlantic-slave-trade.

Hidden in Plain Sight: Making Visible Gullah Geechee Culture

by Michael Allen

On July 2, 1999, Mayor Joe Riley joined the Gullah Geechee community to dedicate a historical marker recognizing the importation of African people to Sullivan's Island, South Carolina. The marker was a seminal change in honoring the arrival and diffusion of Africans in North America. Years later, Mayor Riley noted that taking part in this event spurred him to push for the establishment of the International African American Museum.

The Gullah Geechee influence is powerful in South Carolina. The Gullah people—known as Geechee in some places (and in this essay "Gullah" is used as shorthand for "Gullah Geechee")—are the descendants of enslaved Africans brought from West Africa to work on rice and indigo plantations that extended from the St. Johns River in Florida to the Cape Fear River in North Carolina. The Gullah language, food, and religion came from their native homeland of Africa. These cultural identities merged with the experiences forced upon them in North America, creating distinctive and rich art forms, language, and music integral to our American fabric.

This newly established culture was incubated in the Lowcountry of South Carolina, and on Sullivan's Island specifically. Sullivan's Island, located five miles from the site of the International African American Museum, served as the birth canal for thousands of enslaved Africans ensnared in the global slave trade.

On this island, for nearly ninety years, slave traders quarantined the enslaved Africans, housing and storing them like cargo in small wooden structures known as "pesthouses" or *lazarettos*, waiting ten days to determine whether they were healthy enough to be sold. These enslaved Africans were then taken directly into Charles Town to Gadsden's Wharf, the site simultaneously a cargo storage, marketplace, and auction site. The commodification of Africans was encoded into the history and DNA of South Carolina. Plantation owners from along the Santee, Cooper, Wando, and Ashley Rivers all gathered to purchase the skilled, enslaved individuals to work their land.

In June 1980, I began my career with the National Park Service at Fort Sumter National Monument on Sullivan's Island. Though I am an African American man raised in the rural Jim Crow town of Kingstree, South Carolina, and educated at the historically Black university South Carolina State University, I was really only first introduced to vibrant displays of African culture when, upon graduation, I started my position at Fort Sumter. I became keenly aware that public institutions and historic sites interpreted African American history in ways that neglected a full accounting of the legacy, history, and contributions of Africans. Once I worked and lived in Charleston, I realized that historic and cultural sites often paid little or no attention to African and African American history in the Lowcountry. For instance, the mere afterthought given to Gullah Geechee culture and history was clear at Boone Hall, in Mount Pleasant, South Carolina. The interpretation of Gullah Geechee culture at Boone Hall materialized only in a display of Gullah fabric and by the costumed white guides who referred to enslaved individuals as "servants" instead of slaves. This blatant lack of respect and honor resulted in what I call a "hoopskirt" experience, wherein the guides, in period costumes like hoopskirts, reinforce historic white narratives glorifying the South.

My first summer in Charleston I quickly learned that the many aspects of African history hidden in plain sight, overlooked, or ignored were slipping away. Although Mount Pleasant has long been the American cultural hub of the sweetgrass basket, an important and common art form, this ancient craft has been disregarded historically. When I arrived in Charleston in the 1980s, the traditional gathering places where sweetgrass weavers harvested the raw materials for their baskets were slowly transforming into golf courses, shopping centers, and subdivisions. I saw sweetgrass basket stands lining US Highway 17,

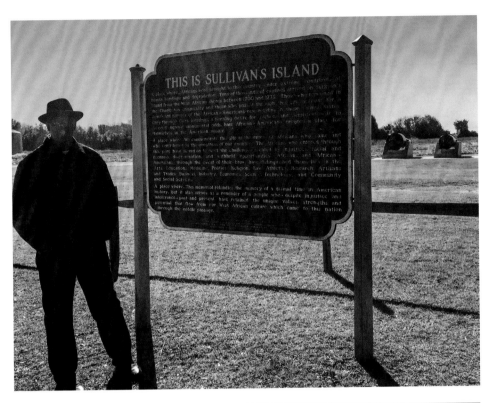

Michael Allen with the African American Importation Historical Marker, for which he tirelessly advocated for years. Sullivan's Island, 2016.

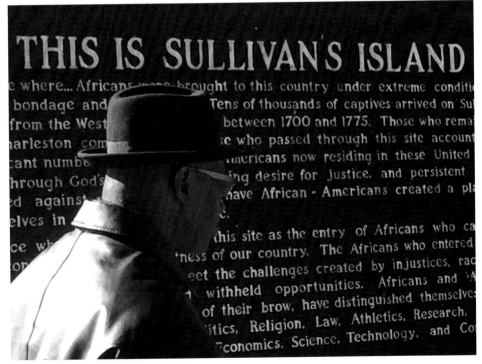

but their existence and survivability were threatened by the increasing traffic and commercial development. Many of the basket makers were forced to travel to Georgia to gather raw materials for the sweetgrass baskets.

I soon realized this cultural fragility, and armed with my own life experiences, I embarked on a forty-year journey to connect the Sullivan's Island community with my own Gullah Geechee roots. To those of us with Gullah Geechee heritage, this culture wasn't exactly hidden, but it needed greater illumination, protection, and preservation within the community.

The contributions of Gullah culture remain clear in contemporary American culture. Currently, approximately fifteen historic Gullah Geechee communities exist in the East Cooper area. Most of them were established after the Civil War by freed African Americans who left the plantations hoping to establish a better life for themselves and their families. Those recently freed landowners passed down their land through multiple generations. Many descendants of the original landowners continue to live on their family property purchased after the Civil War.

In the past, the Park Service had largely neglected Gullah presence in their interpretations of Fort Sumter National Monument's story. Not until 1992 did the Park Service reevaluate the park's narrative and forge a partnership with Gullah Geechee grassroots communities in the East Cooper area to address this grave oversight. But the newly formed relationship faced many challenges because of the rooted mistrust and suspicion of the Gullah Geechee people, who had long borne witness to historic sites inaccurately presenting their history.

The increased interest and emphasis on the Gullah culture at Fort Sumter prompted a shift in the interpretation at many historic sites. Through careful planning, the Gullah communities in the Charleston area built new partnerships with other local historic sites. In the late 1990s, a group of us—individuals from the Gullah Geechee community, local historic sites, the Park Service, and the South Carolina African American Heritage Commission—created the Gullah Geechee Consortium to foster better communication and relationships between historic sites and Gullah Geechee communities, marking the start of earnest dialogue and trust between the two entities. Employees at historic sites sought input from Gullah communities, requesting stories from their perspectives. This new partnership laid the groundwork to explore Gullah Geechee culture through a special resource study conducted by the

Park Service. Entitled "Exploring the Soul of Gullah Geechee Culture," the special resource study turned a national spotlight on the significance of Gullah Geechee culture in American history, shifting how Gullah Geechee history was interpreted, viewed, and respected in the community. It gave voice to a people and a culture whose history was often devalued, marginalized, and ignored.

The journey to uncover what was hidden in plain sight began in the basement of Mother Emanuel AME Church on May 9, 2000. I had organized the meeting on behalf of the Park Service and selected the location, knowing it was a safe space where the community could and would speak freely to Park Service officials. During that first meeting, Gullah communities and the Park Service together established the goals and mission of the resource study.

Community members supported this effort, though some were still suspicious, having experienced similar promises with no results. But because they could see that I had long been working to restore trust, respect, and healing to the Gullah communities, they were willing to wholeheartedly support the study. The next six years yielded public meetings occurring across the fertile crescent, starting in Wilmington, North Carolina, and extending to the coastal areas of St. Augustine, Florida. It was a process both fruitful and rewarding.

The Park Service, with the Gullah communities, led and guided the creation of the Gullah Geechee Cultural Heritage Corridor stretching across southeast North Carolina, South Carolina, Georgia, and northeast Florida. Through the leadership and tireless efforts of U.S. Representative James Clyburn, the Gullah Geechee Cultural Heritage Corridor was established in October of 2006.

Presently, the Gullah communities have a voice and a vehicle to preserve, recognize, and share their culture across the United States. The development of the Gullah Geechee Cultural Heritage Corridor spurred other governmental and grassroots organizations, nonprofit agencies, and historic sites to connect with their local Gullah Geechee communities. In addition, the International African American Museum now fosters opportunities linking these communities in the United States with their West African brothers and sisters, ensuring an ongoing global discussion of Gullah Geechee culture and heritage.

JOURNEY TO CHARLESTON

Bridgetown Port City
by Rhoda Green

The world in the seventeenth century was on the cusp of change. Most of Europe had turned its interest westward toward the Americas. Exploration led to exploitation, and the burgeoning international enterprise of slavery pulled Africa and its people into Europe's orbit. Waterways large and small—oceans and bays, channels and rivers—connected east and west, Europe and Africa across to the Americas. For Africans, especially, water became transformative. As Africans were captured, transported to the west, sold, then willfully and methodically exploited, water provided the passage and embodied the transitions. Africans were debased and reduced to commodities for barter and sale on the open market, no different from sugar, rum, cattle, guns, and munitions. The emergent global economy based on enslaved labor and sugar production realigned the world's economic system. Within this climate, Great Britain claimed and settled Barbados, the most easterly island of the Caribbean archipelago, whose geographic position and climatic conditions enabled British expansion and power in the centuries to follow.

But before Barbados, Europeans established slave ports and maritime endeavors that became the corpus of urban entrepôts in West African ports along the Gold Coast. They were sites of embarkation for the Middle Passage—the journey into the unknown.

Enslaved Africans, hailing from different tribes and speaking varied languages, became suppressed and oppressed societies in bondage, struggling to reclaim freedom, justice, and equality.

At the entrepôts, captured Africans were shackled and packed like sardines into the bellies of ships. Though without understanding of their unfolding plight, they must have had premonitions that their futures would be changed—fraught with pain and peril. Some preferred death instead of further indignities and jumped ship. For those who died because of conditions on board, the Atlantic Ocean became their grave. Survivors longed for firm soil beneath their feet. Barbados and the rest of the Americas awaited them.

Though small, the 166-square-mile island of Barbados was pivotal during the early years of the British transatlantic slave trade.[1] The British claimed the island in 1627, and in the coming years, it grew into the British hub of expansion in the Caribbean as they settled other islands and Carolina on the mainland.[2] Sugarcane experimentation began in the 1640s, and within decades, Barbados had become the most prominent economic center in the Atlantic world thanks to sugarcane production. To perform the work, the British imported enslaved Africans, whose population grew from around 1,000 individuals in the early 1640s to about 27,000 by 1660 (the white colonist population decreased from around 30,000 to 26,000 in that same period).[3] Bridgetown, Barbados's capital city, became the center of a bustling "maritime economy"—a slave mart.

As great as Barbados's importance was as a sugar capital, the island also played a pivotal role in facilitating the slave trade to all reaches of the Atlantic. In Bridgetown, British slave traders and merchants regulated the transshipment of slaves to other ports, as Barbados was the easternmost, and thus first, Caribbean island reached by ships crossing the Atlantic. Bridgetown "offered a haven for sailing ships after the rigors of the Middle Passage," as well as "facilities for 'refreshing' those slaves not sold on the island in preparation for their journey further north and west." The port received and disseminated news about slave prices across the entire region.[4]

British settlers in Barbados created the model for a plantation society, of which its port city was vital. Hence, Bridgetown provides a case study of the vibrancy, vitality, and viability of a port city and its urban landscape where enslaved people were the workforce supporting the urban front of the plantation economy.[5] Enslaved men worked on the docks or in public works, repairing

streets and collecting waste.[6] Women, too, contributed immensely to Bridge-town's economy; white female slave-owners outnumbered male slave-owners in the city. Mulattoes—freed women of color—owned brothels and prostitutes and became successful entrepreneurs in a male-dominated colonial world. Enslaved women worked as domestic laborers, washerwomen, seamstresses, cooks. Hawkers and hucksters— both freed and enslaved—moved through the streets and alleys selling household goods, their chants and songs contributing to the rhythm and vibes of the urban landscape. [7]

Also essential to Bridgetown's functionality was "the cage," a constructed pen to accommodate enslaved humans.[8] Built in the 1650s, the government-maintained the cage, and later established smaller cages in other populated areas of the island.[9] Effectively holding enclosures for animals, these cages were dehumanizing, overcrowded spaces for those whose fate landed them with confinement, whippings, and sometimes maiming. Recently, there has been renewed interest in the history and significance of the cage in colonial Bridge-town. Although the cage itself is gone, today a plaque marks the spot, which tourists now see on walking tours of the city.

Crippled by their obsession with sugarcane wealth, white Barbadians in the seventeenth and eighteenth centuries exploited the island so extremely for this crop that they precluded self-sufficiency. Both maritime business and life on the island depended on the "Triangular Slave Trade" that connected Europe, Africa, and the Americas. Outside traders purchased sugar and rum from Barbados and brought commodities from mainland North America (timber, tar, wood, animal derivatives, and cod from the Northeast) necessary to supporting life on the is-land. And, critically, to produce these commodities, this trade included people. They were valuable commodities on the market as well. But Africans and their descendants wielded power, too. The pariahs of the Caribbean Sea were pirates and buccaneers, among them former enslaved Africans who chose piracy rather than slavery. Black Caesar stands formidable in pirate history.[10]

Craving more profits yet unable to expand plantations on their island, Bar-badians began to cast their eyes elsewhere. They landed on Carolina. The Brit-ish established the first permanent settlement in Charles Towne in 1670, at the urging of prominent Barbadians.[11] Many of Carolina's early colonists migrated from Barbados. Carolina adopted the plantation structure of Barbados—"the Barbados Model," first replicated in other burgeoning British colonies in the

Caribbean, such as Jamaica, and then in the American South. The architects of this model—including the colonists, planters, slave traders, and merchants—honed their understanding and experience in Barbados. The younger sons of Barbados settlers whose birth order inhibited them from inheriting land on the small island later repeated the system, tested and tried in Barbados, upon moving to Carolina. There, these men built an economy and way of life that relied upon widespread racial bigotry, forced labor, exploitation, and violence.[12]

Iconic Charleston plantations such as Drayton Hall, Magnolia Plantation, Middleton Place Foundation, and their owners Arthur Middleton and Thomas Drayton, had strong family links in Barbados. Sir John Colleton, one of Carolina's original proprietors, and his family maintained plantations in Barbados.[13] Other Carolina founding fathers, like Robert Gibbes, traded with Barbados and other Caribbean centers. Christopher Gadsden, whose namesake wharf would mark the landing of so many slaves, also had familial connections in Barbados.

The populations of both South Carolina and Barbados were majority Black early in their colonial years.[14] Sir John Yeamans, of Yeamans Hall in North Charleston and Nicholas Abbey in Barbados, is credited—or, rather, discredited—with introducing two hundred enslaved people from Barbados to the fledgling Carolina colony. White owners and traders continued to bring enslaved people from Barbados, noting they had been "seasoned" on the island. By the 1730s, when rice yielded to South Carolina what sugar had yielded to Barbados, enslaved Africans were then brought directly from the West Coast of Africa to the Sea Islands of Carolina. During that formative period in South Carolina history, the Black-to-white ratio was more than two to one. Such demographics resulted in a culture with shared influences and similarities among the Gullah Geechee communities throughout the Lowcountry that reach back through the Middle Passage from the West Coast of Africa.

Most names and identities of enslaved and freed people brought from Barbados during Carolina's early settlement have been lost to history. The lineage of Richmond Bowens is a rare exception. It is chronicled that Mr. Bowens's enslaved ancestors were brought to Carolina by the Drayton family in the late seventeenth century, and the Bowens family continued to toil for the Draytons in the following centuries. I met Mr. Richmond Bowens on a visit to Drayton Hall in the early 1990s. That visit resulted in Mr. Bowens, and the two generations after his, connecting with the Barbados Bowens in 1996, a trip gifted by

Bardados's Ministry of Tourism. What a heartwarming reunion! Later, the late Mr. Philip Simmons, the iconic artisan and blacksmith, shared with me that one of his foreparents hailed from Barbados, though he had no tangible documentation. But he had the stories of his grandparents.

The Revolutionary War ended active relationships between Barbados and Carolina, but the linked familial lineages—of the enslaved and the enslavers—between the two places could not be erased. Today's growing interest in family research retraces the Middle Passage and sometimes reconnects long-lost families, such as that of Richmond Bowens, when he and I traveled to Barbados together, attempting to complete gaps in his family narrative.

In the early 1800s, the *Barbados Mercury* and *Bridgetown Gazette* published hundreds of advertisements to sell and buy enslaved Africans in Barbados. Some of the subjects were born on the island, and others were new arrivals. Slave traders, merchants, and handlers were always present in the listings. They recorded ships arriving, unloading, reloading, and departing for other ports in the Americas. Slaves and freedman hustled on the city pier: sailors, seamen, fishermen, sailmakers, shipwrights, and also gunsmiths, carpenters, caulkers, wheelwrights, coopers, and other tradespeople were illustrated in busy toil. As I scrolled through the slave notices, my imagination traveled backward in time. I had a notion each one beckoned through the ages.

In these advertisements, I read about Lisbon, 5 feet, 9 or 10 inches, tall, a "rather good-looking square, well-set fellow." Quashey, a "yellow-skin man." Primus had dismembered limbs. Quacco and Cuffey still had their "country marks," the identifying ethnic markings of individuals from certain West African communities.[15] Bango, Cato, Cuffey, Bingo, Quash, Quaco, and Quawn were African names. Cella, Sheneta (of the Timnah Nation), Phibba, Quasheba, and Minna also still bore their African monikers. They hailed from different parts of Africa, like Angola, the Gold Coast, Congo, Côte D'Ivoire, their names often revealing their homeland. The "Barbadian Negroes," or Creoles, were in the mix. The advertisements routinely described the enslaved society in poignant terms: very black, black complexion, tawny, yellow skin, and other racially derogatory descriptions. Classification was their new reality.

Our ancestors were strong, courageous, resilient, industrious, and hopeful. They relied on inner strength and faith for day-to-day survival. Planters, merchants, and slave traders wittingly or unwittingly misread their demeanors

and reactions, labeling them as "insolent" or "docile," furthering their debasement in captivity. But they knew nothing of our ancestors, of their feelings or aspirations. Newspaper descriptions do not define us. They don't express our emotional pain, our detachment, our dislocation. It's we who can vindicate their personhood.

The misfortunes of the enslaved birthed a diaspora characterized by a longing and striving for freedom, denied for them and their descendants. We, the progeny of captivity, continue the yen and fight for that same justice and equality.

Just as pivotal a link along the Middle Passage as Bridgetown, Barbados, was Charleston's Port City. The stories of enslavement are the stories of the Atlantic, and of America. The movement of people past and present have always intersected. We must share and weave our collective experiences. The Middle Passage meant separations. Let us forge connections. The past informs the present. Now, at the IAAM, it is our opportunity to reconnect the pieces of our broken and severed histories.

References

1. Nick Butler, "Barbados and the Roots of Carolina, Part 1," November 16, 2017, 16:58, in *Charleston Time Machine*, produced by the Charleston Public Library, podcast, MP3 audio, www.ccpl.org/charleston-time-machine/barbados-and-roots-carolina-part-1.

2. Ibid.

3. Ibid.

4. Pedro L. V. Welch, *Slave Society in the City: Bridgetown, Barbados 1680–1834* (Miami: Ian Randle Publishers, 2003), 63.

5. Marisa Fuentes, *Dispossessed Lives: Enslaved Women, Violence, and the Archive* (Philadelphia: University of Pennsylvania Press, 2016), 23.

6. Liz Covart, "Marisa Fuentes, Colonial Port Cities and Slavery," February 23, 2018, 54:22, in *Ben Franklin's World*, produced by the Omohundro Institute, podcast, MP3 audio, benfranklinsworld.com/episode-173-marisa-fuentes-colonial-port-cities-and-slavery.

7. Ibid.

8. Jerome S. Handler, "Escaping Slavery in a Caribbean Plantation Society: Marronage in Barbados, 1650s–1830s," *New West Indian Guide* 71, no. 3/4 (1997): 205.

9. Handler, "Escaping Slavery," 205.

10. Melissa Petruzzello, "Black Pirates and the Tale of Black Caesar," Britannica, accessed November 22, 2020, www.britannica.com/story/black-pirates-and-the-tale-of-black-caesar.

11. Nick Butler, "Carolina's Bajan Roots, Part 2," December 1, 2017, 18:54, in *Charleston Time Machine*, produced by the Charleston Public Library, podcast, MP3 audio, www.ccpl.org/charleston-time-machine/carolina%E2%80%99s-bajan-roots-part-2.

12. Ibid.

13. Henry A. M. Smith, "The Colleton Family in South Carolina," *South Carolina Historical and Genealogical Magazine* 1, no. 4 (October 1900): 1–2.

14. Handler, "Escaping Slavery," 183.

15. Covart, "Marisa Fuentes."

Journey to Freedom: The Lowcountry's Other Atlantic Crossing

by Bernard E. Powers Jr.

During the eighteenth century, Lowcountry South Carolina and Georgia became an extension of West and Central Africa given their huge African population and expansive rice fields. No wonder one commentator remarked, "Carolina looks more like a negro country than like a country settled by white people. In Charleston and that neighborhood there are . . . always 20 blacks . . . to one white man."[1] Although the Atlantic slave trade was a formidable catalyst in the economic and demographic transformation of the Lowcountry, other vectors in the migration of African peoples were also important. Charleston and Savannah were gateways to slavery, but conversely they also provided freedom routes traversing the Anglo-Atlantic world. David George, a Black loyalist of the American revolutionary era, offers an illustration. His story links South Carolina to Canada and to West Africa's Sierra Leone, showing the need to consider the African American experience within a hemispheric, Atlantic, and even global framework.

David George was born perhaps of African parents, in the 1740s in Virginia, where he worked as a field hand. His owner's wanton brutality finally caused him to flee to South Carolina. Once there, he was successively enslaved by Creek and Natchez owners before George Galphin purchased him for Silver Bluff Plantation on the Savannah River.

There, upon hearing the preaching of his childhood friend George Liele, he underwent a conversion experience that dramatically changed his life. On the plantation, in the 1770s before the American Revolution, a white preacher organized a congregation among the enslaved people. This Silver Bluff Baptist Church is likely the earliest congregation comprised exclusively of Afro-British (or African American) members. During this time, George married and started a family. He learned how to read and sing hymns, and he began exhorting the congregation. During the Revolution when white clerics could no longer visit, David George ministered to the group.[2] George continued his ministry at Silver Bluff until the British siege of Savannah in 1779. When his Patriot owner fled to avoid capture, George and his family as well as about fifty other Galphin slaves headed for the British military lines in Savannah. George remained in the area for about two years, preaching with Liele, before traveling to Charles Town, which was also under British control. On December 14, 1782, when the British evacuated Charles Town, 5,327 Black people were among them, including the George family. They were en route to Halifax, Nova Scotia, while others dispersed to East Florida, the Bahamas, Jamaica, and Great Britain.[3]

After sailing for three weeks, the George family arrived at Halifax. They comprised an infusion of as many as ten thousand Black loyalists who entered Canada at this time, dramatically expanding its Black population.[4] Unfortunately, the British government was woefully underprepared to settle so many immigrants. Early on, military officials had promised land to many settlers that was not immediately available. When they finally distributed the land, they did so in a racially discriminatory manner. Black people waited much longer and received smaller and lower-quality allotments than white people. When several companies of Black pioneers received land in 1783, they created an all-Black settlement known as Birchtown.[5] Most settlers likely never received any government land. To survive, some indentured themselves to others in exchange for life's necessities. This could jeopardize workers' freedom if they were manipulated by unscrupulous employers. The white working class often perceived these Black immigrants as a threat in the form of employment competition. As a dramatic example, in July 1783, a group of discharged white soldiers attacked Black workers and burned their homes in Shelburne, attempting to drive them from the city. This event has been described as "Canada's first race riot."[6]

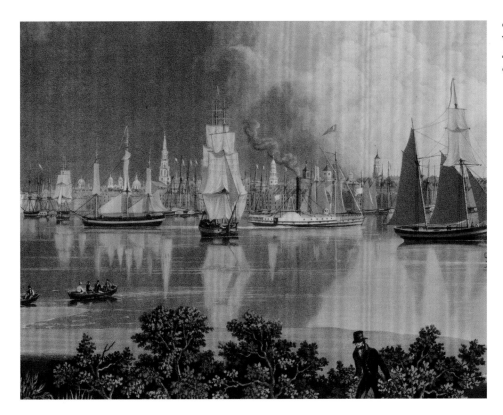

George Cooke (engraved by W.J. Bennett), *City of Charleston, South Carolina, Looking across Cooper's River*, 1838.

David George eagerly continued his ministry in Nova Scotia, but his efforts were sometimes stymied by racist attitudes and attacks. He occasionally baptized white people, at which others took offense. Once, George said white opponents "raised a mob" to prevent it. As George's reputation as a preacher grew, and although his Shelburne congregation was small, its meetinghouse suggested the modest prosperity of Black loyalists, affronting some white people. After refusing to accede to demands that he stop preaching, he was driven from the church physically by white men, and Reverend George and his family fled to Birchtown.[7] The depth of racial antipathy in eastern Canada ensured it could never be the home Black loyalists hoped.

Word about recent developments in Sierra Leone reached Halifax in 1791, offering hope—albeit in faraway lands. Sierra Leone was established in 1787 to relocate London's Black underclass that had grown up in the mid-1780s. That plan failed, but the Sierra Leone Company, which included leading British abolitionists such as Granville Sharp and Thomas Clarkson, reorganized the settlement and sought immigrants.[8] George consulted the project's representative

and became the first to sign up. Subsequently, he supervised the emigration from Nova Scotia. His congregation followed him along with many Black Nova Scotians. On January 15, 1792, more than one thousand passengers departed the harsh Canadian environment and sailed for Freetown.[9]

Of the male heads of households who made the trip (this is how the men were classified in the record), most were from Virginia or South Carolina. More importantly, one-third of them were Africans, making this a real homecoming for so many. John Kizell, for instance, had been kidnapped at age twelve from the Sierra Leone area, enslaved in South Carolina, and fought with the British during the Battle of Kings Mountain in North Carolina. Frank Peters had a similar biography. Most ironically, Lucy Banbury of West Africa was owned by planter Arthur Middleton, a signer of the Declaration of Independence; she also escaped to the British.[10] Those born in the Americas also felt a special connection to this venture. Sierra Leone was known as the "Province of Freedom," and its founders sought to diffuse Western civilization into the continent and develop "legitimate" commerce to supplant human trafficking. Later, after 1808, when the British began suppressing the Atlantic slave trade through legislation, diplomacy, and force, the British navy towed illegal slavers to Freetown and emancipated their captives. Now, the Anglo-African settlers, some of whom originated as far away as South Carolina, hoped their international journey toward liberty and justice had ended. In gratitude, on Sunday, March 11, 1792, David George and others raised a hymn of thanksgiving that reverberated throughout Freetown:

> Awake! And sing the song, of Moses and the Lamb
> Wake! Every heart and every tongue
> To praise the Saviour's name! . . .
> The Day of Jubilee is come
> Return ye ransomed sinners' home[11]

References

1. Betty Wood, *Slavery in Colonial Georgia 1730-1775* (Athens: University of Georgia, 1984), 91, 126; R. W. Kelsey, "Swiss Settlers in South Carolina," *South Carolina Historical and Genealogical Magazine* 23 (July 1922), 90.

2. David George, "An Account of the Life of Mr. David George, from Sierra Leone in Africa; Given by Himself in a Conversation with Brother Rippon of London," in Unchained Voices: *An Anthology of Black Authors in the English-Speaking World of the 18th Century*, ed. Vincent Carretta (Lexington: University Press of Kentucky, 1996), 333–36.

3. George, "An Account," 336; Lamin Sanneh, *Abolitionists Abroad: American Blacks and the Making of Modern West Africa* (Cambridge: Harvard University, 1999), 33; Those Blacks who were evacuated were generally enslaved or free Blacks who fought for or worked for the British or otherwise supported their military effort. See Alan Gilbert, *Black Patriots Fighting for Emancipation in the War for Independence* (Chicago: University of Chicago Press, 2012), 178, 180.

4. Ibid., 208.

5. Ibid., 198, 209; Gale Arlene Ito, "Black Loyalists Exodus to Nova Scotia (1783)," March 8, 2009, www.blackpast.org/global-african-history/black-loyalists-exodus-nova-scotia-1783/.

6. Gilbert, *Black Patriots*, 212, 214; "A difficult life for Black Loyalists," Nova Scotia Museum, accessed October 31, 2020, novascotia.ca/museum/blackloyalists/hardship.htm.

7. George, "An Account," 338–39.

8. Gilbert, *Black Patriots*, 220; George, "An Account," 340.

9. Sanneh, *Abolitionists Abroad*, 77–78; Ruth Whitehead, *Black Loyalists: Southern Settlers of Nova Scotia's First Free Black Communities* (Canada: Nimbus Publishing, 2013), 166.

10. Gilbert, *Black Patriots*, 223–24, 321–22; Kevin Lowther, *The African American Odyssey of John Kizell: A South Carolina Slave Returns to Fight the Slave Trade in His African Homeland* (Columbia: University of South Carolina, 2011), 25, 76–77; Simon Schama, *Rough Crossings: Britain, the Slaves and the American Revolution* (New York: Harper Collins, 2006), 321–22.

11. J. F. Ade Ajayi and Michael Crowder, eds., *History of West Africa: Volume Two* (New York: Columbia University, 1973), 36, 43; Schama, *Rough Crossings*, 321.

Documenting Charleston and the Lowcountry

by Lewis Watts

As part of my over forty-plus-year photographic investigation of the Great African American Migration, I have had some awareness of Charleston, the Georgia Sea Islands, and Gullah Geechee culture. That migration from the American South to the North and West was also a part of my own family history: I am the son of Southern-born parents who came west in the mid-1940s. Indeed, even though my parents had settled in Seattle, I was born in Little Rock, Arkansas—my mother returned there to give birth because she knew the Little Rock doctors.

It wasn't until I saw Julie Dash's film *Daughters of the Dust*, released in 1991, that the history and sense of place of the Lowcountry started to come into focus. The beauty and power of the film reflected a much more complex story, revealing the Gullahs as the "Maroons" of North America, keeping intact more African language and customs than many other people of African descent. Later, the book *Daufuskie Island* (2009) by Jeanne Moutoussamy showed me the great beauty and potential of the Georgia Sea Islands.

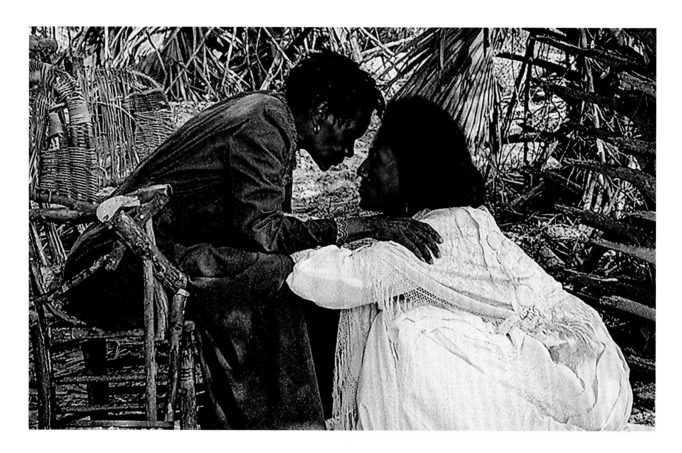

Above and facing page: film stills from *Daughters of the Dust*, written and directed by Julie Dash (1991).

I made my first trip to Charleston in 1995. I photographed a David Hammons installation, the architecture of the city, and the farmland on John's Island. I was passing through and stowed it in my mind as a place to return for further exploration.

I have returned to Savannah a few times, but didn't make it back to South Carolina until 2020, at the behest of my colleague Walter Hood, to explore and contribute to this publication. Thanks to my connection to the International African American Museum, I met many folks very happy about my interest and intention to document the culture, history, and present state of the area, and who were generous in directing me to people and places with breathtaking histories and narratives.

I photographed African American communities in and around Charleston that have existed since before and right after the Civil War. They have endured hardship and outside pressures, but they have survived, and, in many cases, thrived.

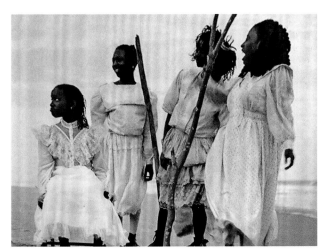

My interpretation of William Faulkner's observation of the South—"The past isn't dead. It isn't even past."—emerges through my photographs. In my work, I am drawn to the past that is never very far below the surface. The past is visually present and juxtaposed to—as well as being in concert with—the present day. Reflecting both the past and the present, the surrounding water and the imprint of the climate upon the land intersperse with the people that I have encountered. Being a region prone to hurricanes has also impacted both the natural and built environment of the Lowcountry. Hurricanes are strong markers that leave visual clues on the economy and those environments. I have been pulled to the marks left on surfaces and on people's lives, and respond to them in my work.

I've witnessed how Charleston houses reflect their owners. Newly purchased houses must be fortified as directed by FEMA to be more resistant to the climatic conditions. These homes stand out from old family homes that have in some cases been restored and in other cases expose the past on their facades. Some families and their homes have been in their communities for generations, and I've seen evidence of their efforts to resist development. It's in instances like this that I have seen why many people of African descent stayed in the South during segregation: It was because they were thriving in spite of, and in the midst of, those conditions. Indeed, there has been a recent movement to resettle in the South as laws have changed and culture thrived. In my visits to South Carolina, I've encountered both South Carolinians who have returned from other places, as well as newcomers. On the other hand, I

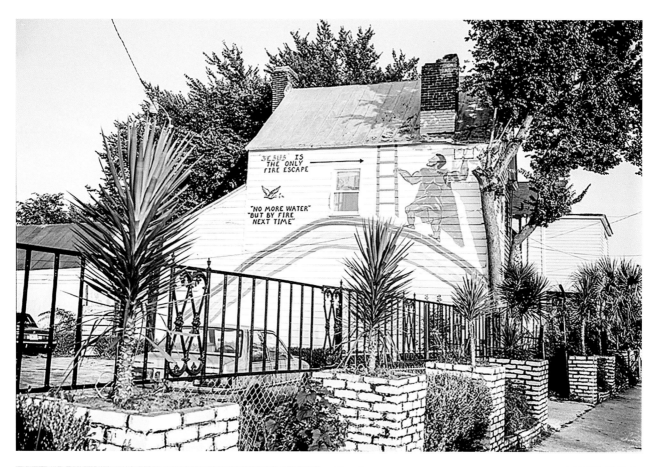

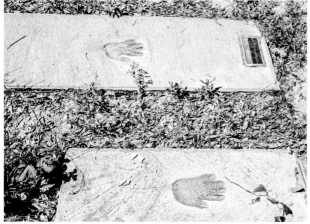
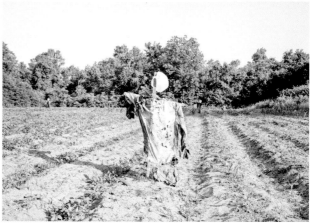

Three views of Charleston and the Lowcountry by Lewis Watts. Top: "But By Fire Next Time," Charleston, 1995. Above left: Graves, Johns Island, 1995. Above right: Scarecrow, Johns Island, 1995.

have seen evidence of the decline of once-thriving sweetgrass weaving tradition—a direct tie to Africa—in the mostly abandoned stands on the side of Highway 17, "the Sweetgrass Highway." Many of the weavers have died. Others have been affected by the widening of the highway that made it difficult for drivers to stop. Some stands remain. So too does a family tradition of selling baskets in the public markets in Charleston and suburban Mt. Pleasant, which was the site of many of the plantations and communities of freed people after the Civil War.

I photographed Mother Emanuel AME Church, one of the oldest and largest African American houses of worship in the area. I found that the grandeur of the structure and the strong presence of history far outweighed the evidence of the 2015 massacre that occurred there. People I met also pointed me toward long-existing, as well as newly discovered, African burial grounds, and also to the African tradition of "bottle trees," the hanging of bottles on surrounding trees to ward off evil spirits.

All that I saw and photographed was enhanced by the beautiful and changing light that I encountered across the Lowcountry, from south of Savannah to north beyond Charleston. The area offers so much to experience that I have just started to scratch the surface, even after four visits in the last few years. It's been thrilling to experience this place, this history, and this land. I've been inspired to make strong images of my experiences, and it's been both a challenge and an incredible opportunity. In doing so, I am honored to contribute to the visual, cultural, and historical record—of the International African American Museum, of the region, of the country—with the benefit of my experienced and very interested gaze. At the opening of the IAAM in the summer of 2023, the museum was filled with families who exhibited pride and engagement at the importance of this beautiful institution.

VIEWS OF CHARLESTON

PHOTOGRAPHS BY LEWIS WATTS

It was an honor and a pleasure to document the land, history, the Gullah culture and the people in the area around Charleston, South Carolina for this book. As a photographer, I responded not only to the beautiful landscapes and light, but also the visible traces of the past that are so close to the surface. This region offers so much to experience that even after numerous visits in the past several years, I feel I have just begun to scratch the surface. To photograph there today presents a window to a still contested past.

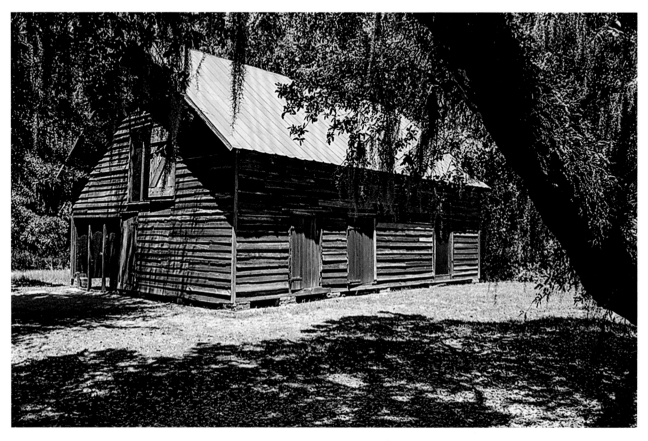

Above: McLeod Plantation, Charleston, 2021.

Right: William Enston Home (U.S. National Park Service), Charleston, 2021.

Spanish moss, Hampton Park, Charleston, 2021.

Top left: Mt. Sinai Holiness
Church, Charleston, 2022.

Top right: Old Slave Mart
Museum, Charleston, 2021.

Right: Bottle tree sculpture,
Spoleto Center, Charleston,
2021.

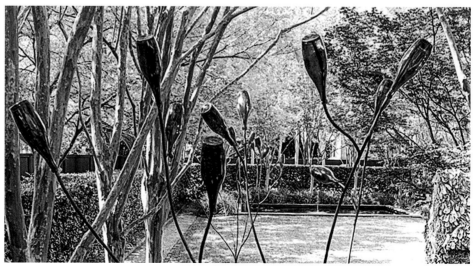

Left: Charleston, 2021.

Below: Shoreline, Ten Mile, 2021.

Mother Emanuel AME Church,
Charleston, 2021.

Left: Mother Emanuel AME Church, Charleston, 2021.

Bottom left: Rev. Eric S.C. Manning, Mother Emanuel AME Church, Charleston, 2021.

Bottom right: Mother Emanuel AME Church, Charleston, 2021.

Marsh boardwalk, Snowden
Community, Mount Pleasant,
2021.

Gullah Sweetgrass baskets
by Betsy Frasier and Family,
Sweetgrass Highway, 2021.

Above: Ocean Grove
Cemetery, Mount Pleasant,
2021.

Far right: Recently protected
unmarked graves, Mount
Pleasant, 2021.

Right: Venning Cemetery,
Mount Pleasant, 2022.

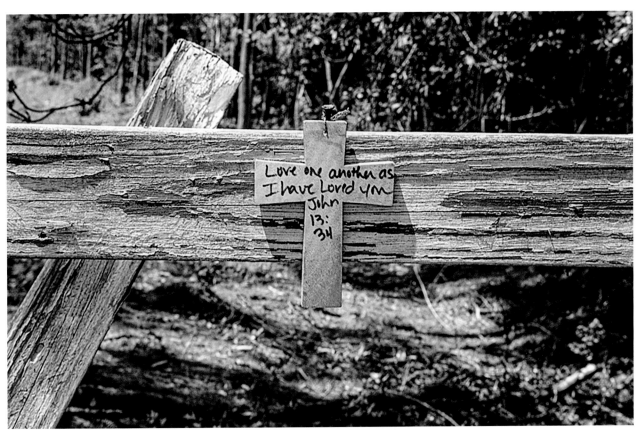

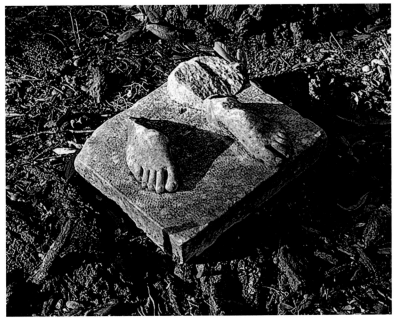

Above: Sweetgrass Highway, 2021.

Left: Ocean Grove Cemetery, Mount Pleasant, 2021.

Grant Cemetery, North
Charleston, 2021.

Above: Mount Pleasant, 2021.

Far left: Joseph Fields, Joseph Fields Farm, Johns Island, 2021.

Left: Fred Wilson, Mount Pleasant, 2021.

Above: Linda's Place, North
Charleston, 2021.

Right: Charlotte Jenkins, chef/
owner of Gullah Cuisine, Mount
Pleasant, 2021.

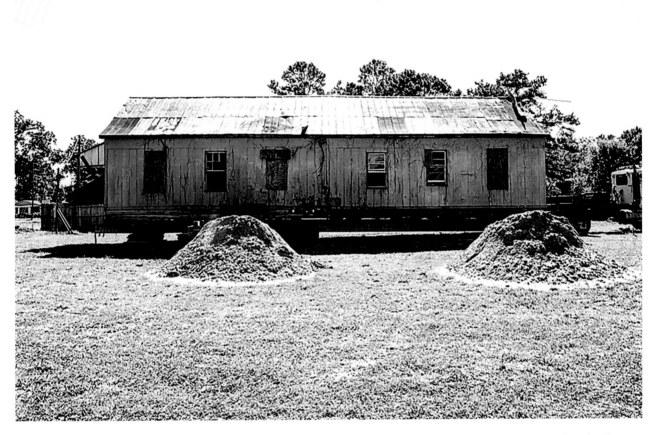

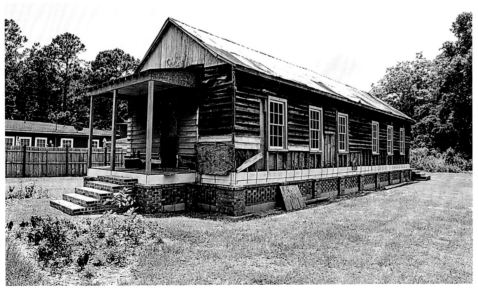

Above: Long Point Schoolhouse, one of the last Black schoolhouses in the Lowcountry, just after relocation, Snowden Community, Mount Pleasant, 2021.

Left: Long Point Schoolhouse undergoing restoration for its transformation into a museum, 2023.

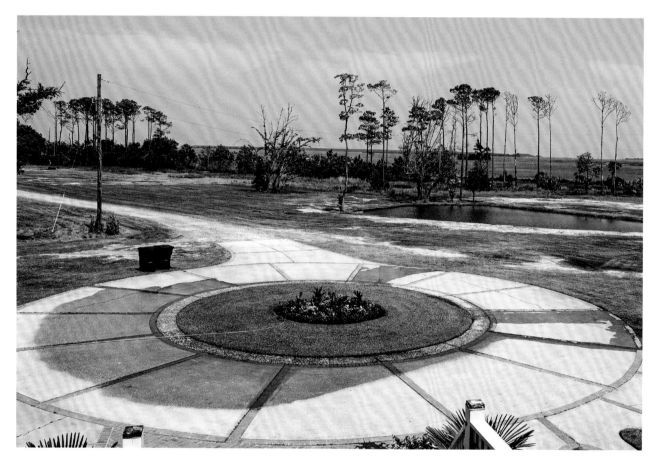

Above and right: Ten Mile, 2021.

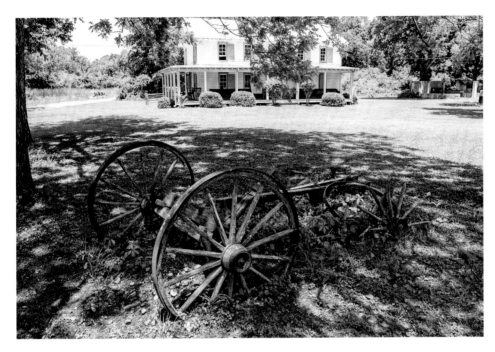

Left and below: Mosquito Beach, 2021.

R.R. TO SAVAN...

LAROACH

BU...

S T.

YATES

J...

MUSTER HOUSE

CHAPLIN

G

J LA ROCH

ADGER

R LA ROCH

W

NEW CUT LANDING

PRES. CHURCH

A

D

WHITE

O

O

HOCKET AR...

C

L

L

FORRESTER

M

L

W.

A

S

D. TOWN

D

E

N

A

P

JENKINS

E

N

W

A

H

ROCK...

CAPERS

REYNOLDS...

RIVERS

S

BEAR BLU...

WILSON

O

U

N

D

NORTH EN...

02 HISTORY OF

CHARLESTON

Repressed Memories
by Dell Upton

Forks of the Road, a nondescript intersection on the outskirts of Natchez, Mississippi, formerly hosted the second largest slave market in the southern United States. A modest interpretive sign explains the site's significance. Next to the sign, unlabeled and unobtrusive, rusty shackles lay partially embedded in an irregular puddle of concrete. Are they sinking or rising? Are they fragments of a forgotten past or reminders that the past cannot be forgotten? Their ambiguity creates an apt metaphor for Americans' understanding of slavery and race, as a memory many wish to erase but that recurs constantly in everyday life.

The vast majority of people of African descent—hundreds of thousands of people—entered the Americas involuntarily, kidnapped from their homelands for their labor. Upon arrival, their white captors sold them into slavery. In what would become the United States, from the sixteenth century until well into the nineteenth, these Africans and generations of their offspring, along with a continuous stream of newly arrived captives, grew to an enslaved population of 4 million people by the end of the Civil War.[1]

The unpaid labor of these Africans and their descendants made possible the enormous agricultural plantations of the mainland and the Caribbean. Their toil supported the comfortable lives of their white owners, both in the Americas and in Europe.

Their proficiencies extended beyond the implications of the "house slave/field slave" stereotype. In North and South, on farms and in cities, enslaved people worked as wood- and ironworkers, spun and wove cloth and shaped it into garments, milled grain, made shoes and furniture and buildings, cooked and played music, and raised and slaughtered animals. Many worked in commercial and industrial settings, plying all these skilled crafts and more. As agriculturalists and manufacturers relied on enslaved labor, merchants bought and sold human beings, and others supplied food, clothing, transportation, and other necessities of the slave system. Enslaved labor was the foundation of the growing capitalist economy worldwide.[2]

Today, the physical evidence of enslaved labor remains visible everywhere throughout the eastern United States and the Caribbean. Slave housing survives, but even more plentiful are the kitchens, barns, smokehouses, shops, and other sites of unfree labor.[3] Although the enormous plantations of wealthy slaveholders are the most conspicuous, both large- and small-scale farms used enslaved labor, and their collections of buildings—often described by visitors as small villages—were carefully ordered, systematic spaces of living and working. The "big houses" themselves were part of this system, sites of labor and sometimes accommodations for enslaved workers, who slept in attics, in cellars, and on floors outside bedrooms. Like the shackles at Forks of the Road, these sites testify to persistent elements of our current reality that are difficult to elude.

When chattel slavery entered the Americas in the sixteenth century, it was immediately recognized as a troublesome practice. Some Catholic missionaries, Protestant clerics, and secular individuals vocally opposed the institution.[4] By the nineteenth century, most non-slaveholders, particularly those outside the South, relied on moral arguments and offered a sentimental view of slavery exemplified by Harriet Beecher Stowe's *Uncle Tom's Cabin* novel (1850), in which she portrays heartless white slaveholders treating enslaved people as childlike victims rather than as people with wills and abilities of their own. Many abolitionists were non-slaveholding merchants and industrialists who employed free people in miserable conditions not much better than slavery, controlling their workers' everyday lives in company towns nearly as closely as enslavers controlled those of their workers. They were often more troubled by slavery as a moral and political sin than they were by the specific fates of enslaved people unfolding under their watch.[5]

Top: Informal memorial at Forks of the Road, Natchez, Mississippi, the site of the second-largest slave market in the United States from the early nineteenth century until it was closed and demolished by the U.S. Army in 1863. Photograph by Dell Upton, 2012.

Bottom: Outbuildings, Four Square, Isle of Wight, Virginia. Street of outbuildings behind the main house. Left to right: slave house (mid-nineteenth century), smokehouse (early nineteenth century), garage (twentieth century), double dairy (early nineteenth century), pumphouse (twentieth century). Photograph by Dell Upton, 1981.

Thomas Coram, *View of Mulberry, House and Street*, ca. 1800, showing street of slave houses. The house, at Monck's Corner, South Carolina, survives but the street of houses for the enslaved does not.

Slaveholders and their allies understood slavery's central economic role and were unashamed of their support for it. The 1861 Mississippi declaration of secession described slavery as "the greatest material interest of the world. Its labor supplies the product which constitutes by far the largest and most important portions of commerce of the earth. These products are peculiar to the climate verging on the tropical regions, and by an imperious law of nature, none but the black race can bear the tropical sun. These products have become necessities of the world, and a blow at slavery is a blow at commerce and civilization."[6] On the floor of the U.S. Senate, South Carolinian John C. Calhoun asserted that slavery "has grown up with our society and institutions, and is so interwoven with them that to destroy it would be to destroy us as a people." Adamant, Calhoun declared slavery as "a good—a positive good.... [T]here has never yet existed a wealthy and civilized society in which one portion of the community did not, in point of fact, live on the labor of the other."[7]

A few slaveholders, including some of the best known, were less straight-
forward in their defense of human bondage. According to the Swedish visitor
Fredrika Bremer, "One thing . . . which astonishes and annoys me here, and
which I did not expect to find, is, that I scarcely meet with a man, or woman
either, who can openly and honestly look the thing in the face. They wind and
turn about in all sorts of ways, and make use of every argument, sometimes
the most opposite."[8] Prominent men such as George Washington, George
Washington Parke Custis, and Thomas Jefferson professed to oppose slavery,
but were unwilling to sacrifice their own and their white families' economic
and creature comforts to abolish it. Washington declared his abhorrence of
the institution, but he wanted the legislature to enact an emancipation act
rather than leave it to individual slaveholders. He freed those slaves whom he
owned upon his death, when they were no longer of use to him, but the people
whom his wife owned remained enslaved. Custis, Washington's step-grand-
son and adopted son, supported the American Colonization Society, which
sought to free slaves and deport them to Africa (the modern nation of Liberia
emerged from this movement), and ordered that his slaves be freed at his
death if the estate were debt free. It was not, and they were accordingly sold by
his executor and son-in-law, Robert E. Lee.[9] Thomas Jefferson is perhaps the
most conspicuous example of such pusillanimity. The author of the Decla-
ration of Independence and vocal proponent of liberty was one of Virginia's
largest slaveholders, and all but seven of his nearly 130 slaves were auctioned
at his death to pay the debts incurred by his lavish lifestyle.[10] For such men,
anti-slavery sentiments might fairly be considered self-justifications that
shielded lives dependent upon the labor of enslaved people for their livings,
luxuries, and social standing.

The shackles began to sink into the concrete even before the Civil War.
Bremer's Charleston interlocutors strove to convince her that "the slaves are
the happiest people in the world, and do not wish to be placed in any other
condition, or in any other relationship to their masters than that in which
they now find themselves."[11] White Northerners and Southerners alike were
charmed by minstrel shows that claimed to present ethnographic portraits
of the lives and culture of happy plantation slaves, which formed a significant
element of American popular culture into the mid-twentieth century. Even
before the Old South was extinguished, Americans understood Black life and

labor under the slave regime through popular admiration for "the grace and grandeur of the southern plantations of the 18th and 19th centuries," in the words of a tourist brochure from Middleton Place in South Carolina. Middleton Place exemplifies that grandeur in its the surviving gardens, whose creation required one hundred enslaved workers to toil for nearly a decade in the swamps and wetlands of the Lowcountry.[12]

Historic-house museums tellingly indicate the struggle to understand the nation's slave underpinnings, and aptly illustrate the metaphor of the semi-concealed shackles. Since the nineteenth century, these were the sites where visitors might have encountered the realities or American slavery, but rarely did. A National Park Service guidebook written in the 1980s describes Hampton, a National Historic Site outside Baltimore, as "the true dichotomy of elegant estate and working plantation bound together as an independent unit," but does not address whose labor achieved this synthesis, even though twenty-three outbuildings, including a slave house, survive on site.[13] Such silences were the rule in historic house museums until very recently. The existence of slaves and the reliance on slave labor has been treated as irrelevant, at best.

This pattern of denial stretches back to the mid-nineteenth century, when in 1858 Mount Vernon was wrested from the hands of the Washington family, as the culmination of a campaign by South Carolinian Ann Pamela Cunningham and her Mount Vernon Ladies' Association of the Union. Several close advisors encouraged Cunningham to destroy the mansion's outbuildings, uncomfortable reminders of the ongoing national conflict over slavery and race, but she refused to do so. Yet, as a former director of the museum pointed out, slavery—and African American workers generally—had little role in the site's interpretation until recently. One of Mount Vernon's Black burial grounds was marked in 1929 but not pointed out to tourists.[14] A barracks for enslaved workers was reconstructed in 1959, but as late as the 1970s the workers' presence was described purely in terms of their convenience and inconvenience to Washington:

> "A large Virginia estate," says Washington Irving in his biography of George Washington, "was a little empire" Mount Vernon is a good example of those little empires, and the orderly arrangement of its dependencies imparts a village-like character to the group of buildings about the mansion. Yet the plan is so well managed that the service lanes do not intrude upon

the area reserved for the use and enjoyment of the master, his household, and his guests. This is a tribute to General Washington's ability in the realm of architecture and landscape design. These subsidiary buildings housed many people and served a variety of essential purposes; only a carefully developed plan could have subordinated them in such close proximity to the main house and, at the same time, incorporated them as harmonious units of the group.[15]

Around the same time, the caretakers of Jefferson's Monticello made similar observations. The service spaces (commonly called "dependencies" in the South) were placed below the terraces to keep "the view from the [house's] lawn unobstructed and concealing the coming and going of servants." Enslaved Black people were "servants," "workers," or "field hands"—but never "slaves." (A nineteenth-century visitor to the South observed that "Slaves are called *servants* by the same sort of euphemism that softens a *lie* into a *fib.*") Mulberry Row, where many of the enslaved people who worked near the main house lived and where blacksmiths, nail makers, and other artisans worked, was presented primarily as "the industrial area" of Monticello, with its residents, Black and white, as afterthoughts.[16]

Gradually, at these and other similar historic sites, the lives of enslaved workers have been called to visitors' attention. The "force of workers" in the first edition of the Monticello guidebook became a "force of slave workers" by the third edition of 1993. Mulberry Row was reframed as a place of residence for free and enslaved workers, and secondarily as an industrial site; the "dependencies" attached to the house were similarly presented as both residences and workplaces.[17]

Since the 1990s, researchers at sites such as Monticello and Mount Vernon have investigated the lives of individual enslaved workers. Newer guidebooks explicitly name those who worked at the sites and what they did. This effort has thus undermined the sense that the plantation consisted of a great man and a faceless supporting cast. It has also revealed the complex social structures of such large plantations, with people differentiated by age, by sex, by skills (many people had more than one), by family ties and other interpersonal relationships, by religious beliefs, and sometimes by languages. The simple division of field slaves from house slaves has collapsed under a

E. P. Christy, *Christy's Plantation Melodies* (Philadelphia, 1851). The title page of this collection of minstrel songs features a vignette showing a Black man playing the banjo in front of a crude house. It was intended to be read as an idyllic image of enslavement.

flood of documentary evidence.[18] And images of the carefree life of enslaved people are erased by the documentation of hard, unrelenting labor, "dawn to dusk, six days a week," from the age of ten, with lighter work requirements before that.[19] Even under slaveholders such as Jefferson, who wished "that the labourers be well treated," the condition was "that they may enable me to have that treatment continued by making as much [profit] as will admit it."[20] Finally, and tellingly, newer research has made clear, in the words of David Brion Davis, "how deeply immersed in African-American life Thomas Jefferson and other major slaveholders actually became," no matter how close or how indifferent their attention to that life.[21] A four-page spread in the 1997 Monticello guidebook, which replaced the older one discussed above, uses an infographic displaying individual human figures to represent every resident of the mountaintop in the late 1790s, making graphically apparent the Blackness of the Monticello population.[22]

Yet the new museum interpretations of slavery, laudable as they are, leave us wanting to know more. To recuperate the lives and identities of enslaved people, they present an image of two separate communities, white and Black, that impinged on one another in relatively limited ways related to labor. They miss, however, the human dynamics: the ways the unequal social system shaped the everyday lives and the world views of both the enslaved and the enslavers.

Unfree labor on the plantation and in its corollaries—the docks, the factories, the shops, the warehouses, and the mills—is, therefore, the foundation of the American economic and social order. In both North and South, fortunes based on slavery continue to underpin elite institutions. Slaver Isaac Royall was a major donor to Harvard's Law School. The Brown family of slave traders in Rhode Island are the namesakes of Brown University. In New York, major colonial families who shaped the politics and economy of the early republic —families such as the Van Cortlandts, the Van Rensselaers, and the Schuylers—amassed much of their fortune through the trade in human lives. These truths are unsettling to a nation whose economic mythology stresses individual enterprise. Only when we acknowledge that American society as it exists today remains grounded in enslavement can we begin to understand contemporary divisions and inequities.

Monticello (Thomas Jefferson, 1770–1816), Charlottesville, Virginia. South service wing, containing the kitchen and residential spaces for some enslaved workers, is set below the edge of the lawn to conceal it from view from the main house. Photograph by Dell Upton, 1990.

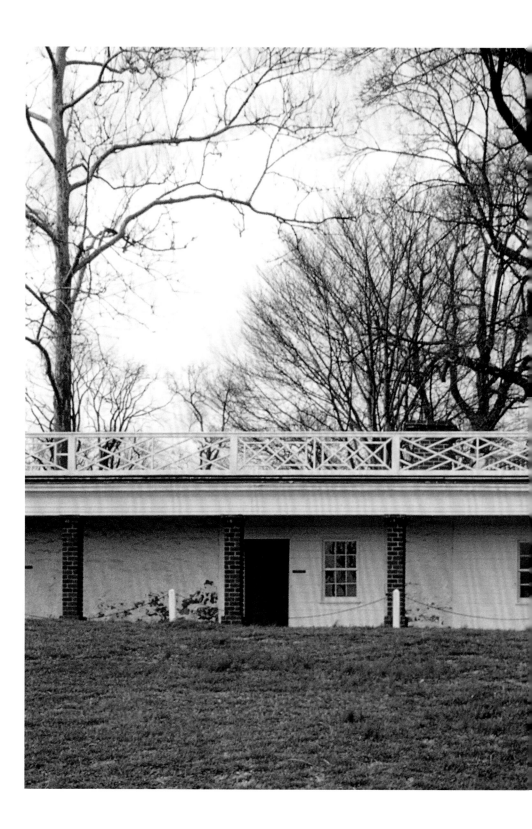

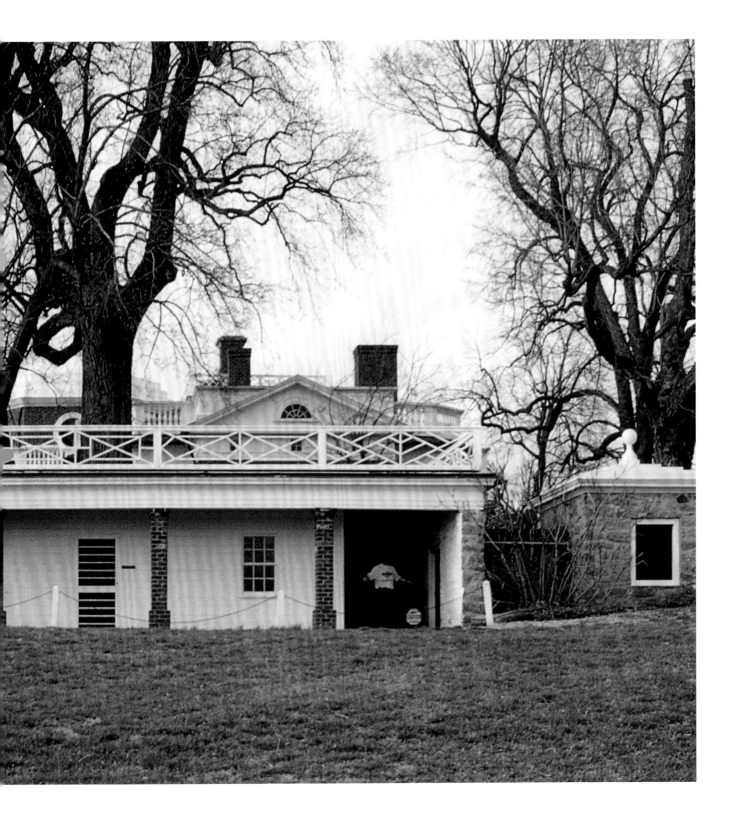

We live with the legacy of slavery because the social, spatial, and economic structures defined by the slave system outlasted Emancipation. Despite vague promises of land redistribution in the aftermath of the Civil War, for example, white Southerners soon reclaimed nearly all their land. The federal government, fearful of economic disruption, coerced Black laborers into returning to work—in conditions startlingly similar to those they endured during slavery.[23] After Reconstruction's end in 1877, Southern authorities devised a variety of legal and extralegal practices, from debt peonage to convict labor to disfranchisement to terrorism, designed to recover, as much as possible, the racial and labor order of the pre-Civil War South.[24] On large and small farms, emancipated laborers continued to inhabit slave housing, often the same people living in the same structures as during slavery times. Industries that relied on enslaved labor, such as sugar refining, tobacco processing, and cotton cleaning, continued to rely on nominally free Black labor. African Americans were disfranchised in the name of white supremacy. As the periodic conflicts over the role of slavery in American history have renewed with particular vehemence in recent years, it is apparent that Americans still haven't shaken off those half-buried shackles at Forks of the Road.

As we contemplate these hard, but central, facts of American history, it is appropriate to do so at the crucible of American slavery, in a city built on the profits of enslaved labor, and whose urban landscape—both the elegant neighborhoods of old Charleston and the workaday spaces that surround it—was and is the product of Black labor, Black disenfranchisement, but also of Black values and Black culture, forged in the centuries of slavery and in the decades of struggle following it. The International African American Museum stands at ground zero for much of this history, and it is a fitting place to begin to understand it. By doing so, we can more keenly understand not only the racial struggles that characterize our own lives, but the economic and political inequalities that divide us.

Maybe we can even begin to alleviate them. In that sense, the International African American Museum offers a profoundly patriotic history.

References

1. Joseph P. Reidy, *Illusions of Emancipation: The Pursuit of Freedom and Equality in the Twilight of Slavery* (Chapel Hill: University of North Carolina Press, 2019), 15.
2. Edward E. Baptist, *The Half Has Never Been Told: Slavery and the Making of American Capitalism* (New York: Basic Books, 2016), 33, 413.
3. John Michael Vlach, *Back of the Big House: The Architecture of Plantation Slavery* (Chapel Hill: University of North Carolina Press, 1993), 183–225.
4. Winthrop D. Jordan, *White over Black: American Attitudes toward the Negro, 1550–1812* (Chapel Hill: University of North Carolina Press, 1968), 194–96, 271–76.
5. Fred Kaplan, *Lincoln and the Abolitionists: John Quincy Adams, Slavery, and the Civil War* (New York: HarperPerennial, 2017), 154–57, 197–98, 306–08.
6. "A Declaration of the Immediate Causes Which Induce and Justify the Secession of the State of Mississippi from the Federal Union," January 26, 1861, Mississippi Secession Convention, in *The Confederate and Neo-Confederate Reader: The "Great Truth" about the "Lost Cause,"* eds. James W. Loewen and Edward H. Sebesta (Jackson: University Press of Mississippi, 2010), 127.
7. John C. Calhoun, "On Abolition Petitions," U.S. Senate, February 6, 1937, in *Confederate and Neo-Confederate Reader*, 33, 34.
8. Fredrika Bremer, *The Homes of the New World: Impressions of America*, trans. Mary Howitt (New York: Harper and Brothers, 1854), 1, 275. Bremer wrote this remark during a visit to Charleston.
9. Mount Vernon Ladies' Association, *George Washington's Mount Vernon: Official Guidebook* (3rd ed.; Mount Vernon: Mount Vernon Ladies' Association, 2016), 109, 137, 194; Nancy Growald Banks, *Arlington House: A Guide to Arlington House, The Robert E. Lee Memorial, Virginia* (Handbook 133; Washington, D.C.: Division of Publications, National Park Service, 1985), 24.
10. Gordon S. Wood, "The Ghosts of Monticello," in *Sally Hemings & Thomas Jefferson: History, Memory, and Civic Culture*, eds. Jan Ellen Lewis and Peter S. Onuf (Charlottesville: University of Virginia Press, 1999), 20–21; Charley Miller and Peter Miller, *Monticello: The Official Guide to Jefferson's World* (Washington, D.C.: National Geographic Society, 2016), 6, 11.
11. Bremer, *Homes* 1, 275.
12. *Middleton Place* (Charleston: Middleton Place Foundation, n.d.), 5, 26.
13. Lynne Dakin Hastings, *Hampton National Historic Site* (Towson, Md.: Historic Hampton, 1986), 63.
14. James C. Rees, "Looking Back, Moving Forward: The Changing Interpretation of Slave Life on the Mount Vernon Estate," in *Slavery at the Home of George Washington*, ed. Philip J. Schwarz (Mount Vernon: Mount Vernon Ladies' Association, 2001), 159–61, 163.
15. Mount Vernon Ladies' Association of the Union, *Mount Vernon: An Illustrated Handbook* (Mount Vernon, Va.: Mount Vernon Ladies' Association of the Union, 1974), 96.
16. Frederick D. Nichols and James A. Bear Jr. *Monticello* (Monticello, Va.: Thomas Jefferson Memorial Foundation, 1967), 14, 53; Edward S. Abdy, *Journal of a Residence and Tour in the United States of North America, from April, 1833, to October, 1834*, 3 vols. (London: John Murray, 1835), vol. 1, 66.
17. Frederick D. Nichols and James A. Bear Jr. *Monticello*, 3d ed. (Monticello, Va.: Thomas Jefferson Memorial Foundation, 1993), 50, 55.
18. See for example Susan R. Stein, Peter J. Hatch, Lucia C. Stanton, and Merrill D. Peterson, *Monticello: A Guidebook* (Charlottesville: Thomas Jefferson Memorial Association, 1997), 61, 76, 106–08.
19. Stein, Hatch, Stanton, and Peterson, *Monticello: A Guidebook*, 102.
20. Miller and Miller, *Monticello*, 105.
21. David Brion Davis, "Preface," in Lucia Stanton, *"Free Some Day": The African-American Families of Monticello* (Charlottesville: Thomas Jefferson Foundation, 2000), 11.
22. Stein, Hatch, Stanton, and Peterson, *Monticello*, 94–97.
23. Foner, *Reconstruction: America's Unfinished Revolution, 1863–1877* (New York: Harper and Row, 1988), 158–63, 171, 183–84.
24. Douglas Blackmon, *Slavery by Another Name: The Re-Enslavement of Black Americans from the Civil War to World War II* (New York: Anchor Books, 2009), 7–9.

"Where Have I Seen These Faces Before?": Presence and Power of African Ancestors in the Architecture of Charleston

by Nathaniel Robert Walker

Out of the huts of history's shame / I rise /
Up from a past that's rooted in pain /
I rise / I'm a black ocean, leaping and wide, /
Welling and swelling I bear in the tide.
— Maya Angelou, "Still I Rise"

Mountains of soil have been moved in Charleston in
a deliberate, sustained attempt to bury Black people,
both living and deceased. Earth has been heaped upon
the African ancestors who played indispensable but
unrewarded roles creating the city. It has been poured
upon their descendants, who built Charleston under the
crushing weight of slavery, and who have subsequently
spent over a century digging out from under its ruinous
legacy. This monumental burial, both literal and
metaphorical, has implicated Charleston's architectural
fabric, from the construction of the city and its masking
of slavery's horrors, to recent and ongoing efforts to
trace the history of Black people within it. The city and
the surrounding landscape testify to the labor, creativity,
and resilience of Black people. They are also the scenes
of awful crimes from which many Americans have
long averted their gaze, frightened by the prospect
of excavation.

The International African American Museum and the surrounding African Ancestors Memorial Garden help us to look and to see—to dive deep into the watery, muddy, bloody foundations of Charleston's history, and bring to light the obscured truth of African presence and power in the making of the city, and, ultimately, of the nation at large. The museum and garden are towering achievements in a multigenerational effort to tear away the shadows cast upon the history and future of Black people. They are built manifestations of memories that Black Charlestonians have recovered from the cemetery and the seabed, under asphalt and behind brick walls. They are also architectural answers to the lies told by other spaces and structures in the city, where the African contribution to Charleston has been ignored or denied. The crucial role of memory in constructing the future was articulated by Elon Cook Lee of the Black Interpreters Guild, who advocated for Black visibility in historic Charleston tours. For too long, the city's guides have either completely ignored African Americans or described them as "window dressing" and "accessories to the lives of the white people," which can make young Black listeners feel shame for their ancestors and doubt their own value.[1] Africans and their descendants endured one of the worst calamities suffered by any people, building Charleston while doing so, and neither the truth nor the people who seek it can stay submerged forever. They rise together.

In May of 2018, as the IAAM approached its fundraising goal, the leading Charleston newspaper, the *Post and Courier,* ran an article about a nearby luxury residential development under the headline "Condo built on Charleston's last slave trading wharf markets history—without mentioning slavery."[2] The elegant row of condominiums, perched along Gadsdenboro Street on the historic southern edge of Gadsden's Wharf, was christened "The Gadsden," and the construction fence surrounding the site featured a banner with a timeline of the area's history. The banner neglected to mention that enslaved labor built the wharf, and the timeline conveniently ended a few years before the wharf's most important period, 1806 to 1808, when it was the last and only place in the United States where slave ships traveling from Africa could legally dock and sell their human cargo.[3] Nor did it recognize "Gadsden" as the surname of nineteenth-century Charleston's most important slave trader. Upon receiving public criticism, the development firm insisted they were not responsible for helping people interpret the past, and quietly dismantled the celebratory banner. Their attempt to leverage a reduced local history, stripped of reference to Africans and to slavery, was

just the latest shovelful of dirt in a burying process underway for centuries. The ground is now shifting, thankfully. The IAAM has risen on Gadsden's Wharf. As the museum and garden powerfully convey, however, the problem is at least as large as the city and the landscapes and harbor that envelop it; also momentous, therefore, are the possibilities for recognition and healing that are nurtured in the light of the garden's spaces for contemplation and conversation.

A Place Called Gadsden's Wharf

The centering of the slave trade upon Gadsden's Wharf was calculated to distance its sights, sounds, smells, and manifold hazards from Charleston's white population. The prominent statesman and businessman Christopher Gadsden had built the enormous wharf—then the largest in North America—in the years before the American Revolution, and it remained at the heart of his family's enterprise for decades. Innumerable enslaved people had carried out the hazardous construction work, just as they completed most of the agricultural labor producing the indigo and rice that drove the wharf's commerce, as well as the ironwork, brickmaking, masonry, plasterwork, and carpentry that had facilitated Charleston's rapid growth since the late 1600s.[4] Indeed, the city's Black people possessed such great architectural skills that, only a few years before Gadsden began his wharf project, the colonial government mandated that all master artisans "constantly employ, one white apprentice or journeyman for every *two* negroes or other slaves" that they used, to protect white workers from destitution.[5] That same law levied a tax on the badges that Black workers were required to wear in all public spaces, "appropriated towards keeping the streets in Charles-Town clean and in repair." Essentially the whole city was built by Black people, either directly through their skills and labor, or indirectly through taxation on the same. They also imparted African and Afro-Caribbean qualities to Charleston's architecture that infused it with its unique character; shady porches and lacy wrought-iron gates fused West African architectural traditions with European ones, creating a hybrid building fabric that one amazed Scottish visitor could only describe as exhibiting "a light Oriental style."[6]

Yet, the impressive infrastructure and architectural beauty of this confluence of Europe and Africa was mired in a monstrous social system. By the mid-1780s, Gadsden's Wharf hosted the sale of human cargo from Africa.[7] After months at sea, those unfortunate individuals likely quarantined for a

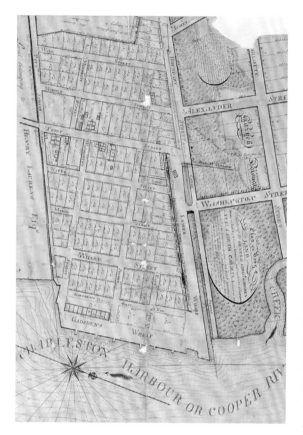

Gadsden's Wharf as built and platted out for development ca. 1795. The only existing structures at this time were the warehouses near the Cooper River, as well as a few residences on the interior, including the Grimké house, here listed as the house of William Blake, near the corner of Front Street and A Minority Street (now East Bay and George Streets). Courtesy of the City of Charleston.

week or more in their crowded ships, or else in the large "pest house" on Sullivan's Island, where hundreds of the enslaved at a time would be crowded until they died or were pronounced clear of disease, their first experience of America being a "sandy, hot, and barren" place.[8] Finally, slave traders unloaded them in chains onto the sunbaked Charleston docks.[9] In 1787, South Carolina closed its ports to ships carrying African captives, as other states already had done, thus halting the legal transatlantic slave trade. In 1803, however, the state legislature reopened Charleston to the trade, shocking the nation as it feasted yet again on the fortunes made by enslaving Africans. At the same time, the city went to considerable expense to move the quarantine site to the bitterly named "Point Comfort" on James Island, on the southern coastline of Charleston harbor, so that the residents of Sullivan's Island, and elite white Charlestonians resorting there, would no longer have to witness or smell the pest house.[10] After completing quarantine, the rapidly proliferating slave ships first docked at many of the smaller wharves near the heart of town, but this exacerbated chaos and crowding, straining the "safety and tranquillity [sic] of the city, as well as good order and propriety."[11] In 1806, Charleston's government declared that all ships bearing enslaved people must unload at Gadsden's Wharf.[12] The change of venue to that vast site evinces the explosive increase in human trafficking. White citizens also, in the words of historian and archivist Nicholas Butler, "wanted to push it to the northern fringes of the city" because the commerce was dreadful to witness.[13]

The evil that occurred at Gadsden's Wharf did not, however, remain invisible. The brutal transatlantic crossing ensured that many Africans perished before they even arrived. Thousands more died from disease, abuse, exposure, and neglect during quarantine or while imprisoned in the dark, dank, insect-infested brick warehouses on Gadsden's Wharf. Those structures had been built to store rice, tobacco, and lumber, and thus made miserable pens for men, women, and children. The English eyewitness John Lambert explained

the brutal commercial logic that precipitated the demise of countless people, and the effects of that mass death on Charleston Harbor:

> When I arrived the sales for slaves were extremely dull, owing to the high price which the merchants demanded for them. The planters, who were pretty well stocked, were not very eager to purchase; and the merchants, knowing that a market would ultimately be found for them, were determined not to lower their demands: in consequence of which hundreds of these poor beings were obliged to be kept on board the ships, or in large buildings at Gadsden's wharf, for months together. The merchants, for their own interest I suppose, had them … supplied with a sufficiency of provisions; but their clothing was very scanty, and some unusually sharp weather during the winter carried off great numbers of them. Close confinement and improper food also created a variety of disorders; which, together with … dysentery and some cutaneous diseases … considerably increased the mortality. Upwards of seven hundred died in less than three months, and carpenters were daily employed at the wharf in making shells for the dead bodies. A few years ago, when a similar mortality took place, the dead bodies of the negroes, to save expense, were thrown into the river, and even left to be devoured by the turkey buzzards; in consequence of which nobody would eat any fish. [14]

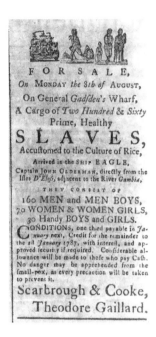

Advertisement for an early sale of enslaved Africans on Gadsden's Wharf, the *Charleston Evening Gazette*, August 6, 1785, 4.

Such cruelty was counted, in Lambert's words, among Charleston's "many instances of white people disgracing themselves by barbarities that would sully the character" of cannibals. [15] The steady manufacturing of coffins that he witnessed at the wharf resulted not from a slight increase in decency, but from the city government's desperate attempts to cleanse the harbor of cadavers. In November of 1805, the city passed a law "to prevent the throwing of dead human bodies into the rivers, creeks, or marshes, within the limits of the harbor of Charleston," upon the penalty of one hundred dollars. But the tide of corpses persisted, and downtown merchants and sailors continued finding dead people floating in their wharves; one reporter complained, in a telling turn of phrase: "This nuisance has

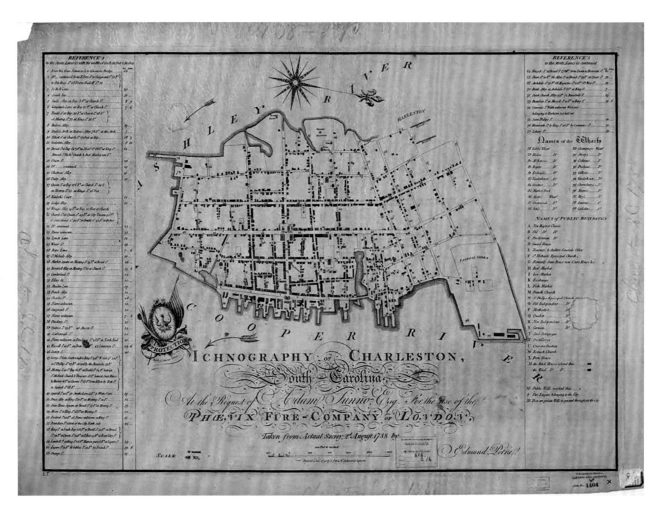

Above: Map of Charleston taken from a survey of 1788, printed in 1790; it reveals the many small wharves near the city center and the enormous mass of Gadsden's Wharf standing alone in the right-hand portion of the map, numbered 99. The brick warehouses shown on the tip of the wharf were periodically damaged and destroyed by fires and hurricanes in the late 1700s and early 1800s, but they were consistently rebuilt until they became the scene of terrible suffering in the last years of the slave trade. Courtesy of the Library of Congress.

Right: Advertisement offering a reward for the return of Barney, a cooper who ran away from the tobacco warehouses on Gadsden's Wharf; the fingers said to be missing from his right hand testify to the hardships of his life of labor, *Charleston Courier*, June 15, 1820, 1.

Ten Dollars Reward.

ABSCONDED from Norton & Lucas' Mill, on Gadsden's wharf, a Negro Man named BARNEY, formerly the property of Mr. George Robertson, deceased. He worked some time at Coopering in the Tobacco Inspection; and is supposed to be about 40 years of age, 5 feet 9 or 10 inches high; two or three of his fingers have been lost from his right hand. He is a good cook, coachman and waiter. Had on black clothes when he went away. If Barney will return of his own accord he will be pardoned. It is supposed he may have gone to Statesburgh, where he is acquainted.—The above reward will be paid on his being lodged in any jail of this state, or brought to the Mill, at Gadsden's wharf. ‡3 June 13

now become so common."[16] In 1807, the city announced that because the law had "been shamefully violated, in a manner shocking to humanity, outrageous to common decency and greatly endangering the health of the citizens," they were offering "a reward of TWO HUNDRED DOLLARS" to anyone who successfully prosecuted a transgressor.[17] Consequently, Gadsden's Wharf developed a coffin-making industry. Once dead Africans were being buried in hastily fashioned shells far from the eyes of most white townspeople, the latter could eat their fish in peace.

The US government abolished the transatlantic trade on January 1, 1808, but it took months for Gadsden's Wharf to conclude the hideous commerce. In March of 1808, David Seldon, a young traveler to Charleston, wrote to his parents in Connecticut: "I cannot but reflect on the awfull [sic] sight to be seen at a place called Gadsden's wharf of about four thousand poor Africans naked, in a maner [sic], and lousy. The most distressing sight ever beheld offered for sale every day at auction to him who will give the most."[18] In the years that followed the final sale or death of these imported captives, the vast area of Gadsden's Wharf was slowly divided up for development and use among different owners, and shifted to heavy industry and to the processing and distribution of commercial goods—often fruits of enslaved labor such as rice, sugar, cotton, and tobacco. The sweat of enslaved people was indispensable to the ongoing operation of the wharf's warehouses, mills, and foundries, and Black workers would sometimes risk torture and death to escape their conditions. After 1808, the trafficking of enslaved people shifted back to the city's center, but the former status of Gadsden's Wharf as the epicenter of the slave trade echoed in the ensuing years as Thomas N. Gadsden (1796–1871), grandson of Christopher Gadsden, leveraged his family's experience, fortune, and prestige to become "the principal slave auctioneer in Charleston."[19] He was lambasted in the Northern abolitionist press as a "high born, wholesale *soul-seller*," but he could have turned for comfort to the assertions by prominent South Carolina writers and politicians such as John C. Calhoun that Africans had no souls to sell—they were not human beings and had no right to be treated as such.[20] For this reason, among others, he insisted that slavery was a "positive good."

Black Charlestonians, however, asserted their humanity in manifold ways, including resistance to their condition. Sometimes at night they carved out space and time for themselves by secretly gathering in shelters built of tree branches

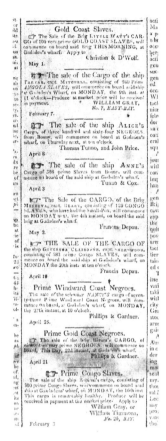

Advertisements for the sale of enslaved Africans proliferated as a veritable flood of human cargo arrived at Gadsden's Wharf, *City Gazette and Daily Advertiser*, May 4, 1807, 2.

and fronds called "bush harbors" or "hush harbors," where they became momentarily free from surveillance and harassment, remembering Africa and claiming agency over their social and spiritual lives.[21] The final traumatic years of the transatlantic trade guaranteed, in a bitter blessing, that Charleston's enslaved population included a high concentration of first-generation Africans. Bernard E. Powers Jr. analyzed how the interactions of these more recent arrivals with "indigenous Afro-Americans allowed many of Charleston's slaves to maintain a profound sense of their original heritage and culture."[22] This legacy fed into Charleston's greatest example of slave resistance, the attempted 1822 insurrection led by Denmark Vesey. He was a free, skilled, literate Black carpenter and one of the leaders of the African Methodist Episcopal (AME) Church, an important institution with two buildings: a principle one in Hampstead, a northern portion of the city, and a secondary structure on Anson Street near Boundary (now Calhoun) Street, about one block from Gadsden's Wharf.[23] As Vesey gathered allies in his church, coconspirators from different African ethnic groups such as the Mandigo and Igbo recruited their fellow countrymen to form fighting companies, leveraging the memories and identities of their lost homelands to gather strength in numbers and in spirit. As Powers explained, "African cultural vestiges were not merely incidental to the conspiracy but in fact provided much of its force . . . [revealing] in microcosm, the process by which many different African people became one."[24]

At this crucial moment, Gadsden's Wharf became a center of Black resistance. At least two of Vesey's allies worked in shipyards there, including the skilled carpenters Polydore Faber and "Gullah" Jack Pritchard. The former worshipped in the African Methodist Episcopal Church building near Gadsden's Wharf; he set to fashioning wooden handles for pikes, while "Gullah" Jack deployed spiritual practices from his birthplace of Angola, including magical concoctions, rituals, and tokens of protection and strength, to inspire African-born collaborators.[25] Weapons were brought in secret to Gadsden's Wharf, which was designated as one of the main rallying points for the launching of the revolt.[26] Before the insurrection could begin, however, the conspirators were betrayed. Vesey was executed with thirty-five of his fellows, including Faber and Pritchard, and the African Methodist Episcopal Church was destroyed.

Fearful white Charlestonians took little comfort from their violent reprisals. Prominent citizen Thomas Pinckney published a pamphlet arguing for the

Iron spikes added to the top the gate protecting the ca. 1765–69 Miles Brewton House after the failed 1822 slave revolt led by Denmark Vesey.

"total substitution" of the city's Black population for a white one. In addition to weakening African American solidarity by dispersing their numbers across the countryside, he argued that removing African bodies from Charleston's streets would improve the lot of white artisans and laborers still struggling to meet "the competition of the blacks."[27] Any such erasure of African Charleston was, however, impossible, because Black people continued to build and maintain the city. Instead, Charleston fortified against itself. A vast arsenal, later named the Citadel, was completed in 1843, fronted by a parade ground for military display that came to be known as the Citadel Green. Houses across the city bristled with broken glass and iron spikes installed atop every wall and fence. Most of these spikes are gone today, but the Miles Brewton House at 27 King Street retains its sharp chevaux-de-frise. They were, ironically, almost certainly made by enslaved ironworkers.

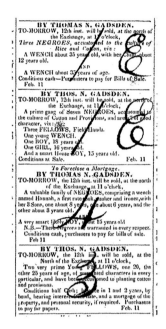

Thomas N. Gadsden perpetuated the family tradition of human trafficking that began on Gadsden's Wharf, *Charleston Courier*, February 11, 1833, 3.

Less Offensive to the Public Eye

Following Vesey's martyrdom, Charleston continued to serve as a major center of the domestic slave trade. Thomas N. Gadsden and his fellow traffickers conducted most of their human auctions on the grounds just north of the Old Exchange Building, in the center of town. Sensitive locals and visitors found the sight repulsive, and, in 1836, the city council proposed an enclosed market for human sales, "in a place more remote from observation, and less offensive to the public eye, than the one now used for that purpose."[28] Newspapers in New York and New England pounced on the blatant hypocrisy of this development: "The people of Charleston . . . seem to be growing somewhat ashamed of the great publicity given to the sale of human flesh, in that city."[29] The famous Charleston-born abolitionist Angelina Grimké declared that the concealment of slave sales revealed "the cowering of the spirit of slavery, under the searching scrutiny occasioned by the Anti-Slavery discussions in the free States."[30] She and her elder sister and fellow abolitionist, Sarah Grimké, had spent most of their youth in a large eighteenth-century, Georgian-style house, now 321 East Bay Street, one of the few residences adjacent to Gadsden's Wharf during its tenure as a center of the transatlantic slave trade.[31] Sarah was old enough to have taken in the awful sights, smells, and sounds of the warehouses about one thousand feet from their front door, and later attested that her hatred of human bondage had begun in "early childhood."[32] With the Grimké sisters in mind, one might say that Gadsden's Wharf imported enslaved people and exported abolitionists.

Mindful that the heartbreaking sights of human trafficking could damage the city's reputation and undermine the institution of slavery, Charleston finally banned public slave sales in 1839. The trade moved to the Sugar House, a high-walled, municipally owned compound near the city jail that had been built to imprison and punish enslaved people with merciless beatings and long hours on a treadmill. One abolitionist paper referred to the Sugar House as "a Moloch temple dedicated to torture, and reeking with blood, in the midst of the city," and it was said that its brick walls contained an interior chamber filled with sand to muffle screams.[33] Any slave seen on the streets of Charleston after curfew was dragged there. After 1839, the Sugar House was the only legal market for the enslaved until local merchants, jealous of its brokerage fees, managed to wrest control of slave sales back from the city.[34] Today, no trace remains of the building; however, after many decades of silence about the horrors of the Sugar House,

on July 13, 2022, the city government of Charleston installed a sign at the site offering historical information.[35]

In 1848, human trafficking returned to the prominent open space just north of the Old Exchange, as well as many other public and private spaces. Visitors remained aghast at the spectacle. English writer and artist Eyre Crowe lambasted a slave auction at the Exchange in the *Illustrated London News*. He reported that the white Charlestonians he encountered were paranoid, with "more or less the character of spies," watching his every step and glaring at the pencil in his hand. Seeing the pain in the eyes of Black people, he excoriated their white oppressors and was compelled to "blush for the unworthy descendants who can thus profane the freedom cherished by their British ancestry."[36] Charleston's leaders found such accounts intolerable, and again passed a law that removed the slave trade from public view. Structures were hastily adapted and built to host indoor sales, including Ryan's Mart on Chalmers Street, today the Old Slave Mart Museum. Following the Civil War and the abolition of slavery, however, Ryan's Mart was, like Gadsden's Wharf and the Sugar House, willfully forgotten, buried in shame and denial. The architecture of slavery had been erased from the official narratives of the city as told by the white elite.[37]

The years following the Civil War witnessed many achievements by African American citizens, who continued to build and maintain the fabric of Charleston. They also constructed new settlements outside the city limits, such as Maryville, Liberty Hill, Lincolnville, the Phillips Community, and Rosemont, working to claim better lives for themselves and their families. These years, however, brought endless attempts by powerful white Charlestonians to fulfill Pinckney's old dream to erase African Charleston. In 1870, a local guidebook written to attract Northern industrial investment instructed visitors to avoid part of downtown because it was "infested by negroes."[38] White violence haunted Charleston in the last quarter of the 1800s and early 1900s, but Black citizens pushed back, claiming the city's streets and public spaces with political demonstrations and exuberant celebrations of emancipation on Memorial Day, Juneteenth, and the Fourth of July.[39] Almost in reply, a sequence of progressively taller stone and bronze statues of John C. Calhoun rose on Marion Square, formerly known as the Citadel Green, casting a shadow upon Black Charlestonians as if to say, in the words of one Black citizen, "You may not be a slave, but I am back to see you stay in your place."[40] Confederate monuments were erected throughout

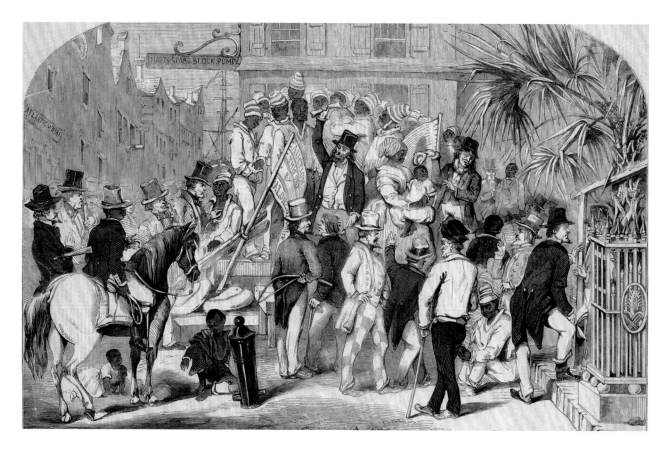

Engraving of an auction of
enslaved people held in the
center of Charleston, based
on a drawing by Eyre Crow,
Illustrated London News,
November 29, 1856.

the city, reinforcing the message as Jim Crow laws stole many of the economic
and political gains earned by African Americans during Reconstruction. Two
different cities were emerging: "The color line separated whites and blacks,"
explained historian William D. Smyth, "assigning to each a different position in
the social order and attaching to each position a different set of rights, privileges,
and arenas of action."[41] Segregation was designed to spatially marginalize Black
bodies, making them as invisible as possible by directing them into separate, in-
ferior, and often screened-off portions of parks, libraries, hospitals, restaurants,
theaters, schools, and other institutions. Negotiation of these racialized spaces
was governed by temporal restrictions, signage, and separate circulation sys-
tems, creating a restricted, secondary urban world made of a byzantine labyrinth
of side yards and back alleys, hidden or partially submerged doors, stairways, and
nosebleed balconies.[42] Black citizens were thus buried alive under the city built
by their ancestors. Refusing to remain confined to the margins, they built their

own thriving cultural and commercial centers such as the Morris Street Business District, but so much of Charleston was closed to them.[43]

As the city developed and expanded in the early-to-mid twentieth century, its white political and economic leaders endeavored to remove Black people from Charleston's future. Half a mile south of Gadsden's Wharf, the city's palatial Federal Customs House became the scene of a crucial battle, as the white Charleston politician and soon-to-be-mayor Robert Goodwyn Rhett (1862–1939) fought vociferously with President Theodore Roosevelt when the latter appointed an esteemed Black community leader, the free-born physician William Demos Crum (1859–1912), as customs director in 1902. Roosevelt refused to budge, and Crum stood strong, becoming an inspiration to African Americans across the city and nation when he proudly declared, "In this present situation I could almost wish I had not been born free, so that my stand against bondage could have stronger effect."[44] Soon thereafter, only a mile north of Gadsden's Wharf, and in a grotesque inversion of that haunted place's role in the slave trade, Rhett and his allies attempted to establish a white-only immigration station with a direct steamship line to Bremen, Germany.[45] A lack of federal support killed the scheme, but local white supremacists would then turn to private real estate development in their efforts to displace the Black people of Charleston and the surrounding region, using imminent domain to seize land from Black families and Black chain-gang labor to drain and level it.[46]

"Real Estate Values Here Are Steadily Enhancing—Demand for Homes Due to Increase in White Population," crooned one headline in 1913. The writer's praise of increased white-oriented redevelopment contained a barely masked celebration of ethnic cleansing: "Many owners of rookeries have caught step and have demolished the shantiesCertain areas which . . . were considered very undesirable have been rendered wholesome and desirable through the erection of homes for desirable tenants . . . [such areas] exert a strong and cleansing influence on . . . places that should be banished . . . [and] purified...by the more desirable elements of the population."[47] On the western edge of the tip of the city's historic peninsula, the city government and private benefactors developed a new, suburban-style waterfront neighborhood along Murray Boulevard—again, using Black chain-gang labor—in which they outlawed the small houses that were typically affordable to African-American citizens and otherwise prevented Black people from living on any of the new property.[48]

"ONE LOOK MEANS A LOT"

Hampton Park Terrace

$400.00 TO $750.00.

$10.00 CASH $10.00 MONTHLY

Surrounded by the beautiful grounds of Hampton Park, affording excellent playgrounds and a beautiful outlook for your home.

With one hundred and fifty home sites reserved for the exclusive use of white families, this beautiful, high, healthy section offers to the people of Charleston an unsurpassed opportunity to build within the city limits a new, modern and attractive suburb upon virgin soil, ten feet higher than the Boulevard, and never overflowed by tides.

Why then continue to rent or live in a crowded section, surrounded by negro hovels, and frequently covered with water, at a greater cost, when such an opportunity offers itself to you to own your own home in a section reserved solely for home purposes, and within fifteen minutes ride to your business.

An unsurpassed site, developed upon modern lines, a healthier section, at less than one-fourth cost to you, this is what we offer.

For full particulars, see

W. C. WILBUR & CO.

EXCLUSIVE AGENTS.

43 BROAD ST. PHONE 3847.

Advertisement for the streetcar suburb of Hampton Park, from the *Charleston Evening Post*, December 30, 1911.

In the 1920s, downtown Charleston birthed the nation's earliest organized urban preservation campaign. Its primary leader, Susan Pringle Frost (1873–1960), publicly rejected the idea that preservation should or would contribute to "the segregation of the races."[49] Some of her colleagues, however, disagreed. In 1933, it was reported that a couple visiting from New York was "shocked by what they called the commercialism of Charleston's charm." They had gone on a pilgrimage to Church Street's Cabbage Row—made famous as Catfish Row, a Black tenement in the George Gershwin opera *Porgy and Bess*—and found that restoration had driven out every Black tenant, ruining its "atmosphere."[50] Enraged, Loutrel Briggs, the landscape architect who had restored Cabbage Row, wrote to the paper: "My Charleston friends appeared to take more pride in the preservation of historic architecture, reflecting in the glory and dignity of the early days rather than in the habitation of fine old buildings by negroes, and they expressed approval of what I had done."[51] Briggs overlooked the fact that the glorious "early days" of Charleston had been populated, and indeed made possible, by large numbers of Black people. With African Americans scrubbed from his vision of Charleston's past, he felt justified in removing them from its present and future.

I Closed My Eyes and Could See

To the horror of white Charlestonians, a Northern white woman named Miriam Wilson bought the old Ryan's Mart building in 1938 and turned it into the Old Slave Mart Museum. One white woman recalled the general feeling of her peers: "There were many non-controversial things of which we should be justly proud . . . the lovely gardens, the beautiful architectureWhy bring up unpleasant subjects like Slavery?"[54] Attempts to erase Black Charlestonians was by now standard

practice, as carefully edited visions of the city's gardens and architecture elided the African contributions of rice and ironwork, sweetgrass and porches. Wilson placated white anxieties by curating her museum to present slavery as "a positive good," in line with Calhoun's assertions. She argued that enslavement helped to civilize savage Africans, and that the 1808 cessation of the transatlantic trade had been a loss to all concerned.[55] She was clearly oblivious to the barbarities committed by white Charlestonians at Gadsden's Wharf. For decades, as Blain Roberts and Ethan J. Kytle explained, her museum "did more to shape Charleston tourists' understanding of slavery than any other site."[56] It also became a favorite destination for South Carolina elementary school trips.

At least one traveler to Charleston defied Wilson's absurd propaganda and independently harnessed the Old Slave Mart Museum's architecture to summon the full humanity and legacy of Black ancestors. African American journalist A. M. Rivera Jr. arrived from Pittsburgh in 1954 to report the conclusion of a landmark South Carolina desegregation lawsuit. As he walked through Ryan's Mart, he considered its exhibits, peering through its windows and contemplating the past and future of the city around him:

> As I stood there . . . looking out over the time-aged cobblestones,
> I wondered just how much of this scene belonged to the past and
> how much a part of the present it still is The guide showed
> us pieces of priceless masonry, handmade sun-dried bricks,
> tapestry and needlework The antique bric-a-brac was interesting,
> but having some knowledge of African lore, it was unimpressive.
> The exhibit that filled me to the overflow, however, was
> an auction notice which was dated, "Thursday, the 25th Sept., at
> 11 o'clock A. M." This document announced the sale of "a prime
> gang of Negroes, accustomed to the culture of Sea Island cotton
> and rice." Ironically, the name of the first slave described on the
> notice was "Aleck," my given name. Aleck was described as a
> 33-year-old carpenter I closed my eyes and almost immediately
> I could see helpless humans being sold, children from
> mothers, wives from husbands. There were little Simon, just
> barely able to walk, and Daphne not walking yet. As I stood there
> I tried to imagine just what a dealer in human beings would look

like, but without successthe more I gazed at the pitiful "mer-
chandize". . . the more they began to resemble people that I have
known. "Where?" I asked myself. "Where have I seen these faces
before?" Then it all dawned on me. They resembled the plaintiffs
in the Clarendon [desegregation] case . . . I had seen them . . . sit-
ting in the Federal Court here just a few blocks away from where
a century ago they were being sold by the pound. "It can't be,"
I kept telling myself, "not after a hundred years." But if there is
such a thing as divine retribution, there is a chance. . . . Of course,
we have no way of proving it, and its just as well, but I couldn't
help wondering how many of the brave parents of Clarendon
County who came to Charleston to fight for full freedom in 1951
were descendants of the sale at Ryan's Mart almost a hundred
years to the day.[57]

With this account, Rivera reversed the historical narrative perpetuated by
white Charlestonians. He summoned Black ancestors to the fore, illuminating
and giving purpose to the ongoing struggles of Black citizens, while pushing back
anonymous white oppressors into the obliterating haze of memory. A visit to a
historic building in Charleston fueled Rivera's vision, as he claimed the power of
the "slave-made bricks" of the Old Slave Mart Museum and the "time-aged cob-
blestones" of its surrounding urban fabric to evoke a picture of the past, bridging
the historical gap between generations. Drawing upon this place, Rivera closed
his eyes, and saw the true Charleston.

In the decades since, many Black and some white scholars, tour guides,
local officials, activists, community leaders, artists, and designers have worked
to reveal Africans ancestors' historic presence and power in Charleston's archi-
tecture. The pace of change has been agonizing: "They might tell you that blacks
used to shine the brass doorknobs," lamented African American tour guide and
author Al Miller in 1994. "Blacks built almost all the buildings in Charleston,
but you don't hear that."[58] Thanks to people like Miller, however, the practice
of burying the histories of African and African American people in Charleston
slowly began to wane. Under Mayor Joseph Riley, the city government purchased
the Old Slave Mart Museum, restored it to its original appearance, and reopened
it in 2007 as a museum confronting the horrors of slavery with scholarly rigor and

honesty. Today the guides direct visitors' eyes to the building's handmade bricks, pointing out the fingerprints of the brickmakers pressed into the clay, many of them so small as to almost certainly be those of children.

Bricks have come to serve as potent symbols of Black ancestors in Charleston. In addition to bearing unique remnants of the people who formed them— people whose personal identities have been otherwise lost—they also, by their hand-sized nature, evoke the gestures of those who made and stacked them, as well as those who transported them and laid them, one by one, into a wall. They manifest and echo the millions of individual acts of labor and skill that drew raw materials from the land to form the architectural fabric that allowed the city to rise, and that keep it alive today.

In 2013, the rhetorical power of antebellum brick was concentrated into a modest but eloquent memorial near one of Charleston's oldest houses of worship. When the 1787 Unitarian Church pierced an interior wall to construct

Fingerprints in the slave-made bricks of the 1859 Old Slave Mart Museum, as identified by Ista Clarke, 2015. Photograph by the author.

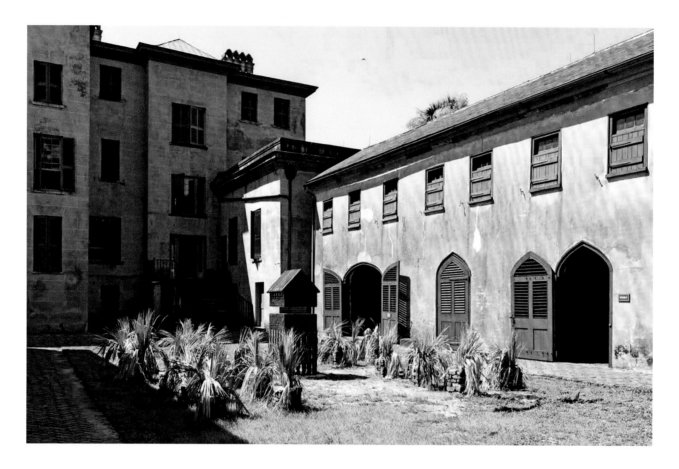

Work Garden, an installation using reclaimed metal and wood, slave-made bricks and palmetto fronds, in the exhibition *Promiseland*, co-curated by Fletcher Williams III and Kelly S. Turner, Aiken-Rhett House Museum, Charleston, June 11–July 15, 2020. Photograph by the author, used with permission of Fletcher Williams III.

a wheelchair access ramp, a white congregant and historian, Paul Garbarini, decided to use the dislodged bricks "to memorialize the anonymous, enslaved people who built the church."[59] He had no experience handling antebellum bricks or building memorials, but he found knowledgeable help just beyond the city's edge, at Fort Sumter and Fort Moultrie National Historical Park. There, Black leaders such as master brickmason Rodney Prioleau and community partnership specialist Michael Allen had, over many years, intensified storytelling about slavery and Black resilience in tours, exhibits, and signage, attesting to the African presence in places like Sullivan's Island.[60] In 2008, they had installed a single elegant bench facing the waters of Charleston harbor, for the contemplation of African ancestors and their experiences. They had been inspired by Toni Morrison's famous 1988 call for a place to do just that:

There is no place you or I can go, to think about or not think
about, to summon the presences of, or recollect the absences of
slaves. . . . There is no suitable memorial, or plaque, or wreath,
or wall, or park, or skyscraper lobby. There's no 300-foot tow-
er, there's no small bench by the road. There is not even a tree
scored, an initial that I can visit or you can visit in Charleston or
Savannah or New York or Providence or better still on the banks
of the Mississippi.[61]

There is still no three-hundred-foot tower, but the bench was a start, and it draws
upon the power of the vast harbor. While the Unitarian Church's monument
also falls far short of three hundred feet, it subtly implicates the church's tower.
Prioleau conserved and assembled the church bricks into a simple and dignified
sculpture resembling a fragment of a wall raised on a granite slab. Atop the mon-
ument are seashells, which have been customarily placed on grave sites by the
African-descended Gullah Geechee people of the Carolina Lowcountry. These
shells evoke the Atlantic Ocean, which connects Charleston to West Africa, and
is the place of eternal rest for countless enslaved Africans who died on their voy-
age to American ports, including Gadsden's Wharf. On the face of the monument
is affixed an iron *Sankofa* fashioned by the studio of famous African American
blacksmith Philip Simmons. This Adinkra symbol, created by the Asante people
of present-day Ghana, represents a bird arching its neck to pluck a seed from its
back, exhorting people to "go back and fetch it," or draw wisdom from the past
to move into the future with greater power. Resting at the edge of the church's
graveyard, the small monument reads like a cenotaph. It casts the nearby church
structure as a great reliquary invested with the spirits of nameless slaves, who
share its beautiful sanctuary with today's congregation.

Garbarini's passion for memorializing the enslaved led him to work as a
guide at McLeod Plantation Historic Site, a Charleston County–owned antebel-
lum plantation that features a row of well-preserved slave dwellings. McLeod's
programming departed sharply from that of the average tourist plantation, which
typically romanticized the lives of the white elite inhabitants and distorted or ig-
nored the experiences of everybody else. Instead, McLeod centers its narratives
upon the lives of the enslaved, who, after all, comprised most of the people who
lived and died on the land.[62] This change was a major victory for local African

American history advocates, as McLeod represented the achievement of real, meaningful reform at a high-profile, official venue. It has stubbornly survived the outraged blowback issued from the mouths and pens of white tourists unprepared to confront African American experiences.[63]

The pace of such reform accelerated when, as one British travel writer observed, the racist murders of June 17, 2015, in Mother Emanuel African Methodist Episcopal Church—a descendant congregation from the church that Denmark Vesey helped lead—"jolted many in Charleston out of complacency."[64] Since that atrocity, the Historic Charleston Foundation has meticulously excavated the neglected portions of their property where enslaved people lived and worked; their large, luxurious 1820 Aiken-Rhett House Museum has renewed its narratives about the workhouses and slave dwellings wrapping its rear courtyard, where Black people lived and labored for generations. They have earned acclaim for telling the truth that "the city of Charleston did not function without the enslaved on the peninsula."[65]

In the summer of 2020, with the steel frame of the International African American Museum rising a short distance away, the Aiken-Rhett House hosted a groundbreaking contemporary art exhibition by the young Black artist Fletcher Williams III. Entitled *Promiseland*, the show's paintings, sculptures, and digital projections filled the interior and exterior spaces of the whole antebellum complex, engaging, as Williams's work often does, with the intersections of race and Charleston's built environment. In the workhouse courtyard, Williams installed the piece *Work Garden*, composed of piles of slave-made bricks, each sprouting palmetto fronds, arranged in rows on either side of *Homestead*, a sculpture in the form of a small cottage raised above the ground and fabricated from materials salvaged from Reconstruction-era, Black-built rural buildings. This central element, a small but defiant tower of rusted metal and wood, asserted Black courage, faith, creativity, and the undeniable will to rise—a David standing up to the Goliath of the big house. The surrounding brick clusters represented the ruins of slavery reclaimed by that will, as a stolen heritage is carefully gathered and cultivated to flourish. Charleston's progressive house museums owe a great deal to another local Black leader, the historian and advocate Joseph McGill. In 2010, he founded the Charleston-based Slave Dwelling Project, dedicated to "Giving voice to our ancestors and changing the narrative, one slave dwelling at a time."[66] McGill identifies slave dwellings across the nation—whether commonly known

Monument to the enslaved workers who built Charleston's 1787 Unitarian Church, Paul Garbarini and the workshop of Philip Simmons, 2013. Photograph by the author.

or totally forgotten, dilapidated or well preserved—and honors their history by spending the night in them, often with guests and friends, some of them white. He hopes to slow the alarmingly rapid disappearance of slave dwellings. Destruction has sometimes resulted from ignorance or neglect, and sometimes it has been violently deliberate, inspired by the same impulses of hate and shame that have driven attempts to bury Black people themselves. McGill also organizes larger events, including the 2019 Prints in Clay: Still, We Rise!, a Black heritage festival combining musical performances, a tour of the Aiken-Rhett House, a culinary event entitled Food of the African Diaspora, and a photography exhibition featuring the fingerprints of enslaved workers found in Charleston bricks.[67] Young Black photographer Dontré Major contributed artworks to the latter, including a digitally manipulated photograph that superimposed a translucent fingerprint over the facade of Charleston's enormous Second Presbyterian Church. Their mixed-race congregation had invited Major to ascend the bell tower to photograph fingerprints among its hundreds of thousands of bricks. Enslaved labor and skill built the tower between 1809 and 1811; it rose not far from Gadsden's Wharf, soon after the final legal docking of the transatlantic slave ships. Major's

Photograph of a fingerprint digitally superimposed over the 1809–11 Second Presbyterian Church of Charleston, Dontré Major, 2018; from the exhibition *Prints in Clay: Still, We Rise!*, curated by Joseph McGill at the Gaillard Center, Charleston.

superimposition of a fingerprint over the whole church asserts an unacknowledged ownership of a towering building that Africans made without pay. He took the concealed Black presence within, and overlaid it upon the high, whitewashed exterior, demanding from the church, and ultimately from the city it serves, a confession of its true lineage. All the towers that constitute the skyline of the "Holy City" of Charleston are implicated by those fingerprints, and by Major's eloquent photograph.

Prints in Clay: Still, We Rise! took place at Charleston Gaillard Center, a performing arts and city government office complex. That structure, completed in 2015, replaced a universally detested urban renewal complex that had displaced many Black families in the 1960s. The architecture of the new facility features decorative motifs by David M. Schwarz Architects that evoke sweetgrass baskets and Charleston ironwork, celebrating the city's status as an American mixture of Africa and Europe. In 2016, another event at the Gaillard also poetically asserted the inner African nature of Charleston's built fabric: Spoleto Festival USA's production of *Porgy and Bess*, with celebrated Gullah artist Jonathan Green leading visual design. Since its original Broadway opening in 1935, *Porgy and Bess* accumulated a long history of representing Black people as the impoverished denizens of slummy, rundown Charleston tenements. Green agreed to apply his vibrant, colorful aesthetic sensibility to the sets and costumes of the new *Porgy and Bess* only if he could defy the Black ghetto cliché and reinterpret Charleston's architecture. "I saw in the stereotypes," Green explained, "a complete disrespect for the continent of Africa . . . What if West Africans came as immigrants? What would we be looking at? What would we see? And what are we missing because we haven't supported that?"[68] To convey a "greater truth" about Charleston's debt to African peoples, who were not only physical laborers but also creative cultural agents with deep histories and irrepressible spirits, Green drew upon colorful diamond patterns in the art and architecture of Black communities in South

Carolina and West Africa, and placed them all over Charleston building types, such as the "single house" with its famous Afro-Caribbean porch. The vibrant sets turned inside-out the urban fabric of Charleston, displacing European-style architectural ornament to reveal the secret African heritage previously veiled in iron and brick. His vision of a wealthy, confident, exuberantly African Charleston was, according to the *New York Times*, beautiful and evocative.[69]

While the opera dazzled audiences in the Gaillard, Green designed other diamond decals to temporarily adorn a scattered series of real Charleston buildings with special significance to Black history. These "Porgy Houses" ranged from immaculate townhouses to derelict cottages. When some of those cottages were restored, in tandem with the adjacent construction of a large apartment building, the architects admirably made permanent Green's African diamond decorations. The buildings themselves, however, now contain office space and a

Photographer Dontré Major photographs the bricks of the monumental Second Presbyterian Church tower in 2018; photograph by the author.

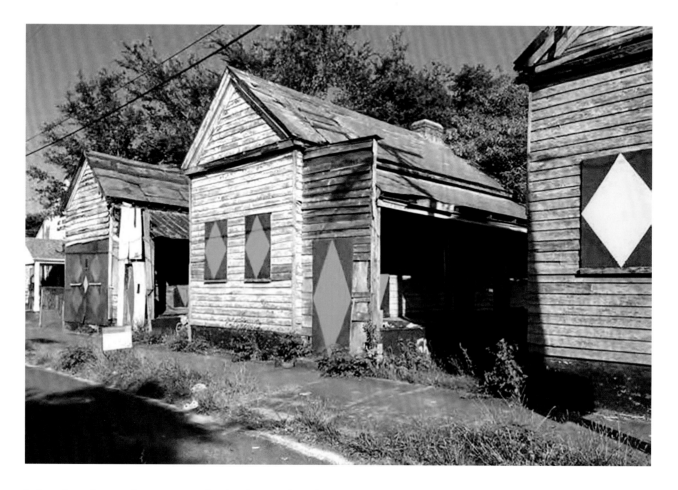

Jackson Street Cottages, in a derelict state in 2016 as "Porgy Houses" with African diamond decals by Jonathan Green (above), and after their 2019 renovations into office space and a wine bar (opposite page). Photographs by the author.

posh wine bar, and are little used by the mostly poor African Americans who live nearby. The legacy of slavery means even well-intentioned design interventions can contribute to the gentrification crisis that has been accelerating in Charleston since the 1930s, threatening to evict Black Charlestonians, as Thomas Pinckney had dreamed. Green's vision of a proudly African Charleston architecture seems a little closer to realization, but his dream of a prosperous and secure Black Charlestonian community is still beyond the horizon, and at times seems to be slipping further away.

The Gaillard Center sits on the former westernmost edge of Gadsden's Wharf. During the center's construction in 2013, a previously unknown African burial ground was discovered. The bodies had been carefully, respectfully buried, with one youth having coins placed over his eyes; these dated to the mid- to late 1700s, suggesting that the site was used in the first quarter of the

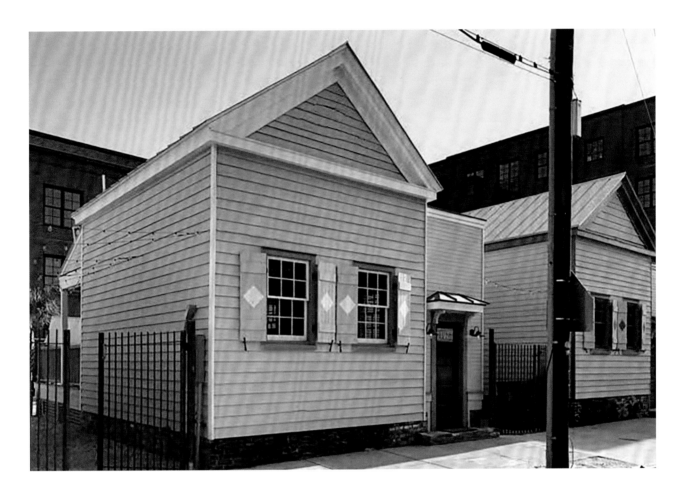

1800s at the latest. Isotope analysis revealed that many of the people interred had African birthplaces, and therefore had known the horrors of the Middle Passage, and perhaps had suffered in the wretched warehouses of Gadsden's Wharf. It is likely, but not yet confirmed, that the burial ground was connected in some way to the immediately adjacent Anson Street building of the African Methodist Episcopal Church that was destroyed after Vesey's foiled revolt. The people laid to rest there may have worked on the nearby wharf, may have known the conspirators, may have worshipped with them, and may have prayed for liberty with them. In any case, their interment on the margins of town and the subsequent neglect of their gravesites surprised nobody, given Charleston's history. Now, however, they were resting in the very heart of a vastly enlarged city, and their modern descendants would demand respectful commemoration.

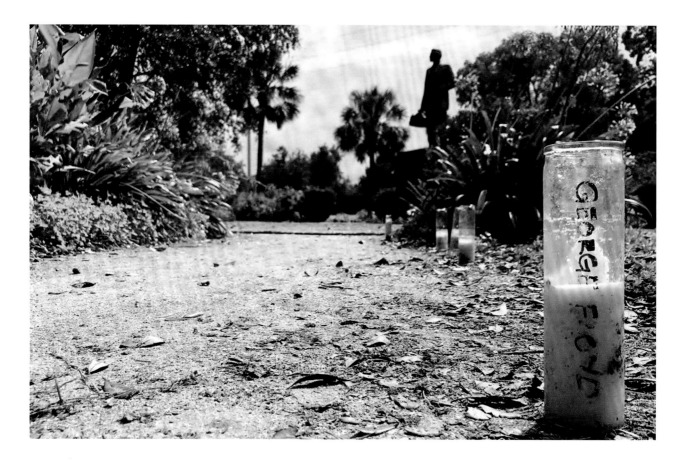

The candle of vigil for George Floyd, among dozens of other candles featuring the names of black victims of police brutality, arranged around the enclosure of Denmark Vesey's statue in Hampton Park, Charleston, on July 4, 2020. Photograph taken on July 6, 2020, by the author.

When the site was discovered, a local African American cultural advocacy group called the Gullah Society sprang into action, leading an extensive research and public engagement process. Their events were named "Rise!" in an exhortation both to ancestral spirits and to living Black Charlestonians.[70] In April of 2019, a ceremony led by Gullah Society director Ade Ajani Ofunniyin gave African names such as Risu, Kwabena, and Kuto to each of the deceased ancestors. These names humanized them, helping Charlestonians to imagine their faces and seek their reflections in the eyes, hands, and voices that fill Charleston's streets today. A few days later, the reinterment of the Anson Street African Burial Ground remains was attended by a lively public parade. Hundreds of Charlestonians donned African attire, drumming and singing, to lay these ancestors to final rest. The front page of the *Post and Courier* reported on the event:

Led by the hearse, dozens of followers crossed George and King
streets in downtown Charleston. Many wore flowing robes,
shirts and pants of golds and purples. Whites and yellows.
Browns, oranges, and greens. Onlookers gathered as the swell
of people, some children and others up in years, passed by. For
a city still grappling with its dark and unequal racial history, the
celebration of the remains presented a moment. The walkers'
clothing, the metronomic drumming that guided them and the
chanting that lifted them was purposefully rooted in Africa, in
honor of the enslaved ancestors forced to toil its land. . . . Dr.
Ade Ajani Ofunniyin, founder and director of the Gullah Society
. . . [placed] cards on top of the indigo blankets that covered the
boxes [of remains], with messages written for the dead. "To my
beloved ancestors, thank you for life and making your journey to
Charleston, SC," offered one person. "You are honored and may
God bless your souls." It was signed, "with love." The drumming
paused as the Rev. Willie Hill, from nearby St. John's Reformed
Episcopal Church, gave a brief sermon. The bones of the people
in the boxes in front of them were free, he said. Nothing could set
them in bondage again.[71]

The parade, with historical precedent dating to the jubilant events of Recon-
struction-era Charleston, demonstrated that, of all the social assemblies and
political partisans that have claimed the city's fabric since its founding, African
American solidarity has endured the longest. Black Charlestonians have been
imprisoned and cast out, undermined and inundated in a thousand ways, but
they refuse to go silent.

Towers Fall and Gardens Rise
By the close of 2019, Black history was finally being articulated and celebrat-
ed at official venues and by official voices, but when one compared the new
but diminutive markers of Black commemoration to the old but still-towering
statues of white supremacy, the former could feel like footnotes in Charleston's
architectural history. The benches had always been, and will continue to be, of
great value—but where was Morrison's three-hundred-foot-tall tower? Refram-

ing the monumental fabric of the old city was and remains a potent strategy, but to a certain extent, one still had to close one's eyes, as Rivera did, to see the true Charleston.

This was not for a lack of trying. The Denmark Vesey and the Spirit of Freedom Monument Committee, working closely with the City of Charleston, erected a substantial and beautiful bronze statue of Denmark Vesey in 2014. Designed by the accomplished Black sculptor Ed Dwight, it represents Vesey as a well-dressed, free, literate man, holding his architectural tools and a Bible, and contemplating the fight for his people's liberty, as Moses had done for the Hebrews. Supporters of the monument wanted it in Marion Square, the original parade ground of the white-supremacist Citadel—built to suppress potential slave revolts—and today a central, prominent space where thousands of citizens and visitors could witness Vesey confront the old arsenal and the enormous Calhoun statue. Instead, white resistance exiled Vesey to an enclosed garden inside Hampton Park, far from the touristy city center.[72] The statue and its setting feature high-quality materials and elegant design, but from the perspectives of many Charlestonians, the memories of Denmark Vesey and his brave allies remained obscured, more or less.

Marion Square and Hampton Park became key gathering spaces during the 2020 nationwide Black Lives Matter protests that erupted after the police murder of George Floyd in Minneapolis. A large rally was held in Hampton Park on the Fourth of July, which, as noted previously, Black Charlestonians have long celebrated with the claiming of public space.[73] The intimate, enclosed nature of the Denmark Vesey monument transformed it into a perfect nighttime hush harbor, as people lit candles bearing the names of dozens of Black victims of police violence and arranged them like spirits rallying to Vesey's side for the coming fight. Some candles burned for days. Perhaps the spirits were stirred by the Charleston City Council's unanimous vote, just over a week before, to bring down Marion Square's towering Calhoun statue. The next day, when an exhausted crew finally sawed through the solid bronze and thick epoxy that had held the racist leader more than a hundred feet in the air for over a century, Charleston mayor John Tecklenburg quipped, "Like racism, he was deeply rooted in there."[74]

Not three weeks passed between the fall of Calhoun and the topping out celebration at the construction site of the International African American Museum, when the main structure's last steel beam rose into the air and was fitted in place.

Despite the raging COVID-19 pandemic, many officials and citizens gathered, with masks and safe social distancing, to celebrate the fruition of decades of work and nearly $100 million of public funds and private donations. After the building's structural completion, the African Ancestors Memorial Garden was built and planted, bringing to life a place once choked with death. This museum and its garden embody relentless courage, in the spirit of Denmark Vesey, Polydore Faber, and "Gullah" Jack Pritchard, by confronting the full horror of the slave trade and striving to enlighten the minds and lift the spirits of every soul that visits. These great works of architecture finally provide Charleston with the towering affirmation of African genius and resilience that it needs.

The garden spaces are personal and intimate, as Charleston's billions of bricks are each personal and intimate—but they are also overwhelming, as the heartbreaking history of Gadsden's Wharf is overwhelming. Nothing will stay buried under the earth, nor submerged in the sea, not hidden behind high walls or in the darkness of eviction and exclusion—all will be brought into the light. Then we will see. And we will recognize the faces, because we have seen them before.

References

1. Tariro Mzezewa, "Enslaved People Lived Here. These Museums Want 1 You to Know," *New York Times*, June 26, 2019, www.nytimes.com/2019/06/26/travel/house-tours-charleston-savannah.html.

2. Thad Moore, "Condo built on Charleston's last slave trading wharf markets history—without mentioning slavery," *Post and Courier*, Tuesday, May 8, 2018, www.postandcourier.com/business/condo-built-oncharleston-s-last-slave-trading-wharf-markets/article_06147d60-52df-11e8-a787-2faf72144698.html.

3. For an account of the last years of the legal transatlantic slave trade, see James A. McMillin, *The Final Victims: Foreign Slave Trade to North America, 1783–1810* (Columbia: University of South Carolina Press, 2004).

4. For a classic study of Black building skills, see John Michael Vlach, *By the Work of Their Hands* (Charlottesville: University of Virginia Press, 1991).

5. Articles XXII and XXIII, as recorded in *The South-Carolina Gazette*, Saturday, August 25, 1764, 3; see also Harlan Greene, Harry S. Hutchins Jr., and Brian E. Hutchins, *Slave Badges and the Slave-Hire System in Charleston, South Carolina, 1783–1865* (Jefferson, NC: McFarland & Companu, Inc., 2004), 20–21, and John Garrison Marks, *Black Freedom in the Age of Slavery: Race, Status, and Identity in the Urban Americas* (University of South Carolina Press, 2020), 91–97.

6. Basil Hall, *Travels in North America, in the Years 1827 and 1828*, vol. 3 (Edinburgh: Cadell and Co., 1829), 139–40; see also Jay D. Edwards, "Open Issues in the Study of the Historic Influences of Caribbean Architecture on that of North America," *Material Culture* 37, no. 1 (Spring 2005), 44–84, and Nathaniel Robert Walker, "'In a Light Oriental Style': Cosmopolitan Classicism in Charleston," *Classicist: Journal of the Institute of Classical Architecture and Art*, 13, no. 1 (2016), 36–45.

7. "For Sale, On Monday the 8th of August, On General Gadsden's Wharf, A Cargo of Two Hundred & Sixty Prime, Healthy Slaves . . . ," *Charleston Evening Gazette*, August 6, 1785, 4.

8. Pelatiah Webster, *Journal of a Voyage to Charlestown in So. Carolina by Pelatiah Webster in 1765* (Charleston: The South Carolina Historical Society, 1898), 13–14.

9. Nic Butler, "Quarantine in Charleston Harbor, 1698–1949," Charleston County Public Library blog, April 10, 2020, www.ccpl.org/charleston-time-machine/quarantine-charleston-harbor-1698-1949; see also Robert Behre, "Historian sheds new light on how many slaves might have been quarantined on Sullivan's Island, but no one knows for sure," *Post and Courier*, August 25, 2017, updated September 14, 2020: www.postandcourier.com/news/historian-sheds-new-light-on-how-many-slaves-might-have-beenquarantined-on-sullivans-island/article_4ccf5b44-89a9-11e7-98a6-77354b396238.html.

10. Thomas Roper, "An Ordinance to raise and pay into the City Treasury, an additional Tax on each of the Lots on Sullivan's Island, to defray the cost of erecting a Pest House, on the north east point of James Island, called Point Comfort," in *Ordinances of the City Council of Charleston, in the State of South Carolina* (Charleston: W.P. Young, 1802), 191–93.

11. "Harbour Master," in *Digest of the Ordinances of the City Council of Charleston, from the Year 1783 to July 1818* (Charleston: A.E. Miller, 1818), 120.

12. Ibid., 122.

13. Nic Butler, "The Story of Gadsden's Wharf," Charleston Count 13 y Public Library blog, February 2, 2018, www.ccpl.org/charleston-time-machine/story-gadsens-wharf; please note that Butler mistakenly argues that slave sales never took place on Gadsden's Wharf in the 1700s. They do seem rarer there than they were at other wharves, but as demonstrated above, at least one large sale took place.

14. John Lambert, *Travels through Canada, and the United States of North America, in the Years 1806, 1807, and 1808,* vol. 2, 2nd ed. (London: C. Cradock and W. Joy, 1814), 166–67; see also Robert R. Macdonald, "The Power of Place: Gadsden's Wharf and American History," independently published in Charleston, 2014, www.academia.edu/36605059/THE_POWER_OF_PLACE_GADSDENS_WHARF_AND_AMERICAN_HISTORY; Peter McCandless, *Slavery, Disease, and Suffering in the Southern Lowcountry* (Cambridge University Press, 2011), 49–50; McMillin, *The Final Victims*, 111–15.

15. Lambert, *Travels through Canada, and the United States of North America*, 172.

16. "A Jury of Inquest was held Monday last, on the body of a Negro Man, found floating . . . ," and "A Jury of Inquest was held yesterday, on the body of an African Negro, found floating . . . ," *Charleston Courier*, Wednesday, April 8, 1807, 3; "A Jury of Inquest was held yesterday, on the body of an African Negro woman, found floating . . . ," *Charleston Courier*, Wednesday, April 22, 1807, 3.

17. "Proclamation," *City Gazette and Daily Advertiser*, April 27, 1807, 3.

18. Letter to Reverend David Selden from his son David Selden, March 5, 1808, in the collection of the Smithsonian National Museum of African American History and Culture, item number 2014.174.2, collections.si.edu/search/detail/edanmdm:nmaahc_2014.174.2? The museum lists the year of the letter as 1800, but this is a misreading of the hastily written date, which upon close observation, and consideration of the history, emerges as 1808.

19. Theodore Dwight Weld, ed., *American Slavery as It Is: Testimony of a Thousand Witnesses* (New York: The American Anti-Slavery Society, 1839), 174.

20. For the reference to Gadsden as a "wholesale soul-seller," see Weld, *American Slavery as It Is*, 174; for the account of the conversation in which Calhoun denied the humanity of Black people, see Alexander Crummell, "The Attitude of the American Mind toward the Negro Intellect," a speech originally delivered in 1898, republished in J. R. Oldfield, ed., *Civilization and Black Progress: Selected Writings of Alexander Crummell on the South* (Charlottesville: University Press of Virginia for the Southern Texts Society, 1995), 206–07.

21. Janet Duitsman Cornelius, *Slave Missions and the Black Church in the Antebellum South* (Columbia: University of South Carolina Press, 1999), 8–12; Mario Gooden, *Dark Space: Architecture, Representation, Black Identity* (New York: Columbia University Press, 2016), 22–23; Paul Harvey, Through the Storm, *Through the Night: A History of African American Christianity* (Plymouth, UK: Rowman & Littlefield Publishers, Inc., 2011).

22. Bernard E. Powers Jr., *Black Charlestonians: A Social History, 1822-1885* (Fayetteville: University of Arkansas Press, 1994), 31.

23. The Anson Street church building has been almost entirely forgotten; for reference to it, see Edward A. Pearson, ed., *Designs Against Charleston: The Trial Record of the Denmark Vesey Slave Conspiracy of 1822* (Chapel Hill: University of North Carolina Press, 1999), 167, 288, 328.

24. Powers Jr., *Black Charlestonians*, 31.

25. Pearson, ed., *Designs Against Charleston*, 44–45, 113–14.

26. Pearson, ed. *Designs Against Charleston*, 106, 134, 216.

27. Archates [Thomas Pinckey], *Reflections, Occasioned by the late Disturbances in Charleston* (Charleston: A. E. Miller, 1822), 15, 27; see also Douglas R. Egerton, *He Shall Go Out Free: The Lives of Denmark Vesey*, rev. ed., (Lanham, Maryland: Rowman and Littlefield Publishers, Inc., 2004).

28. "Mart for Negroes," *Charleston Courier*, Thursday, May 12, 1836; this year of the *Charleston Courier* is not available in most archives, but the article was incomprehensibly reprinted as a nostalgia item in "Backward Glances: News Our Great-Grandfathers Read," *Charleston News and Courier*, Tuesday, May 12, 1936, 4.

29. See, for example, "N.Y. Transcipt, Negro Market," *Vermont Chronicle*, Thursday, June 23, 1836, 2/3.

30. A. E. Grimké, *Letters to Catherine E. Beecher* (Boston: Isaac Knapp, 1838), 74.

31. Louis W. Knight, "The Grimké Family Home, 1803-1819," *Carologue* 30, no. 4 (Spring 2015), 21–25.

32. Gerda Lerner, *The Grimké Sisters from South Carolina: Pioneers for Women's Rights and Abolition* (Chapel Hill: University of North Carolina Press, 2004), 37.

33. Weld, *American Slavery as It Is*, 171.

34. Edmund Drago and Ralph Melnick, "The Old Slave Mart Museum, Charleston, South Carolina: Rediscovering the Past," *Civil War History* 27, no. 2 (June 1981), 141.

35. Abigail Darlington, "Amid debate about Confederate monuments, Charleston sites aim to recognize African American history," *Post and Courier*, Friday, May 27, 2016, www.postandcourier.com/features/arts_and_travel/amid-debate-about-confederate-monuments-charleston-sites-aim-to-recognize/article_2687a4ae-f38d-5182-a088-4b1b04d8aa31.html.

36. Eyre Crowe, "Sale of Slaves at Charleston, South Carolina," *Illustrated London News*, vol. 29 (Nov. 29, 1856),555.

37. For studies of the willful forgetting of the architecture of slavery in Charleston and beyond, see Blain Roberts and Ethan J. Kytle, "Looking the Thing in the Face: Slavery, Race, and the Commemorative Landscape in Charleston, South Carolina, 1865–2010," *Journal of Southern History* 78, no. 3 (August 2012), 639–84; Stephanie Yuhl, "Hidden in Plain Sight: Centering the Domestic Slave Trade in American Public History," *Journal of Southern History* 79, no. 3 (Aug., 2013); Ethan J. Kytle and Blain Roberts, *Denmark Vesey's Garden: Slavery and Memory in the Cradle of the Confederacy* (New York: The Free Press, 2018).

38. *Premium List of the South Carolina Institute, Incorporated in 1850, for the Promotion and Encouragement of the Arts, Agriculture, Ingenuity, Mechanics, Manufactures, and a General Development of Industry* (Charleston: Walker, Evans, and Cogswell, 1870), 36.

39. Kytle and Roberts, *Denmark Vesey's Garden*, 73-78.

40. Thomas J. Brown, *Civil War Canon: Sites of Confederate Memory in South Carolina* (Chapel Hill: The University of North Carolina Press, 2015), 84.

41. William D. Smyth, "Segregation in Charleston in the 1950s: A Decade of Transition," *The South Carolina Magazine* 92, no. 2 (April 1991), 100.

42. Elizabeth Guffey, "Knowing Their Space: Signs of Jim Crow in the Segregated South," *Design Issues* 28, no. 2 (Spring 2012), 46–49.

43. See the forthcoming online exhibition on the Morris Street Business District, a 43 joint endeavor of the Preservation Society of Charleston and the Lowcountry Digital History Initiative of the College of Charleston.

44. Willard B. Gatewood, "William D. Crum: A Negro in Politics," *Journal of Negro History* 53, no. 4 (Oct. 1968), 302.

45. "Mayor Rhett's Annual Report," *Year Book 1906: City of Charleston, So. Ca.* (Charleston: The Daggett Printing Company, 1907), xiii; E.J. Watson, "Immigration from Europe," appendix to *Year Book 1906: City of Charleston, So. Ca.* (Charleston: The Daggett Printing Company, 1907), 1.

46. Kenneth G. Marolda and Nathaniel Robert Walker, "'Not Sold to Persons of African Descent': Racism and Real Estate in Twentieth-century Charleston," in Nathaniel Robert Walker and Rachel Ama Asaa Engmann, eds, *Architectures of Slavery: Ruins and Reconstructions* (forthcoming, Charlottesville: University of Virginia Press, 2025).

47. "Real Estate Values Here Are Steadily Enhancing," *News and Courier*, Friday, May 23, 1913, 15–16.

48. "Committee on West End Improvements," June 17, 1911, 1, in *Joint Committee Ways and Means and West End Improvements 1910 to 1911*, Charleston City Archives; "Mayor Rhett's Annual Report," Year Book 1909: City of Charleston, So. Ca. (Charleston: Walker, Evan and Cogswell Company, 1910), xiv.

49. "The Zoning Ordinance," *News and Courier*, Friday, March 8, 1935, 5.

50. "Writers 'Shocked' at Commercialism," *News and Courier*, Monday, December 25, 1933, 2.

51. "Cabbage Row," *News and Courier*, Wednesday, December 27, 1933, 4.

52. See, for example, the "Chicora Place" advertisement in *The Charleston Evening Post*, January 5, 1904, 6, and "Hampton Park Terrace" advertisement, *Charleston Evening Post*, Saturday, December 30, 1911, 13.

53. "Big and Daring Plan for the Building of a City," *News and Courier*, Friday, May 23, 1913, 35.

54. Judith Wragg Chase, "Miriam Bellangee Wilson - Founder, Old Slave Mart Museum," *Preservation Progres* viii, no. 3 (May 1963), 8.

55. Kytle and Roberts, *Denmark Vesey's Garden*, 254.

56. Ibid., 246.

57. A. M. Rivera Jr., "Rivera Wonders How Much a Part of the Past Lives," *Pittsburgh Courier*, Saturday, November 13, 1954, 11.

58. Mark Wrolstad, "Charleston Rediscovers Its Past," *Picayune Times*, March 13, 1994, A2.

59. Michelle Bates Deakin, "Slave Memorial honors builders of Charleston church," *UU World: Liberal Religion and Life*, www.uuworld.org/articles/slave-memorial-charleston.

60. Felicia R. Lee, "Bench of Memory at Slavery's Gateway," *New York Times*, July 28, 2008, E2, E6; Jessica Johnson, "Slave trade story made real in Sullivan's exhibit," *Post and Courier*, March 12, 2009, D8.

61. Toni Morrison, "Melcher Book Award acceptance speech," published online on August 11, 2008, via *UU World*, www.uuworld.org/articles/a-bench-by-road; see also the official website of the Toni Morrison Society, which launched the "Bench By the Road Project" to follow through with Morrison's request for commemorative places, www.tonimorrisonsociety.org/bench.html.

62. Eve M. Kahn, "Plantation Museum Tells the Story of the South," *New York Times*, April 24, 2015, C28.

63. Robert Behre, "Despite pushback, Charleston historic sites expand their interpretation of slavery," *Post and Courier*, September 1, 2019, www.postandcourier.com/news/despite-pushback-charleston-historic-sitesexpand-their-interpretation-of-slavery/article_d8786e3c-c5e4-11e9-a77a-13ef0ca177de.html; Heath Ellison, "Charleston plantation guides say a negative reaction to stirring history can be a good thing," *Charleston City Paper*, August 21, 2019, www.charlestoncitypaper.com/2019/08/21/charleston-plantation-guides-say-a-negative-reaction-to-stirring-history-can-be-a-good-thing.

64. Juliet Rix, "How the elegant city of Charleston is facing up to its troubling past," *The Telegraph*, May 12, 2019, www.telegraph.co.uk/travel/destinations/north-america/united-states/articles/charleston-slavery-historytravel.

65. "Charleston 'did not function' without slaves on the peninsula. Here's a look at their homes," *Post and Courier*, August 23, 2018, www.postandcourier.com/columnists/charleston-did-not-function-withoutslaves-on-the-peninsula-heres-a-look-at-their-homes/article_d3e01c6a-9c07-11e8-934e-3b3b6ae36c70.html; Mzezewa, "Enslaved People Lived Here," *New York Times*.

66. Official website of the Slave Dwelling Project, slavedwellingproject.org; see also Tony Horwitz, "One Man's Epic Quest to Visit Every Former Slave Dwelling in the United States," *Smithsonian Magazine* (October, 2013), www.smithsonianmag.com/history/one-mans-epic-quest-to-visit-every-former-slave-dwelling-inthe-united-states-12080.

67. Andy Brack, "FOCUS: Prints in Clay at Gaillard to celebrate spirituals, culture," *Charleston Currents*, August 27, 2018, charlestoncurrents.com/2018/08/focus-prints-in-clay-at-gaillard-to-celebrate-spirituals-culture; please note that the event was originally schedule to take place in September 2018, but it was moved to January 2019 due to Hurricane Florence.

68. Jeffrey Brown, "New rendition of classic opera 'Porgy and Bess' offers a 'greater truth,'" *PBS News Hour* news feature and transcript, posted online on June 9, 2016, www.pbs.org/newshour/show/new-rendition-ofclassic-opera-porgy-and-bess-offers-a-greater-truth.

69. James R. Oestreich, "'Porgy and Bess,' a Spoleto Festival USA Homecoming," *New York Times*, May 29, 2016, www.nytimes.com/2016/05/30/arts/music/porgy-and-bess-a-spoleto-festival-usa-homecoming.html.

70. "Anson Street African Burials Project," Gullah Society, www.thegullahsociety.com/anson-streetburials.html.

71. Stephen Hobbs, "Tears and celebration mark Charleston reburial of skeletal remains of 36 people," May 5, 2019, A1.

72. Ted Mellnik, "The remarkable history of Charleston's racial divide, as told by the city's silent statues," *The Washington Post*, June 24, 2015, www.washingtonpost.com/news/wonk/wp/2015/06/24/the-remarkablehistory-of-charlestons-racial-divide-as-told-by-the-citys-silent-statues.

73. Tony Fortier-Bensen, "Black Lives Matter supporters plan rally at Denmark Vesey statue at Hampton Park on July 4," official website of ABS News Channel 4, July 3, 2020, abcnews4.com/news/local/black-lives-mattersupporters-plan-to-rally-at-hampton-park-on-july-4.

74. Stephen Hobbs, Gregory Yee, Jerrel Floyd, Mikaela Porter, Fleming S 74 mith and Rickey Ciapha Dennis, "John C. Calhoun statue taken down from its perch above Charleston's Marion Square," *Post and Courier*, June 23, 2020, updated July 13, 2020, www.postandcourier.com/news/john-c-calhoun-statue-taken-down-fromits-perch-above-charlestons-marion-square/article_7c428b5c-b58a-11ea-8fcc-6b5a374635da.html.

A Walk Through the Garden and Beyond

by Robert R. Macdonald

It is a warm spring morning in Charleston, South Caro-
lina. The sun and a gossamer haze rise over the harbor.
Soft breezes carry the scent of star jasmine, and the
only sound I hear is the waves lapping at the seawall.
This is an idyllic location once called Gadsden's Wharf.
When it was built in the mid-eighteenth century by
the American patriot Christopher Gadsden, it was
the largest wharf and the last major entrepôt for en-
slaved Africans in North America. Here, thousands of
chained men, women, and children were off-loaded
from slave ships and sold. In the nine years between
1801 and 1810, more than four hundred slave ships
docked here, unloading a cargo of an estimated 72,000
enslaved human beings.[1]

Life for the enslaved on Gadsden's Wharf was cruel.
Under constant guard, human cargo was herded like
cattle, awaiting an uncertain fate in a new and strange
land. Shelter, clothing, and food were minimal. Sick-
ness and death were constant. David Ramsay, a prom-
inent Charleston physician, reported, "The first seven
months [of 1807] produced nothing very uncommon,
except the dysenteries and dropsies [also known as
edema, a swelling due to accumulation of water in the
body's soft tissues] carried off great numbers of the
newly imported Africans … there was scarcely a car-
go of Negros brought into the port, of which there was
not a portion laboring under dropsical swellings, most
generally of the anasarcous [general] kind."[2]

During a harsh cold snap in January 1806, over seven hundred enslaved humans kept in the wharf's rice warehouse died from malnutrition and exposure as slave traders held out for higher prices. Their bodies were tossed into the harbor or deposited in nearby marshes, there devoured by turkey buzzards and other vultures.[3]

In March 1808, three months after Congress outlawed the international slave trade,[4] a young visitor to Charleston (mentioned in Nathaniel Walker's preceding essay) wrote his parents in Connecticut describing the cry of human misery and the stench of death of four thousand half-naked, lice-covered Africans huddled on the wharf and in the arriving slave ships.[5] They had survived the perilous Middle Passage across the Atlantic from Africa only to be auctioned to the highest bidder. Their owners scattered them throughout the newly independent United States, from South Carolina's Lowcountry to the recently acquired Louisiana Territory, to work in slave labor camps, euphemistically called plantations.

When its use as a slave depot ended, Gadsden's Wharf became a center for the exportation of "Carolina Gold," the rice varietal requiring the specialized knowledge and backbreaking labor of the enslaved, which made South Carolina planters wealthy. Later, a rice mill was built on the site, and a ferry landing connected Charleston to outlying communities and beyond. In the following decades, industries on the site or adjacent to it produced coal tar and pine pitch and manufactured gas, paint, and chemicals, polluting the area.[6] By the 1990s, what had been Gadsden's Wharf had been declared a Superfund site requiring extensive mitigation.[7] Following the removal of contaminants, multistory apartment and condo buildings were constructed, and the South Carolina Aquarium and the Fort Sumter Visitor Education Center were built on the site's northern edge.[8]

By the beginning of the twenty-first century, Gadsden's Wharf and its history had been largely forgotten. The collections of the Charleston Museum, one of America's oldest museums located only a few blocks from the site, contained no information on the wharf. Nor did the National Park Service reveal any knowledge of Gadsden's Wharf. African Americans who grew up in the adjacent neighborhoods had never heard of it.[9] As with much of Charleston's African American history, Gadsden's Wharf and its role as North America's major slave port and market had been buried in the past, covered by a thick layer of mythologies about a genteel life of sweet tea and magnolias, antebellum mansions,

and live oak–lined streets that has made Charleston one of America's favorite tourist attractions.

I moved to Charleston in 2002, following my retirement after seventeen years as director of the Museum of the City of New York. As a historian, I immersed myself in the history of my new home. I became an advisor to the International African American Museum. My research on the role of Gadsden's Wharf in American history led Mayor Riley and the other stakeholders to relocate the International African American Museum to the last open space on the harbor, where Gadsden's Wharf had been.[10] The City of Charleston purchased the new location for $3 million. One of America's most dreadful historic sites would be transformed into a place of learning and remembrance.

Visiting the International African American Museum, and walking through the Memorial Garden to Our African Ancestors and along the streets of Charleston, gives me a strengthened sense of time, place, and self. James Baldwin captured the essence of the experience when he wrote,

> For history, as nearly no one seems to know, is not merely something to be read. And it does not refer merely, or even principally, to the past. On the contrary, the great force of history comes from the fact that we carry it within us, are unconsciously controlled by it in many ways, and history is literally present in all that we do. It could scarcely be other-wise, since it is to history that we owe our frames of reference, our identities, and our aspirations.[11]

In that way, I carry within me the history of Gadsden's Wharf and the Memorial Garden to Our African Ancestors. They are a part of who I am as an individual and as an American. Although separated from Gadsden's Wharf's atrocities by two and a quarter centuries, when I stand at this site, I sense the link between the racism that brought enslaved Africans here in chains and sold them into a life of misery and death and the scourge of white supremacy and systemic racism that continues to scar the United States. And I begin my walk through the garden and beyond.

Standing on the water's edge, I look four miles east toward the Atlantic Ocean. At the entrance to Charleston Harbor, I see Fort Sumter, where the American Civil War began. That conflict over white supremacy and slavery

led to the deaths of more than 600,000 Americans. The visible and historical connections between Gadsden's Wharf and Fort Sumter are startling and profound: the American Civil War flowed directly from slavery and the inhumanity suffered on the ground where I stand.

I turn into the memorial garden and cross a footbridge straddling an image of Africans stacked like cordwood in the hold of an eighteenth-century slave ship. I hear a panoply of African voices from the garden's hidden speakers. The different languages echo the geographic and ethnic diversity of the individuals brought here. I pass sculptures representing the enslaved individuals who worked in the fields that produced Carolina Gold. Heading west, I walk and soon arrive at Concord Street lined with condos and a public park. The section of Concord Street stretching 840 feet from Calhoun Street to Laurens Street marks the width of Christopher Gadsden's creation. Laurens Street, on the southern edge, was named for Henry Laurens, who operated America's largest slave-trading firm.[12]

Looking west from the garden I see Gadsdenboro Park, and, across its green, I look at the circa-1789 white-framed house where Sarah and Angelina Grimke grew up overlooking Gadsden's Wharf. The horrors that the sisters witnessed from the galleries of their home eventually compelled them to become the most famous pre–Civil War female abolitionists and, later, crusaders for women's equality. Theirs reminds me of the complexity of Charleston's stories composed of good and evil, courage, human depravity, tragedy, and triumph.

I turn right, walking north on Concord Street to Calhoun Street, originally named Boundary Street, marking the eighteenth-century northern edge of Charleston and Gadsden's Wharf. The four-lane street crosses the Charleston peninsula, east to west, from the Cooper to the Ashley River. Today the street is a mixture of commercial and residential areas, and the College of Charleston lines its southern border for several blocks. For much of the twentieth century, the street demarcated white and Black Charleston. South of Calhoun was considered reserved for whites; north of the street, most Black Charlestonians lived, attended school, and shopped.

The street was renamed for John C. Calhoun, South Carolina's most prominent nineteenth-century politician in 1850, not even one year after his death.[13] Calhoun—whose various positions included senator, secretary of state, and vice president of the United States—was an outspoken apologist for slavery.

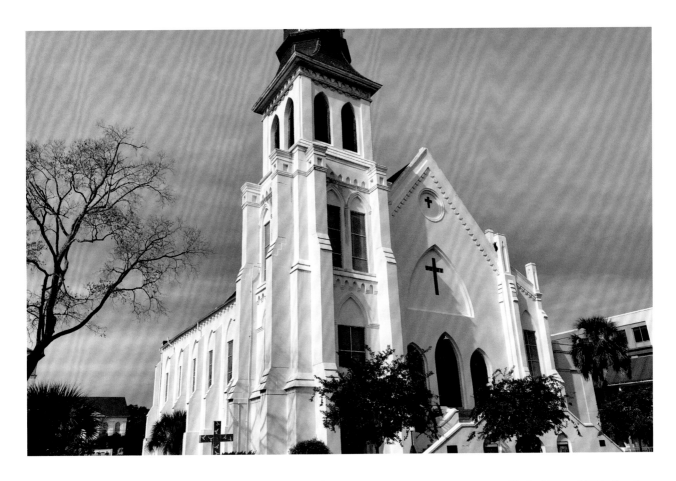

Mother Emanuel AME Church, Charleston, 2019.

Speaking before the U.S. Senate in 1837, he declared,

> I hold that in the present state of civilization, where two races of different origin, and distinguished by color, and other physical differences, as well as intellectual, are brought together, the relation now existing in the slaveholding States between the two, is, instead of an evil, a good—a positive good.[14]

Calhoun also formulated the concept of nullification, whereby states had the right to disregard actions of the federal government. For Calhoun, the immediate issue was the Tariff of 1828, which the South believed favored the North.[15] In 1860, nullification became the rationale for states to secede from the Union, leading directly to the Civil War. In the twentieth century, supporters of the "Lost Cause," the revisionist ideology that viewed the South as the

righteous victim in leaving the Union to protect a way of life founded on slavery, resurrected Calhoun as their champion. Along with the Lost Cause, Calhoun's concept of nullification became the basis for the "states' rights" dogma, the Southern defense of segregation, and the rebirth of the Confederate flag.

Walking west on Calhoun Street, I pass the recently built headquarters of the Charleston County School District, which stands directly across the street from the Charleston County Public Library. Until 1963, Charleston operated racially segregated schools, relegating the heirs of Gadsden's Wharf arrivals to second-class educations. Even today, Charleston's public schools with majority-Black student bodies receive less financial support than majority-white schools.[16] Charleston's public library system was also segregated until 1964.[17] Before integration, African Americans were restricted to the John L. Dart Library (initially founded in 1927 as a reading room by African Americans to serve their community).[18]

Next to the school headquarters is the recently renovated Gaillard Center for the Performing Arts, which stands on what was Gadsden's Wharf's western boundary. In the spring of 2013, during the center's renovation, the remains of thirty-six Africans were exposed—the site was a Black burial ground. Analysis dated the remains, which were arranged in a well-spaced and orderly fashion, to about 1780, or a few decades afterwards.[19] In May 2019, the community gathered at a reburial ceremony for these people within a collective open burial vault, engraved with African names, newly given to the interred to honor their heritage.[20]

Further west on Calhoun Street, I stand before a white Gothic Revival church with a towering black spire: Mother Emanuel African Methodist Episcopal Church. Here, on June 17, 2015, Gadsden's Wharf's legacy of brutality and terror reemerged when a young white racist murdered nine African Americans attending Bible study. Gazing at Mother Emanuel, I consider the enduring bond between past and present and ask myself how many of Mother Emanuel's innocent victims had ancestors who were thrown from a ship and sold on Gadsden's Wharf?

Gadsden's Wharf's bequest of white supremacy and racial terror reaches beyond Mother Emanuel as well. Did George Floyd, Breonna Taylor, Freddie Gray, Eric Garner, Tamir Rice, Walter Scott, Trayvon Martin, Ahmaud Arbery, and other innocent Black men and women murdered by police and others, as well as the more than four thousand African Americans lynched during the

Jim Crow era, have ancestors shackled and sold on Gadsden's Wharf?

I leave Mother Emanuel and walk a block west on Calhoun Street to Marion Square, one of Charleston's most prominent public spaces. I examine the ornamental ironwork of the memorial to Holocaust victims—those who suffered and died at the hands of forces of another racist ideology. Until recently, a large column stretched 100 feet into the sky here. It served as the pedestal of a twelve-foot-tall bronze sculpture of Calhoun, erected in 1895, to announce the triumph of white supremacy and the beginning of the Jim Crow era. It replaced an earlier Calhoun statue, lower in height, that had been frequently mocked and vandalized by African Americans. From its higher perch, for 124 years Calhoun's statue stood safe from vandalism and dominated Charleston until public outcry prompted by George Floyd's police lynching. At the order of the Charleston mayor and city council, the statue was removed on June 24, 2020. Two months later, contractors hired by the city pulled down the column.[21]

Even if Marion Square's John C. Calhoun statue is gone, the white supremacy it represented persists. African Americans experience its oppressive legacy daily: inequalities endure in education, health care, jobs, and housing, among countless other elements of the corrosive racism haunting America. We have witnessed these inequities for generations, but we have chosen to ignore the wrong. Do we ask ourselves if we recognize and care about the implications of white supremacy? Do we even believe that systemic racism exists? Ultimately, do Black Lives Matter to us as a nation? We have avoided these troubling questions for most of our history.

After Americans gained their independence from Great Britain, an American observer wrote:

> While all is joy, festivity, and happiness in Charles-Town, would you imagine that scenes of misery overspread in the country? Their ears by habit are become deaf, their hearts are hardened; they neither see, hear, nor feel for the woes of their poor slaves, from whose painful labors all their wealth proceeds and no one thinks with compassion of those showers of sweat and tears which from the bodies of Africans, daily drop, and moisten the ground they till. The cracks of the whip urging these miserable beings to excessive labor, are far too distant from the gay Capital to be heard.[22]

Although pulled from history, these words continue to carry striking resonance with our contemporary society. When we walk through the African Ancestors Memorial Garden and through the streets of Charleston, do we hear the voices of Gadsden's Wharf's descendants crying *I can't breathe,* demanding equality and freedom from official terror? Our eyes, ears, and hearts could be closed to the power of Gadsden's Wharf's legacy that continues to run like a tortured stream through America—or they could be open.

My walk through the African Ancestors Garden and into the city traversed only a few blocks, but it encompassed more than two centuries of history. It crossed a landscape that forcefully asks the questions: How far have we come? How much further do we have to go? Will the International African American Museum show us the way? Will the African Ancestors Garden help us get there? One thing is clear: it is a good place to start.

References

1. James A. McMillin, *The Final Victims: Foreign Slave Trade to North America 1783–1810* (Columbia: University of South Carolina Press, 2004), 94.
2. Ibid., 113–14
3. John Lambert, *Travels Through Lower Canada and the United States in the Years 1806, 1807, and 1808*, vol. 2, 3rd ed. (London: Baldwin, Cradock, and Joy, 1816), 166–67.
4. Although the international slave trade was legally abolished with the enaction of the Act Prohibiting Importation of Slaves, international smuggling as well as an active domestic ("coastwise") trade persisted. archives.gov/education/lessons/slave-trade.html.
5. David Selden to his parents, March 5, 1808, Collections of the National Museum of African American History and Culture.
6. "Reuse and the Benefit to Community: Calhoun Park Area Site," Environmental Protection Agency, p. 2. semspub.epa.gov/work/04/11121287.pdf.
7. Ibid., 3.
8. Ibid., 5, 7.
9. Robert R. Macdonald interview with National Park Service employee, March 5, 2004.
10. Robert R. Macdonald, "The Power of Place: Gadsden's Wharf and American History," unpublished manuscript, 2004.
11. James Baldwin, "The White Man's Guilt," *Ebony Magazine* (August 1965), 47.
12. McMillin, *The Final Victims*, 75; "Slavery and Justice," Report of the Brown University Steering Committee on Slavery and Justice, 14.
13. "Wards of Charleston, 1783–1960," The Charleston Archive, Charleston County Public Library, www.ccpl.org/wards-charleston-1783%E2%80%931960.
14. John C. Calhoun, remarks before the United States Senate, February 6, 1837. Richard K. Crallé, ed., *Works of John C. Calhoun* (Charleston: Walker and James, 1856), 631–32.
15. John C. Calhoun, en.wikisource.org/wiki/South_Carolina_Exposition_and_Protest.
16. *The State of Racial Disparities in Charleston County South Carolina*, College of Charleston Avery Research Center for African American History and Culture, prepared by Stacey Patton, 2017.
17. Nic Butler, "Segregation and Integration at CCPL, 1931–1965," *The Charleston Archive*, February 10, 2012, ccplarchive.wordpress.com/2012/02/10/ccpl_integration.
18. John L. Dart Library, Charleston County Public Library. www.ccpl.org/branches/dart.
19. Adam Parker, "Discovering the dead: Gullah Society takes on preservation of black burial grounds in Charleston," *Post and Courier*, August 19, 2017, updated December 28, 2022. www.postandcourier.com/features/discovering-thedead-gullah-society-takes-on-preservation-of-black-burial-grounds-in-charleston/article_16837424-8131-11e7-9059-cfd92f7e6eaf.html.
20. Stephen Hobbs, "Tears and celebration mark Charleston reburial of skeletal remains of 36 people," *Post and Courier*, May 4, 2019, updated March 8, 2022. www.postandcourier.com/news/tears-and-celebration-mark-charleston-reburial-of-skeletal-remains-of-36-people/article_1fbabaa4-6774-11e9-a624-3f897829437b.html.
21. Mikaela Porter, "In 21 seconds, granite column that held John C. Calhoun above Charleston tumbled to ground," *Post and Courier*, August 26, 2020, updated December 22, 2020. www.postandcourier.com/news/in-21-seconds-granite-column-that-held-john-c-calhoun-above-charleston-tumbled-to-ground/article_ea5a9238-e712-11ea-a826-03d4603d02cf.html.
22. J. Hector St. John de Crevecoeur, *Letters from an American Farmer*, Letter IX, 1782.

Remembering the Ancestors

by Louise Bernard

There is a strange emptiness to life without myths.
 – N. K. Jemisin

Let us begin with the concept of mythos as it lends itself to Afro-diasporic making—a sensibility bound up in the fraught intersections of life and death, the haunting, never quite reachable *betwixt* that conjoins across time and space the "Old" world and the "New." To invoke "the ancestors" (at once definitive and destabilizing) is to conjure those who can only be *re-membered* against the grain of competing modalities, namely the historical, the anthropological, the medical, the literary, the linguistic, or whatever *disciplinary* taxonomy might attempt to capture and frame some always failed understanding of personhood as it sits in awful tension with the *image* of "the slave." And by "the slave," I mean the captive African bound up in the triangular trade or its aftershocks and rendered in sharp relief by those empowered to wield an assumed mastery over Black life, and that which such a life begets—the peculiar lineages and painful legacies to which any post-slavery economy is heir. As we call forth "the ancestors" we embark, then, on a journey into a partial knowability.

This search means sifting through the palimpsest that lays claim to documentation, to the archaeological trace, to those indelible memories, tastes, and sounds that, on the one hand, stake a defiant claim rooted in an evidentiary ethos—a name here in the ledger, that rock which marks a boundary, this word that ushers forth remnants, recast, of a mother tongue. On the one hand, stake a defiant claim rooted in an evidentiary ethos—a name here in the ledger, that rock which marks a boundary, this word that ushers forth remnants, recast, of a mother tongue. On the other hand, this palimpsest defies easy understanding of peoples simultaneously present and absent within the confines of the archive, that symbol of all that is colonial or bureaucratic, violent in its capacity to both codify and erase.

With this in mind, the history of Atlantic World slavery seemingly charts a course in dialogue with epistemology itself, particularly as it relates to the idea of "cultural retention" that, in turn, weighs heavily on the process of recollection. We find, across a representative, scholarly landscape a progressive, ontological shift from the assertion of a homogenous West African culture and its presumed survivals: in Melville J. Herskovits' formative text, *The Myth of the Negro Past* (1941), to the dis/continuities and creolized transformations central to Stanley W. Mintz and Richard Price's *The Birth of African-American Culture: An Anthropological Perspective* (1992), and the regional specificities undergirding chattel slavery as captured by the data-driven yet contextualized work of David Eltis and David Richardson's *Atlas of the Transatlantic Slave Trade* (2010). This theoretical framework with its fractured genealogies is, in part, deconstructed by Saidiya Hartman's transgressive quest to disrupt, as a type of reckoning, the very limits of historiography in a writerly practice she calls "critical fabulation." Hartman's approach is rendered with emotional acuity in her personal account, *Lose Your Mother: A Journey Along the Atlantic Slave Route* (2007), and expounded upon further in her essay "Venus in Two Acts."

The quest to understand the role of memory in slavery's epochal turns as it pertains to the forging of modern capital, and the labors of Black people, hinges on the inherent problematic of the Middle Passage as the site of rupture *and* rebirth. Such a formulation calls forth the concomitant specters of "natal alienation" and slavery as "social death," ideas that have largely been distilled and abstracted from the Jamaican sociologist Orlando Patterson's now classic treatise. Such blunt contractions dwell largely on a sense of inef-

fable loss in keeping with the associated wounds of so radical a dispossesion. A sense of dislocation, endured across generations, is echoed in the very disenfranchisement that characterizes the lived experience of de jure and de facto segregation before, during, and after the period known as Jim Crow (expressed on both sides of the Mason Dixon line), and which is felt most palpably in our current age of mass incarceration by those many thousands gone—Black men and women, including minors, effectively disappeared from the democratic promise of civil society. We are confronted, always, by the vagaries of freedom as tied, in the U.S. context, to those inalienable rights that sit at the heart of the nation's effective charter, and how those rights rub up against the inhumane conditions of prolonged and systemic racism.

And yet it is the conjunction—the *and* which sutures the redoubled traumas of rupture and rebirth—that gives shape and weight to Afro-diasporic memory, to self-determination and agency, however narrowly constrained those proud assertions might be. For it is resistance as it relates to resilience (to survival in the fullest sense of that term) that is, above all else, the hallmark of slavery and post-slavery life. Any recollection, as it pays homage through cultural expression to those who went before—to the ancestors as we might commune with them—is premised upon not only a refusal to forget but a willed desire through timeless ingenuity and improvisatory skill to take the canvas of this unforgiving land and to make it anew; a sentiment that we find most alive, for example, in the dynamic contours of Gullah language and storytelling, foodways, and spirituality.

The question is, perhaps, not merely *what* remains but *how*? How is testimony encountered and embraced? How do we honor mythos—the stories, whether of sorrow or joy, woven out of the dark hold—and give witness to this impossible past as it imprints our living present? It is against the backdrop of the archive as limit text and the various silences that give voice to a formative history underpinned by untold brutality and despair that we might contemplate the figure of the museum, and its role in the act of recollection, as a kind of vessel—not so much a container for the past (the museum as mausoleum), but as a living, breathing entity energized by human interaction and framed by the power of place. Nowhere is this perhaps better understood than in the South Carolina Lowcountry and the site of Charleston as a port city inextricably tied to the Circum-Atlantic's cross currents—from the Senegambian lit-

toral and the embarkation point of Bunce Island, to the early plantation life of Barbados, and the commercial thrust of Liverpool or Bristol. We discover that the wide arc of this geography coheres at the threshold of Gadsden's Wharf and is then refracted through the durational concept of arrival. And while the phantasmagoria of the slave trade and its afterlife is captured in the representative port city's resplendent architecture, it is in the distinct formation of the Sea Islands that we find a liberatory culture made manifest.

I am drawn, in reflecting upon the Lowcountry's evocative cartography, to Édouard Glissant's poetic vision of "the museum as an archipelago": a repository that reaches out to embrace the world of ideas, antithetical in spirit to the absoluteness of "continental thought"—that which is parochial or nationalist in its discourse and which runs counter to the rich, cross-fertilizations embodied by diasporic dispersal. Similarly, the artist Torkwase Dyson's nuanced articulation of "Black compositional thought" provides a grounding register by which to imagine "how paths, throughways, waterways, architecture, objects, and geographies are composed by Black bodies, and then how additional properties of energy, space, scale, and sound all work together in networks of liberation." In each of these theoretical frameworks, the concept of Lowcountry material culture as shaped by the human hand—by the African forebear as inventor and artisan—is at one with the surrounding terrain and the broader cosmos as sacred space.

The motifs of ritual brought to bear on, say, rice cultivation, indigo and sweetgrass production, or masonry, each a signature craft indicative of Black labor as combined with creativity, shed light on the uncanny relationship fostered between subject and object. With the museological in mind—the compelling means by which an artifact holds stories, illustrates lived experience—we might consider how those humans objectified by enslavement or the harsh social codes of a supposed freedom, wrest back from subjugation the power of subjectivity as it is captured in the very emblems (or objects) of daily life. These things of beauty, as they speak to the quotidian, give new meaning to memory work and artistry alike. One such example might be found in the craft of master blacksmith Philip Simmons, whose myriad gates, screens, and grilles give Charleston a decorative sensibility steeped in the traditions of pre-colonial Africa—the ceremonial properties of bronze (and other materials) as found in the Yoruba kingdoms of Benin and Ife. There is

an elegiac quality not only to Simmons's work, but also in that of the Tanzanian-born Ghanaian-British architect Sir David Adjaye, whose design of the bronze facade enveloping the National Museum of African American History and Culture in Washington, DC, captures the ancestral spirit . The facade's latticed skin, with its revolving daylight hues, bestows a warmth and depth upon the building's majestic corona, itself an abstraction drawn from the West African caryatid, a column carved in human or animal form that supported the verandas of important religious shrines. One such example is found in a three-tiered wooden structure sculpted by Yoruban artist Olowe of Ise (ca. 1900). Simmons' work, forged out of the Lowcountry's distinct Gullah heritage, finds a new vernacular resonance amidst the monumental culture of the National Mall. It is this synergy that connects the nation's capital—its seat of power—back to that key locus of arrival at Gadsden's Wharf and to the International African American Museum as it sits at the water's edge looking out to Charleston's harbor and beyond.

References

1. Saidiya Hartman, "Venus in Two Acts," *Small Axe* 26 (June 2008), 11.
2. Orlando Patterson, *Slavery and Social Death: A Comparative Study*, second edition (Cambridge, Mass.: Harvard University Press, 2018). See also Vincent Brown, "Social Death and Political Life in the Study of Slavery," *American Historical Review* (December 2009), 1233–34.
3. Édouard Glissant and Hans Ulrich Obrist, *100 Notes — 100 Thoughts* (No.038), dOCUMENTA (13) (Ostfildern: Hatje Cantz Verlag, 2012).
4. "Torkwase Dyson in Conversation with Mabel Wilson: Black Compositional Thought." In Torkwase Dyson, *1919: Black Water*, exhibition brochure (New York: Arthur Ross Architecture Gallery, Columbia University, 2019), 14.

Respect for My Heritage

by Jonathan Green

Every second Sunday, I visit my mother, Ruth, to attend church with her in Gardens Corner, South Carolina. As the day begins, I watch her prepare our meal that we'll eat after the church service. Invariably, she makes vegetables and rice dishes filled with ever-changing ingredients that my Gullah ancestors have used for generations. The home permeates with a magnificent aroma flowing from the stove, through the kitchen, and into the connecting rooms. While the meal slowly cooks, we attend the Huspah Baptist Church. The choir often sings a cappella. Theirs is a call-and-response deeply rooted in the memory, tradition, and rhythms of the enslaved African and African Americans who created, lived, and died working the rice plantations of South Carolina, North Carolina, Georgia, and Florida for more than 250 years.

Whenever I drive south on Highway 17 or along the surrounding back roads across the Harriet Tubman Bridge or the ACE Basin, I encounter plantations created by my Gullah African ancestors who were captured in Africa, enslaved, and ultimately brought to our shores to build the empire of Carolina Gold rice. I recall my astoundment at a statement written by the University of South Carolina archaeologist Leland Ferguson. His description of a rice plantation clarified the magnitude of physical labor demanded of the enslaved Africans:

These [rice] fields are surrounded by more than a mile of earthen dikes or "banks" as they were called. Built by slaves, these banks . . . were taller than a person and up to 15 feet wide. By [1800], rice banks on the 12½-mile stretch of the East Branch of the Cooper River measured more than 55 miles long and contained more than 6.4 million feet of earth. . . . This means that . . . working in the water and muck with no more than shovels, hoes, and baskets . . . by 1850 Carolina slaves . . . on [tidal] plantations like Middleburg throughout the rice growing district had built a system of banks and canals . . . nearly three times the volume of Cheops, the world's largest pyramid.[1]

Often, I recognize a plantation's name, and I recall that, when I was a child, elders from my community told me that my family came from that plantation. I am filled with a sense of pride—pride based on my knowledge of what it took to build, maintain, and work in the swampy mosquito-filled rice fields rife with diseases such as malaria, amebiasis, cholera, and yellow fever. The phenomenal ability of my ancestors from Africa and, subsequently, their African American descendants to survive these conditions and create a rich and vibrant Gullah culture unique to America is humbling.

Every time I approach the canvas to express my respect for my heritage and culture, I strive to capture the magnificent legacy my ancestors left me and my family despite their enslavement, oppression, and the other horrific challenges they faced daily, and that continued even after the Civil War and the Emancipation Proclamation. I marvel how, under such conditions, they shared such incredible love with one another, maintained a sense of community, created an atmosphere of belonging, and instilled in their children a sense of purpose and meaning in life. For these reasons I choose to paint my heritage not with angst, but to celebrate the traditions, customs, and mores that convey a sense of space, privacy, dignity, purpose, family, love, and community. Many of my paintings reflect my attempt to capture the life of my people still living and working in rural South Carolina in their gardens, homes, fields, and communities. Some paintings portray the history of family sustenance: rice as a reminder of my bridge to Africa and to my ancestors.

Out of this context, I established the Lowcountry Rice Culture Project to assemble visual arts created by contemporary African American and

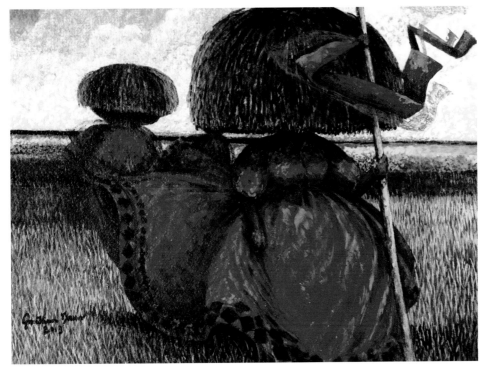

Top: *Rice Arrival*, 2013. Acrylic
on WC Paper, 10½" × 14".

Bottom: *Rice Morning Harvest*,
2013. Acrylic on WC Paper,
10½" × 14".

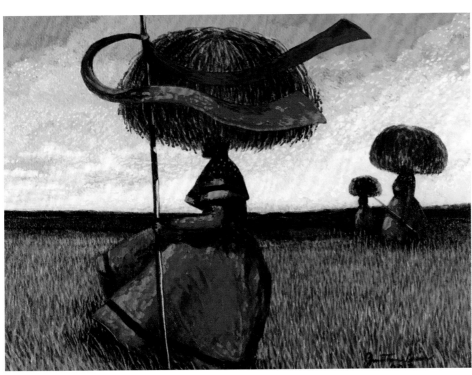

Top Left: *Rice Plantation*, 2013.
Acrylic on WC Paper, 11" × 14".

Middle left: *Three Rice Carriers*,
2013. Acrylic on WC Paper,
10½" × 14".

Bottom left: *South Carolina Gold Rice*, 2012. Acrylic on WC Paper,
11" × 14".

Top right: *Rice Morning Tasks*,
2013. Acrylic on WC Paper,
10½" × 14".

Middle right: *Riding a Rice Barge*,
2013. Acrylic on WC Paper,
11" × 14".

Bottom right: *Strolling by a Sluice Gate*, 2013. Acrylic on WC Paper,
11" × 14".

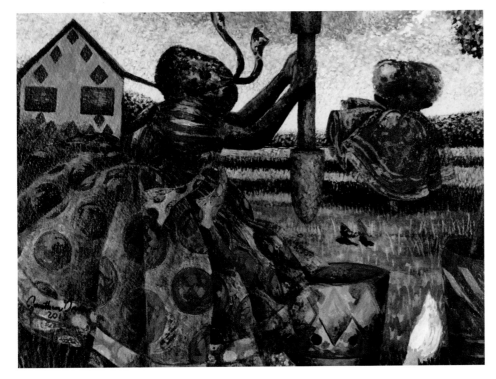

Top: *Early Morning Husking*, 2013.
Acrylic on WC Paper, 10½" × 14".

Bottom: *Hulling Home Rice*, 2013.
Acrylic on WC Paper, 11" × 14".

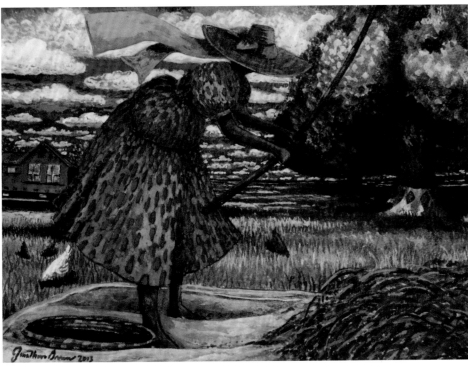

Top: *Loaded Rice Barge,* 2013.
Acrylic on WC Paper, 11" × 14".

Bottom: *Lowcountry Blue House,*
2013. Acrylic on WC Paper,
10½" × 14".

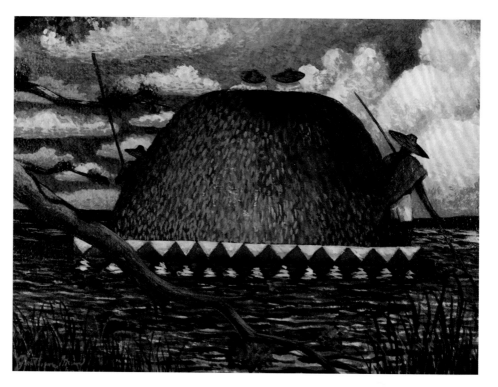

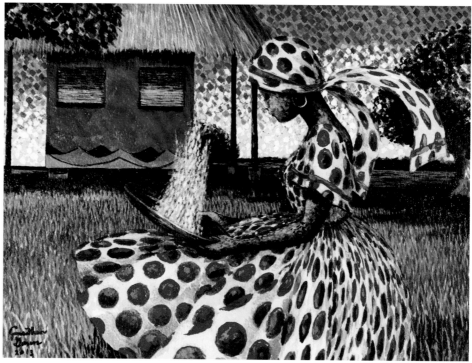

Top: *Lowcountry Rice Culture*, 2012. Oil on Canvas, 11" x 14".

Bottom: *Morning Winnowing*, 2013. Acrylic on WC Paper, 10½" × 14".

Top: *Threshing Lowcountry
Home Rice*, 2012. Oil on Canvas,
11" x 14".

Bottom: *Mill House*, 2013. Acrylic
on WC Paper, 10½" × 14".

Euro-American artists and grow awareness of the Gullah Geechee people and their contributions to American culture. Historically, the isolation of the enslaved Africans working in the rice plantations supported the development of family, religious, and community activities by which they expressed their African-derived customs and practices with limited interference from many slave-owners and overseers. Yet, throughout time, the rich contributions of the Gullah Geechee people to the American economy, foodways, art, music, dance, and other cultural arenas have consistently been interpreted from a Euro-American perspective that has discounted the identity, value, and contributions of numerous Southern African Americans to American culture and economy. The Lowcountry Rice Culture Project thus endeavors to elevate the Gullah Geechee contributions, demonstrating their essential role in southeastern American heritage.

References

1. National Park Service, *Low Country Gullah Culture: Special Resource and Final Environmental Impact Statement* (Atlanta: NPS Southeast Regional Office, 2005), 42.

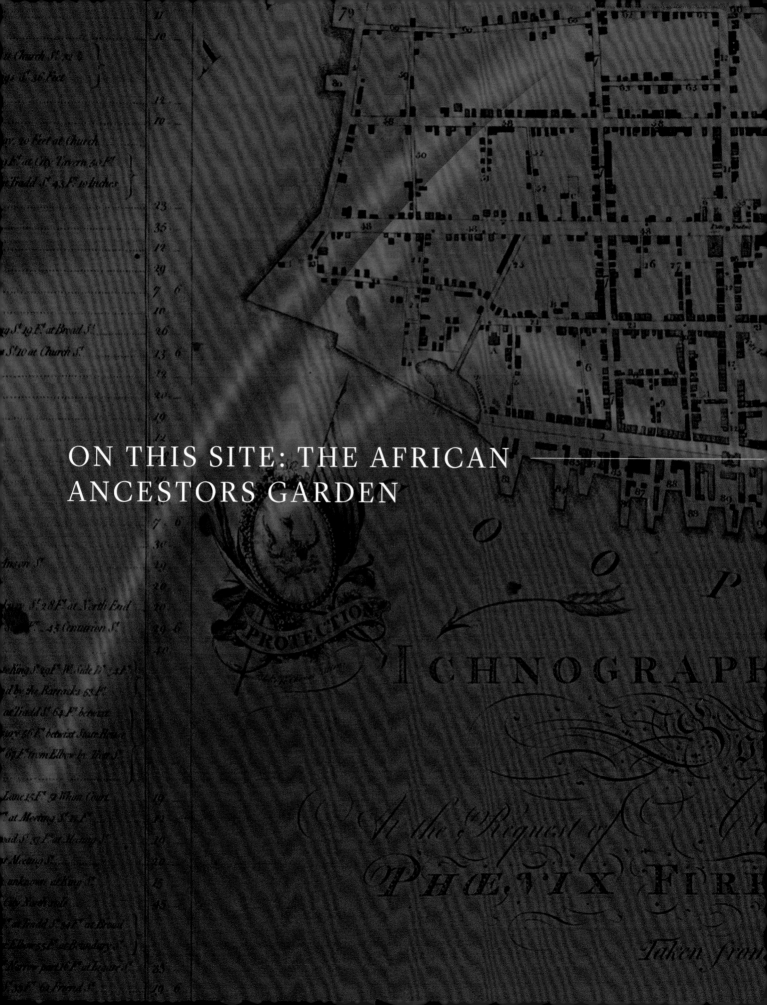

ON THIS SITE: THE AFRICAN
ANCESTORS GARDEN

After twenty years of planning and development, the International African American Museum opened the weekend of Juneteenth, 2023. The spaces and features that collectively make up the African Ancestors Garden occupy the hallowed site around and underneath the museum building, composed of native Lowcountry plantings and materials that commemorate and celebrate our ancestors.

The palms, native to West Africa, symbolize the harrowing
journey across the Atlantic endured by countless souls.

Left: Infinity reflection at the historic warehouse location.

Below: The Tide Tribute Fountain and brick Serpentine Wall.

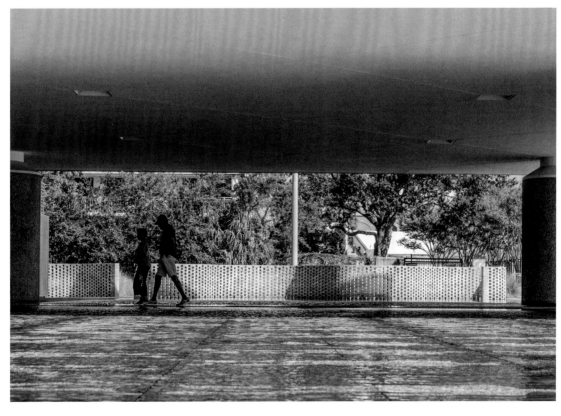

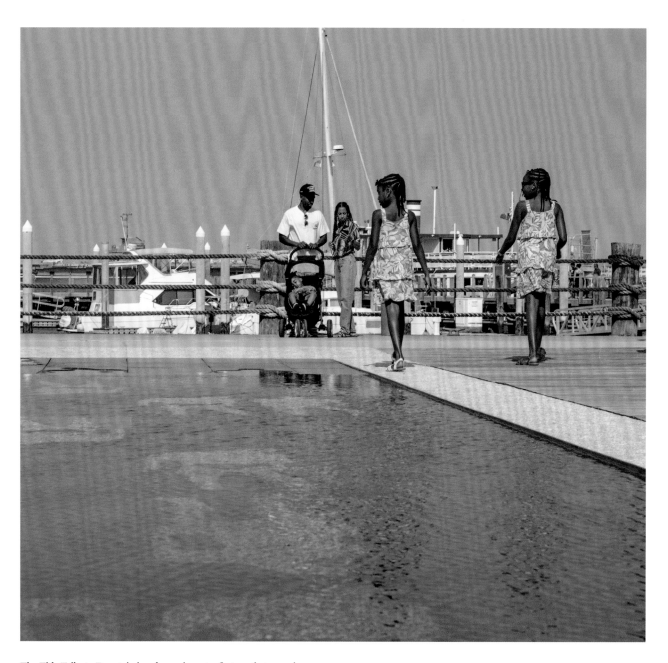

The Tide Tribute Fountain is a dynamic water feature that reveals
and conceals figures beneath the surface, reflecting the visibility and
anonymity of those who made the voyage across the Atlantic.

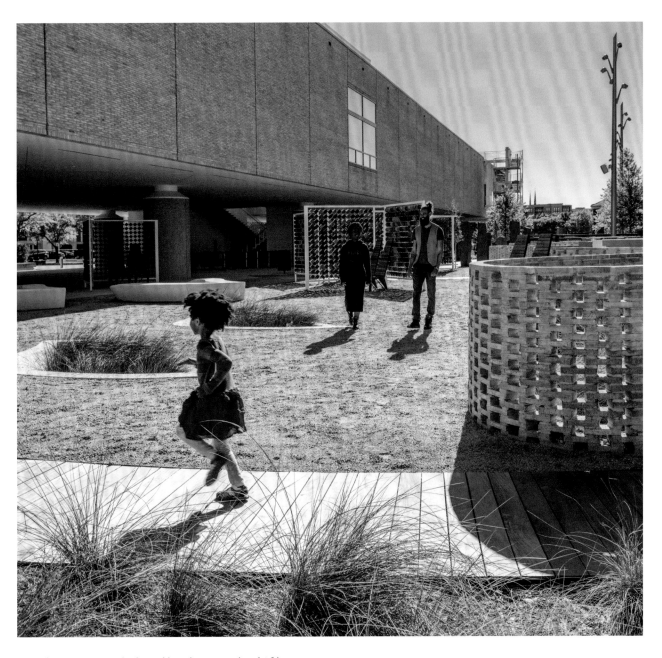

More than twenty years in the making, the International African
American Museum commits to sharing African American stories
and celebrating their descendants' achievements.

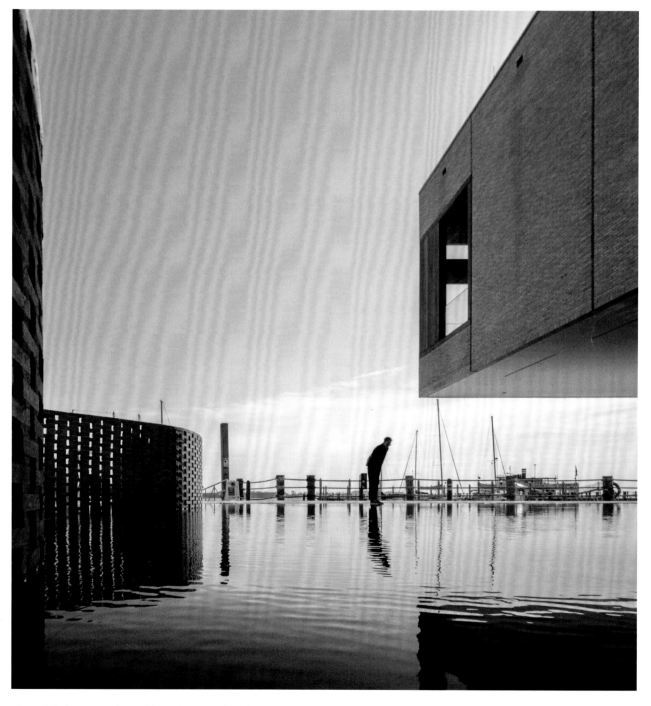

The undulating Serpentine Wall is a reference to the robust, curved brick structures built by enslaved Africans from sites ranging from the University of Virginia to Middleton Place in Charleston.

Left: The terrain in the Dune Garden rises from the rest of the site, a signal to approaching visitors of its sacred nature. Its sculptural landforms pay homage to the coastal dune formations, offering a playful gathering space tucked under the shade of palm trees.

Below: The pierced serpentine brick wall gracefully weaves along the boundary of the sweetgrass field. A testament to the historical labor of enslaved Africans, brickmaking and laying were tasks commonly assigned to them.

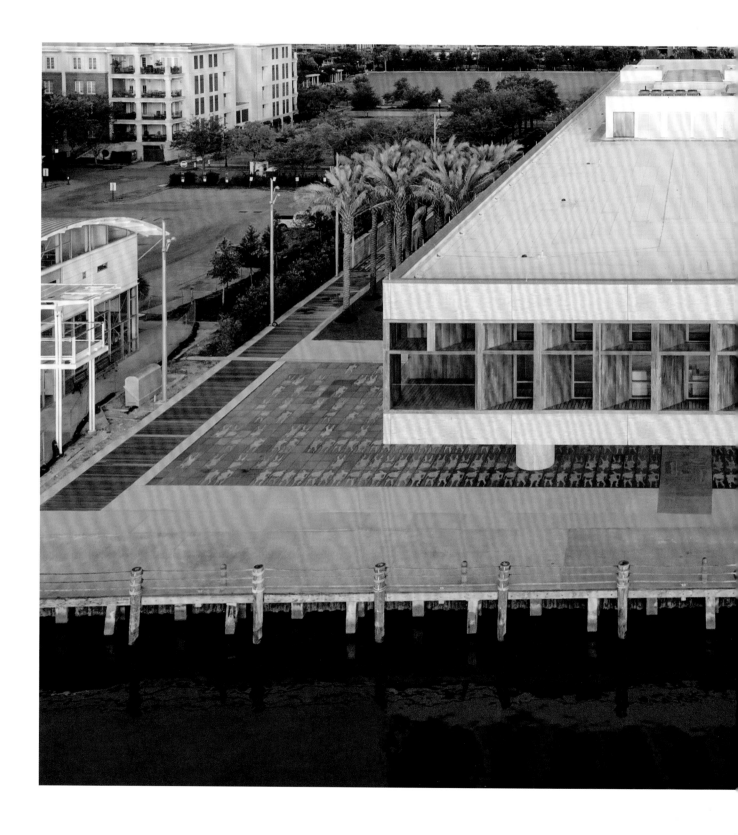

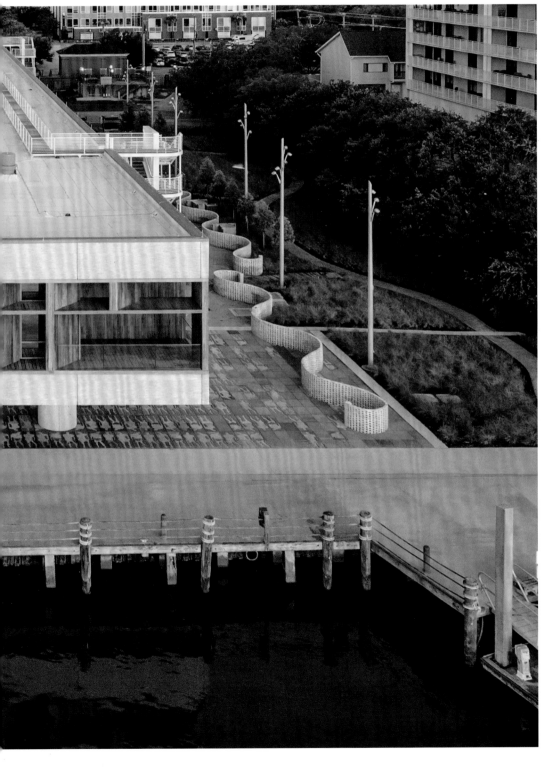

The International African American Museum transcends its architectural significance, becoming a sacred space for preserving and sharing the diverse narratives of African Americans. It encapsulates their resilience, struggles, triumphs, and contributions, serving as a beacon of hope and understanding.

This page and opposite: The Badge Frame Garden displays a series of steel frames adorned with wood block patterns. The wood block patterning draws inspiration from the designs of Moorish Gardens. These intricately designed screens create fresh apertures, inviting us to engage in thoughtful reflection and dialogue with one another.

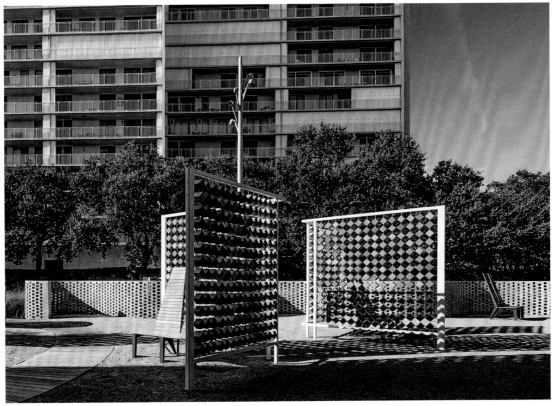

The floor of the Tide Tribute Fountain, with water receded, reveals relief figures representative of the men, women, and children who were transported, side-by-side, in the bellies of the ships that were once anchored just steps away in the harbor.

Top: The Lowcountry Garden showcases a collection of concrete benches, their design inspired by the contours of the mudflats native to the region. These benches form a circle around a ground depression, a natural collection point for the site's water runoff.

Bottom: Traditionally used for commemorative purposes, steles—often intricately carved in relief—serve as significant historical markers that provide insight into past cultural events.

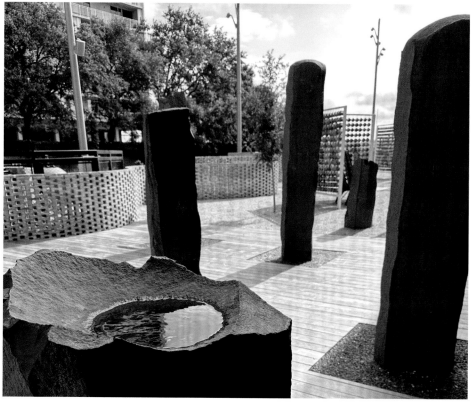

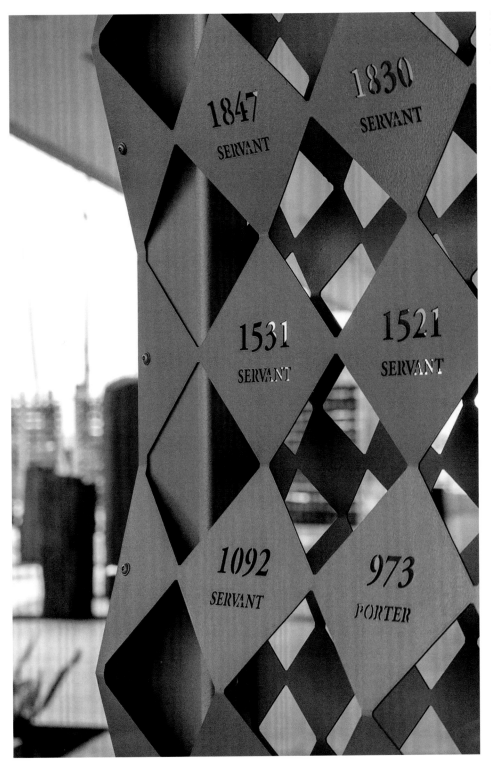

Historically, slave badges were manufactured in Charleston and required to be worn by enslaved individuals working within the city, denoting the type of labor they were allowed to perform.

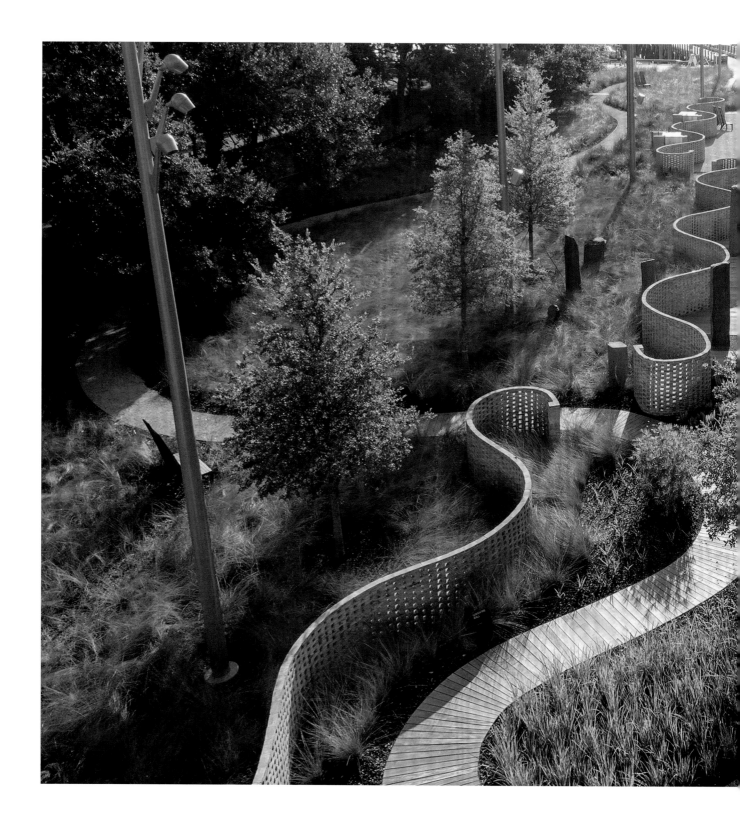

A series of subgardens, nestled within the overarching landscape, celebrates the artistry, craftsmanship, and labor that African Americans have contributed throughout history.

The Stele Garden, with its basalt columns, resonates with the enduring legacy of those who preceded us, inviting visitors to wander among them.

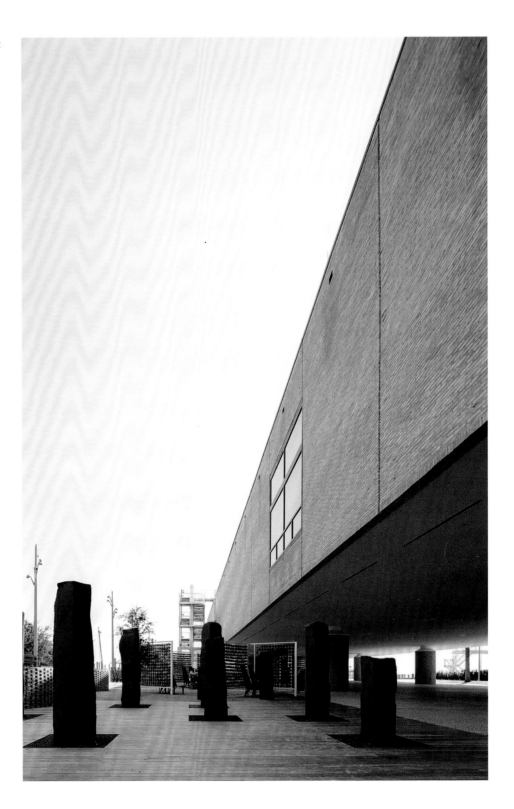

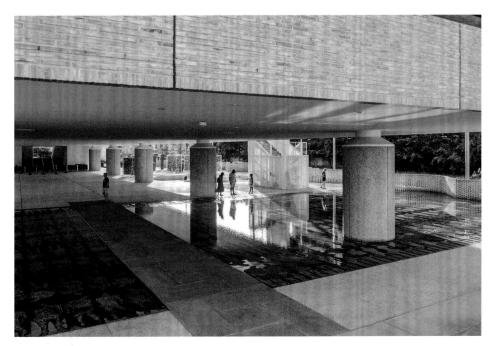

Left: Through thoughtful design and installations, the garden serves as a space for education, reflection, and healing, offering a profound experience that resonates with all who visit.

Below: Within the archaeologically constructed outline of Gadsden's Wharf warehouse, five kneeling figures cut through two polished granite walls, paying tribute to the enslaved Africans who were brought to Charleston and the Lowcountry via the transatlantic slave trade.

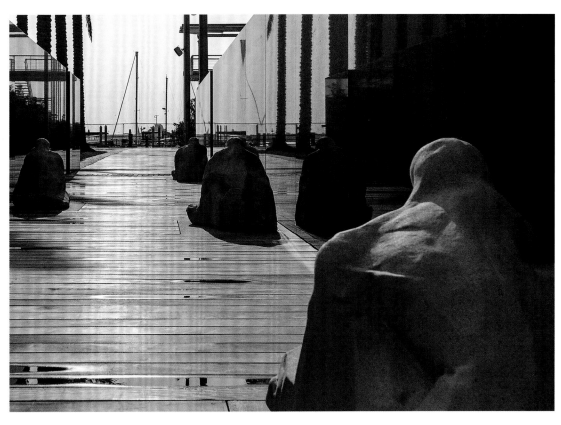

The African Ancestors Garden
is a sacred space that blends
nature, art, and history.

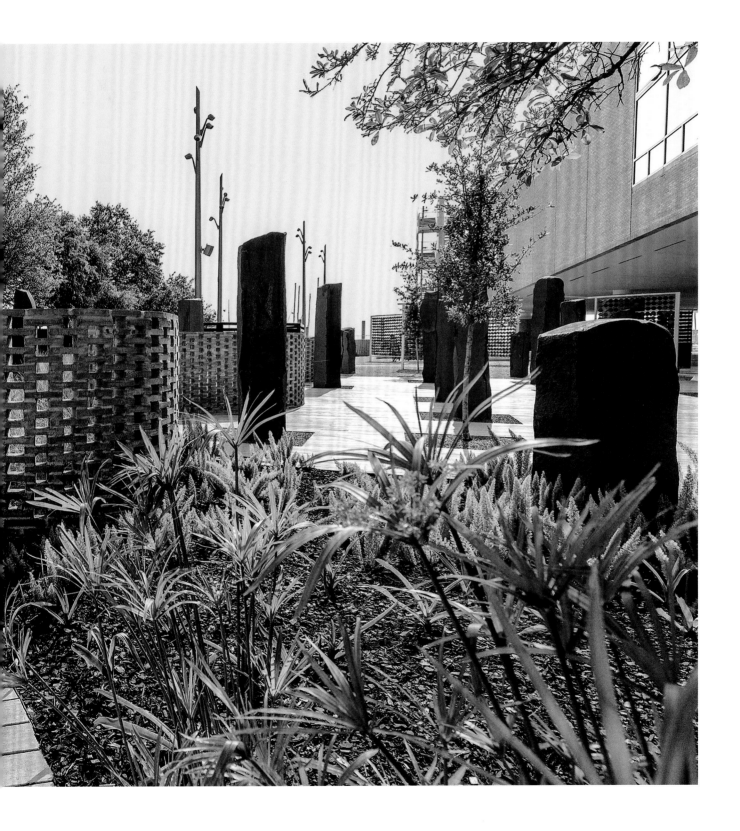

03 HISTORY AND MEMORY AT THE INTERNATIONAL AFRICAN AMERICAN MUSEUM

Our Ancestors' Garden

by Walter Hood

Designing the garden

Middleton Place, a plantation estate in Charleston, is considered one of America's first colonial gardens. But, in the current cultural context, monuments and landscapes in Charleston and other postcolonial sites, are under scrutiny for exuding noninclusive, ostensible histories and persistent genteel romanticism. Middleton Place epitomizes what art historian W. J. T. Mitchell expresses as "race hiding in plain sight," reinforcing Du Bois's concept of double consciousness, and the "veil" mediating the perception of others, "making possible a 'second sight' into racism and the experience of racial differences."[1]

It's not hard to imagine visiting Middleton Place today in search of a wedding venue (the city of Charleston hosted 6,000 wedding parties in 2019), rather than visiting to inquire about the lives and contributions of its past enslaved residents. Presented with those two options, one sees the paradox of the American landscape, particularly pertaining to the national stain of slavery. Shaped by the complex relationship between colonialism and race, the innocence of whiteness pervades the United States, reinforcing the idea of a "second sight"—one free of the images associated with slavery.

A white citizen learns to see only the beauty and the pristine aspects of the Southern landscape. Middleton, for instance, is remembered as a landscape of assorted gardens, distant riverine views, and moss-lichened oak trees. The labor and trauma that created it are erased from this recollection.

This omission is not happenstance. Since the end of the Civil War, the City of Charleston has rewritten its history through the lens of cultural hegemony.

> The birth of modern tourism industry in Charleston bolstered the sanitization of the cityscape, in an effort to revive its dismal economy, the city had built a tourist infrastructure—a tourist bureau, elegant hotels, and serviceable roads—by the end of the 1920s. The promotional literature that accompanied this tourist boom featured a historical narrative that became and essentially still is—the official history of Charleston. Guidebook emphasized the opulence and social harmony of days gone by, while largely ignoring slavery. When the institution was discussed, it was framed as benign and natural. An early guidebook argued that "the condition of the Southern Slave" was "suited admirably to the temperament of the Low-Country Negro."[2]

Today, the formal gardens at Middleton Place include a Secret Garden, Inner Garden, Mount Garden, and the Octagonal Garden. Like their European precedents, their names are inspired from their form and function. Standing between the gardens and the open fields, one can see, off near the house, a 900-year oak, witness to all that took place here. It's called the Middleton Oak. From the same point, the view down to the Ashley River is punctuated by the Butterfly Parterre Garden, a beautifully graded slope foreshadowing the rice fields where the enslaved toiled and labored. At the top of the hill sits a now-defunct bell—the object previously used to structure time for the enslaved.

In 2005, Middleton Place unveiled a new pedagogical display inside the Eliza house, a freedman's house, entitled "Beyond the Fields," that lists enslaved people owned by the Middleton family. Only their first names are listed. But imagine instead if a bench were placed under the Old Oak, with a

clear vista of the butterfly lakes and Ashley River, inscribed to read: "Middleton Plantation in South Carolina was the most complex and sophisticated example of American Colonial garden design, inspired primarily from the monarchical French Grand style, built and maintained by enslaved Africans."

Matteo Milani at the Butterfly Lakes at Middleton Plantation, Charleston in 2016.

If sites like Middleton Place produce a "second sight" that cloaks and erases the Black body and history from the visual and physical experience of the landscape, could it be possible to flip the script at this benign park, situated between two residential condos and a marina, to reveal the history of Gadsden's Wharf that literally lays beneath the surface? We posed this question. And, through exhuming Gadsden's Wharf's past, we asked if a garden could be reshaped and reimagined with a Black consciousness to tell the truth.

We imagined a dune garden, a reminder of the water's edge; a sweetgrass field, evoking a lost ecology; an ethnobotanical garden displaying botanic contributions; a stele garden harnessing the mythology of stone through sound; a palm grove speaking native tongues; rice and moss screens and planters celebrating the epiphytes and production. We imagined an Atlantic Crossing Garden: a flooded ground plane of Black figures perched above Charleston Harbor.

In 2009, a new exhibition, *African Passages*, opened at Fort Moultrie Visitor Center on Sullivan's Island. It includes drawings and paintings by local artists and a modest set of vitrines featuring slave identification badges, leg shackles, and other graphic paraphernalia. What is striking about the exhibit is its placement, toward the back of the space, as well as its meager size compared to the Visitor Center's mission of recording the events of Fort Sumter and Fort Moultrie during the Civil War.

But one cannot avoid being impacted by the exhibition items, which illuminate the psychological and physical aspects of slavery: images of slaves

Top: Drawing of Middleton
Place plantation.

Bottom: View towards
Ashley River.

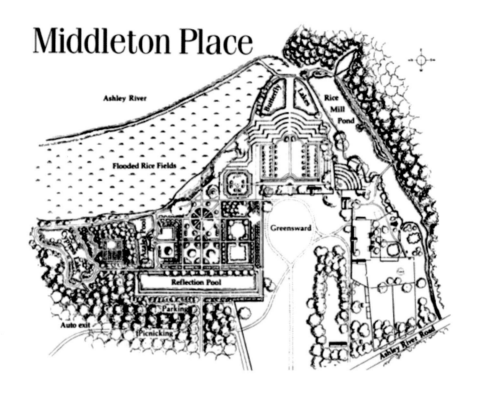

being carried from ships ashore in wagons along a long pier at Gadsden's Wharf; the metal badges the enslaved had to wear in public; the worn image of the historic Brooks Diagram, which from a distance reads as textile, but upon close inspection reveals the pattern as human forms. There are heavy facemasks and neck restraints made from iron. A flyer, whose bold text reads: "Rice-Field Negroes wanted." Taken together, seeing this material culture of slavery makes one wonder: What if the installation were at the front of the museum? Would we interpret Fort Moultrie differently?

The one landscape element on the island that attests to the history of enslaved Africans sits south of the fort, down toward the beach. A large brown-and-gold National Park Service sign begins, "This is Sullivan's Island." Erected in 1990 largely due to the efforts of Michael Allen, it describes the island's role in the slave trade, pertaining especially to Charleston. Again, without this signage, the landscape is as picturesque as it comes—white sands set against a beautiful vista of Charleston Harbor and the Atlantic Ocean.

The exhibits and pedagogical displays behind the glass vitrines and on standard Park Service signage fix in time the heinous accoutrements and accounts as precious, singular items, even though they were instruments of everyday practices. But freed from their context and circumstance, the objects take on a new visual aesthetic and language not simply referential to the past, but also to a reminiscent future. Inspiring sculptural elements and spaces that speak truth to place challenge normative spatial experiences and integrate them as the everyday—not as the commemorative. A reminiscent future is filled with reminders of the past, but it also celebrates the future by reshaping that familiar past into something new that benefits and redefines the contemporary community. The benefits are multidimensional for all, as they contribute to the facets of healing—social, cultural, political, psychological, and historic—that still needs to happen.

So how can the artifice on display at Sullivan's Island, responsible for the trauma and legacy of slavery, be seen anew? How can they inspire spaces and objects that are reconciliatory, but also that can help heal the trauma and provide spaces for reflection, spirituality, and advocacy? Returning to the city of Charleston, and Gadsden's Wharf, these objects provide a lens to exhume, interrogate, and navigate the city's cultural past. And at this place, and at this time, where the new IAAM is built atop the archaeological field of the wharf,

Map of Sullivan's Island illustrating different "pest houses," or quarantine stations, used to isolate sick enslaved Africans before being sold.

the medium of landscape expresses the material culture of slavery and the material culture of the city.

Seven different landscape mediums inspired the original twenty-one landscape experiences and concepts that eventually became the African Ancestors Garden at the IAAM. They include bricks made by hand from Lowcountry clay; the wetland ground as a malleable industrialized system; steel and iron used for bondage; water as topography and spirit, time and temporality, apparition, haunt and spirit, and the practice of ritual.

They are referenced as "blood bricks."

In 2019, a tour guide suggested to "shake hands with an enslaved ancestor through the bricks of Charleston." Brick passages, brick vaults, brick towers amongst us, vertical brick towers rising from a brick topography—bricks are ubiquitous. From the civic market and buildings to the homes and cottages, to the sidewalks and the streets, you can find the imprints of labor in this clay material. In many cases, even today you can still see the fingerprints of enslaved children. Stacking bricks can create a "Tower Amongst Us," illuminating the numbers of enslaved labors it takes to make bricks. Brick topography envisions the ground where the enslaved walked (on the street and not the sidewalk) as an architecture heaving and bulging to create a space of occupancy and ritual. Brick vaults borrow the brick wall ruins from the Sugar Mill ruin and projects them horizontally on the ground.

They were referred to as Rice Negroes. From 1729 to 1739, the South Carolina colony's Black population rose from twelve thousand to twenty-nine thousand. And with this increase, planters gained "the labor force to clear swamps and construct the infrastructure necessary for relocating rice cultivation to the highest yielding inland swamps."[3]

An Ancestral Amphitheater is imagined looking outward toward the harbor, inscribing a circle so community members can gather and commune with our ancestors. A Serpentine Mound snakes its way under the building,

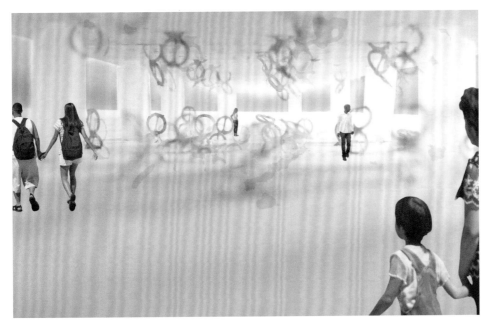

Left: Conceptual sketch of the Broken Chains feature of the original IAAM landscape design proposal.

Below: Fort Moultrie's military museum featuring artifacts of slavery: left, shackles and chains; right, badges worn by slaves whose labor was leased out.

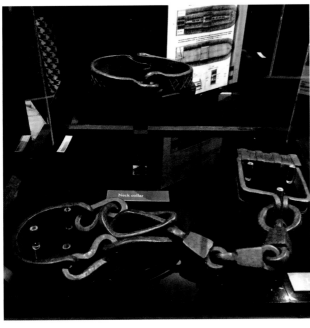

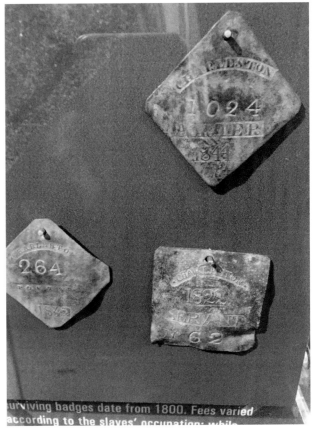

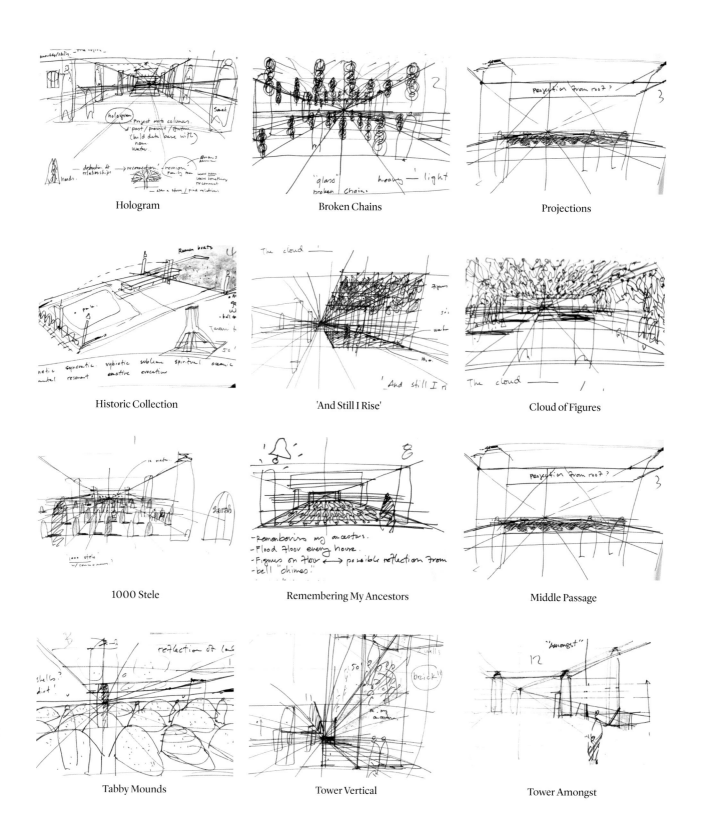

Hologram

Broken Chains

Projections

Historic Collection

'And Still I Rise'

Cloud of Figures

1000 Stele

Remembering My Ancestors

Middle Passage

Tabby Mounds

Tower Vertical

Tower Amongst

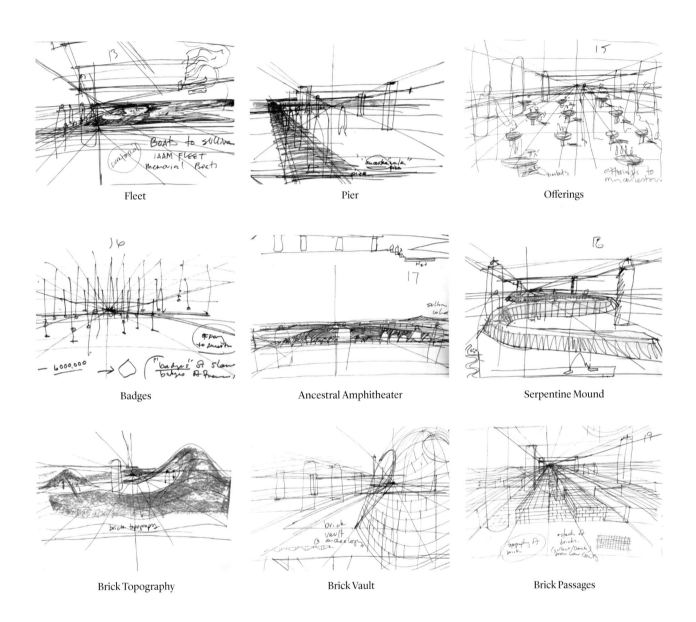

Fleet

Pier

Offerings

Badges

Ancestral Amphitheater

Serpentine Mound

Brick Topography

Brick Vault

Brick Passages

After three days of immersion in local landscape and history in 2016, the Hood Design Studio team marked out resonant places on the site: the interface with the harbor from one end of the city to the other, the site of the old warehouse, and other conceptual details. This exercise, informed by the impressions from the tour of the local landscape, formed the basis for the creative development of the initial landscape design proposal. The twenty-one resulting concepts derive from single ideas extrapolated to their fullest extent within the landscape.

introducing water and topography to the building's underside. Tabby Mounds mark the arrival of the enslaved to the wharf, producing a field of undulating shell mounds numbered marking each ship's cargo.

In 1991, John Machael Vlach wrote about Philip Simmons, a Charleston craftsman who had been practicing traditional blacksmithing for fifty-two years. Having learned the craft from a formerly enslaved blacksmith whose father was also a blacksmith, Simmons's work represents the culmination of more than 125 years of ironworking experience.[4] This number is probably larger if we connected the diaspora of enslaved labor who learned and practiced ironworking.

A question arises: Did slaves make their own chains and bonds? A Broken Chain celebrates the making and breaking of steel and iron, celebrating the power of production and freedom. Badges made from steel can identify labor of yesterday and accomplishment of today, as the former President and First Lady, Barack and Michelle Obama, will have the first badges.

The Brookes Ship made eleven voyages during its tenure as a slave ship after its first launch from Liverpool in 1781. An engraving was published in 1788, depicting the passenger conditions onboard the Brookes. It became the iconic image that bolstered abolitionists to fight to end slavery. It also gave the required dimensions for the hull's capacity, citing spaces six feet in length for men, and five feet in length for women and children. The width for all spaces was no more than a foot and four inches.

The semiotics of this lithograph has become a powerful source linking the worlds of the African Diaspora. The Brookes ship is symbolic of all ships that made the voyage. When trying to imagine how to spatialize this journey at the IAAM, we thought of how an infinity fountain can function in urban spaces: it's a civic element that doesn't prohibit people from stepping through it and splashing in the water. We asked, what if the ground were etched with six-foot-long figures inspired from the Brookes lithograph, and water periodically drained out and refilled. If it were located next to the Pier in Charleston Harbor, would a trip on the Harbor Fleet out to Sullivan's Island, Fort Moultrie, and Fort Sumter be experienced the same?

Maya Angelou's poem "And Still I Rise," written in 1978, is an anthem of strength incapsulating the spirit of our ancestors and their resiliency to keep getting up. The closing stanza inspires aberrations and imagery of temporality, the

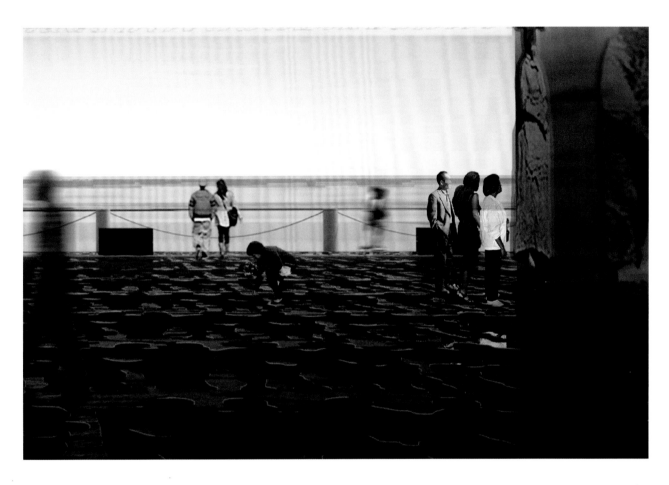

Early conceptual renderings of the Tide Tribute fountain. Top image is low tide, bottom image is high tide.

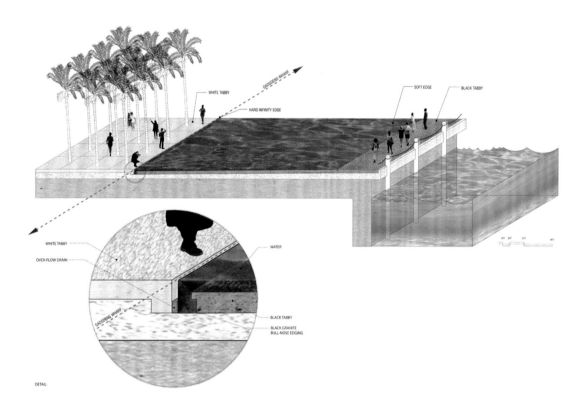

Above: Technical axonometric
drawing of the Tide Tribute
fountain.

Right: Final conceptual site plan
with Tide Tribute Fountain and
historic warehouse location.

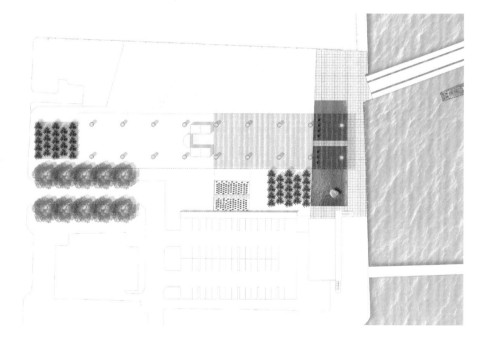

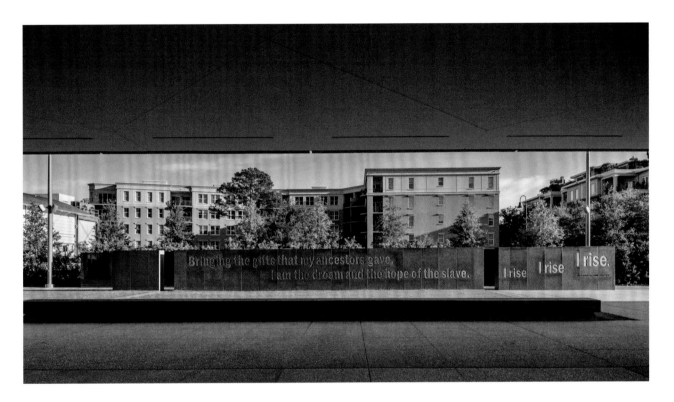

sky, light, and resurrection. Holograms projected in the harbor resurrect those lost at sea and celebrate them through aberration. Projections of the building's columns resurrect our ancestors who were lost on land, and figures emanating from the building's soffit form a cloud that rises outward into the city skyscape.

Turning onto Highway 41, the Gullah settlement of Phillips is documented with a simple sign that reads, "This community settled along Horlbeck Creek in the 1870s by freedmen was named after the Phillips Plantation." They were former slaves from the Laurel Hill, Parker Island, and Boone Hall Plantation. Today, Highway 41 is a two-lane road that preserves the settlement's rural quality as large yards flank the road. Other settlements in North Charleston, such as 10 Mile and Scallionville, have parallel histories. These histories are under threat as suburban development erases the African Diaspora from their memory.

How do we remember our ancestors in the Lowcountry? What are the "Historic Recollections"? What are the memories of our ancestors who have lived next to wetlands for the past century in Charleston? To facilitate these memories, can we bring rock and stone from the land to Gadsden, reformed

Stanzas from Maya Angelou's poem "And Still I Rise" imprinted on the north-facing granite wall at the historic warehouse site.

"Steles" that speak to generations in tongues now unfamiliar but are our history? Can we recollect through flooding the underside of the building periodically, as our history is washing away on the land? And as sound and water emanate through the Gadsden landscape, the sound of the bell rings daily as nightfall comes.

Mother Emanuel AME Church was founded in Charleston in 1817. It is the oldest Black congregation in the Southern United States. On June 17, 2015, nine members of the congregation were murdered by a white male during an evening Bible study. Months after the massacre, the commemoration committee for the IAAM Ancestors Garden visited the church, concluding our charrette and Lowcountry tour with a prayer service. Outside the church, mourners inscribed and wrote notes on the bark of the large shade standing in front of the building.

What transpired the months after the massacre swept the world and once again illuminate our resiliency. During a press conference with the victim's survivors, some family members used the power of forgiveness, and showed empathy for the white murderer saying they forgave him. Blocks away at the new IAAM, sweetgrass basket inspired pots dot the landscape awaiting offerings "To My Ancestors" from "Charlestonians." Will they, too, know the power of forgiveness and reconciliation?

This is how we and our ancestors continue to rise.

References

1. W.J.T. Mitchell, *Seeing Through Race* (Cambridge, Mass.: Harvard University Press, 2012).
2. Blain Roberts and Ethan J. Kytle, *Looking the Thing in the Face; Race, and the Commemorative Landscape of Charleston, SC, 1865–2010, Journal of Southern History,* vol. 78, no. 3, 673.
3. Judith Carney, *Black Rice,* (Cambridge, Mass.: Harvard University Press, 2002), 86.
4. John Michael Vlach, *By the Works of Their Hands* (Charlottesville, Virginia: UVA Press, 1992), 28.

A Story Told
in This Order

by Jonathan Moody

The International African American Museum must exist on *this* site at Gadsden's Wharf. The process of the museum coming into being has shown me exactly why. Many different characters and stories contributed to the evolution of this project, all of them pointing to the same inevitable conclusion: this project had to be realized by any means necessary. I am not comfortable with the idea that something so important became so difficult, but I recognize that the story of sacrifice around realizing this project reflects the stories of the ancestors it honors. This museum provides tangible evidence for identity, legacy, perseverance, and hope. The act of siting it at Gadsden's Wharf gives us all the opportunity to touch and feel the power of our history.

At a personal level, this story has many layers that affect me. This story has implications for my family, my architect father Curtis J. Moody, myself, Moody Nolan, and future generations. All of us need this place to exist as a touchstone of empowerment. A place where we can physically connect some of the threads that tie together the story of where we came from, how we got to where we are, and how that knowledge can empower us to go forward. This museum must exist on *this* site because it connects me to something I have been searching for. It signifies the end, middle, and beginning of a story that must be told in that order. I have been searching for a more tangible idea of hope.

The mere act of this project on *this* site gives me hope. Identity can change over time. When I arrived at Cornell University as an eighteen-year-old, I believed I had a clear picture of myself. That lasted only a few hours. I was part of a prefreshman summer program created to help students of color find early success. Most of the students were from New York City. The first question they asked me was, "Where are you from?" Simple question, simple answer: "Columbus, Ohio." Like most American families who came here from somewhere else, these New Yorkers I met identified themselves by their family's native origins. In that moment, I learned the extent of New York City's diversity. Most of my peers could trace their roots to the Caribbean or Africa or elsewhere. Accordingly, they followed their first question with, "But where is your family from?" I'd offer another simple answer: "Ohio." That is where the confusion often started on both sides of the conversation. Their inevitable next question: "No, but what country is your family from?" My confused response: "America?" Now with both of us puzzled, they asked, "But what country did your family come from before America?" My sad reply, "I don't know." This unknowability is a difficult reality for many Black Americans.

The enslavement of Africans has created a void in the identity of many Black Americans. Museums can help tell stories to fill these voids. The International African American Museum was one of the first projects I worked on upon joining Moody Nolan. The project had started a few years prior to my arrival, and challenges around budgeting, fundraising, and site had caused delays. During this process I first learned the history of Gadsden's Wharf. Around the same time, we had a family gathering in Columbus that brought together members from around the country and tied many strings of our story together. I discovered that my oldest known ancestor was Willis Spearman. He had grown up in Newbury, South Carolina, around 1790. I felt the void closing. More than likely, my family roots connect across the Middle Passage, through the Lowcountry, all the way to Ohio from Gadsden's Wharf. Though my view was hazy, I could stand on the pier in Charleston, South Carolina, and see the journey of my ancestors. This project must exist on *this* site so I can tell my family's story.

The design process for this museum has its own legacy and story. Gadsden's Wharf was not always the site. The team was not always the team. Before I came to Moody Nolan, my father collaborated on this project with Antoine

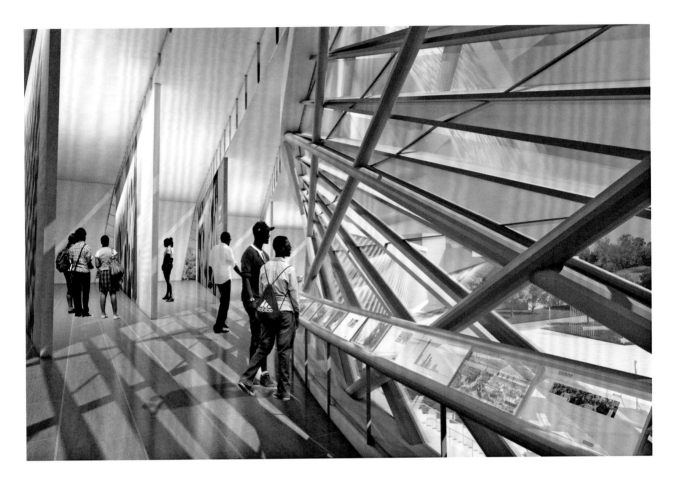

Predock, a highly regarded design architect. Theirs was a true collaboration, complementing each other's design strengths, that had previously known great success. When they worked on the IAAM, the museum's site abutted a parking garage. At that time, its design was more about the building. Predock quickly assessed the importance of water to this endeavor and initiated a dialogue to move the site. Charleston's broad community of stakeholders rejected numerous design ideas for many different reasons. Much of the criticism concerned how the museum reacted to its context. Michael Woods, a designer involved early in the process, felt insulted by the community's criticism that the architecture for a museum connecting the history of Black Americans should reflect the colonial history of Charleston. These conversations helped the museum team realize that for many reasons, the right direction forward needed to be more about the site than the building.

Moody Nolan's design study rendering of IAAM building before Gadsden's Wharf was selected as the final site for the museum.

My father asked me to help design a new study proposing the museum as a smaller building on a larger site. I asked if Predock would be involved, and my father said we could do this on our own. In the process, our team was pushed to create a design that responded to Black culture with curves and forms and improvisation, like jazz music. I enjoyed the process, and the outcome produced a design that won an international award from the Chicago Athenaeum and, in turn, restarted the fundraising effort. I figured if we could win an award for a study, we could lead the design for the building. What an honor it would be to help tell the story of my ancestors through the design. But an idea was floated to open a new design competition to raise the visibility of the project. Former Mayor Joe Riley, the project's ultimate advocate, resisted that idea and insisted on keeping Moody Nolan on the team. We remained the architect of record, but in order to raise the necessary money, the museum would also hire a highly recognized architect to lead the design.

Part of this project's story is about perseverance and overcoming, and that was equally applicable as we established our design team. Adding new team members would require a delicate balance of telling the story communicated by the original team's design concepts without discouraging potential new teammates. As the architect of record, Moody Nolan still had the responsibility to push the project to completion. Architect Harry Cobb, of the internationally acclaimed firm Pei Cobb Freed & Partners, joined to solidify our team's museum résumé and bolster our team's design strength. Mayor Riley remained the most central figure in realizing this project. He asked our team to consider adding Walter Hood as the landscape architect, and Bob Larimer, Moody Nolan's partner in charge, obliged and asked Hood to join the team. With a potential new project location, we knew thoughtful site design would be critical. We were thrilled that Hood agreed. It was absolutely essential to have his presence on *this* site.

As we at Moody Nolan had come to realize, site was also the first element that Cobb felt needed addressing. He successfully insisted upon the museum's siting on Gadsden's Wharf, and he and his team pushed concepts emphasizing this location, allowing the building to float above it. Cobb advanced a project thesis that, in order to show reverence to the site, the building should be simple, beginning and ending at the water. His masterful command of the room during meetings drew on more than seventy years of expertise. I was

honored to have the opportunity to witness it. Harry Cobb passed away in March of 2020, and his impact on the architecture profession is beyond question. I will miss him.

Overcoming so many challenges became the story of the project as we found a way to look forward. As an architect, it's always humbling to accept that the places we frame are not about the building, or even the site. They are about the different ideas of community coming together around the creation of a building. They are stories of how people learn what they have in common and unite around a series of values. In this case, it is a story about how a building atop a certain piece of land can be an impetus for a people discovering a way to look to the future.

The IAAM building on *this* site at Gadsden's Wharf brings us hope. It signifies the end, middle, and beginning of a story that must be told in that order. This landmark project serves as a touchstone of empowerment. People will come here from around the world and experience the place where the story of their ancestors' journey across the Middle Passage ended—the place where my family's Middle Passage ended. *This* site offers the opportunity to learn about the middle of our stories that began with the journey across the Atlantic, continued through enslavement and great migrations, and into many homes of Black Americans today. *This* site offers many people the opportunity to begin a new story about hope. Hope must be an actionable effort of creating a better future. This museum must exist on *this* site so we can all start new stories about the beginning of our journeys toward creating a better future, firmly standing on and honoring the story of our ancestors.

The Threshold
by Matteo Milani

The notion of threshold engages in many ways: it is linked to the idea of a passage, to a change. It refers to the moment in which transition occurs—from inside to outside, from a friendly territory to a hostile one, from light to shade, etc. In short, we have a threshold when something turns into something else. In movies, as well as in the novels of Dostoevsky, the threshold comes at that moment of detachment or disengagement between one situation and another that produces the "action." Perhaps thresholds are the truest spaces of freedom because they correspond to moments of decision, and of uncertainty. Going, separating, staying, taking this or that direction, etc. Walter Benjamin insists on contrasting the concept of threshold with the concept of limit or boundary. "The threshold must be carefully distinguished from the boundary." In his view the threshold is a zone and to be precise a zone of transition.

In 2014, Joe Riley and Harry Cobb identified the current site for the International African American Museum while driving along the Charleston waterfront: a dusty parking lot and an unpretentious public park, surrounded by conventional, scattered residential buildings and the Maritime Center and its marina.

They had spotted what looked like a blank page in the plot of the city, right where Gadsden's Wharf once stood as the main port of arrival in North America for thousands of enslaved African women and men. After the two men determined this location as the museum site, archaeologists began digging to confirm the exact positions of the eighteenth-century wharf's edge and the warehouse that had held African slaves. No trace of this history remained part of the urban fabric of Charleston: cities sometimes forget their past, and other times, they intentionally erase or overwrite it.

A few decades ago, the discipline of architecture considered history as a lighthearted source of inspiration for urban and architectural design. It was a season of optimism and excessive lightness, very different from our present day. Since the beginning of our work in Charleston, we knew we could not walk along that same path. It was critical that our design acknowledge and reveal the site's history in a different and unrhetorical way.

Two fundamental principles ground the IAAM's design: first, the intention to build without occupying the site's hallowed ground; second, the creation of a sheltered public space on the ground plane that would carry a necessary gravitas. One precedent in particular constantly inspired us: Mario Fiorentino's Fosse Ardeatine Mausoleum, a memorial in Rome that remembers the tragedy that took place there while honoring the 385 civilian victims of the Nazi massacre of March 24, 1944. The IAAM, however, aims also to reconcile, housing a museum floating above the African Ancestors Memorial Garden. It is a place where both tragedies of history are told and achievements of African American culture are celebrated—a place open to all and, like the Roman god Janus, with the power to look at the past and the future at the same time.

As such, the design team carefully modulated the museum's entry thresholds. Eighteen six-foot-diameter columns with an oyster tabby finish match the exterior paving design, which Walter Hood selected for the oyster shell's deep connections to African burial culture. The columns, thus, emerge from the ground, elevating the museum's main body and revealing and interpreting the site's history. In addition to the eighteen columns, the structure's only element touching the ground is the monumental stair (flanked by two small rectangular service cores with and elevator and service stair) that ushers visitors into the museum. The design team shaped the entrance sequence as

Drawing of entry stair amphitheater with columns and enclosure poche.

a threshold between the site's experience and the museum's exhibits, and an outdoor atrium, covered by a skylight, acts as a destination and transitional space at the same time. This course embodies the notion of passage in multiple ways: ascending from ground to upper level, passing from shadow to light, moving from past to future. The space is a negotiation between the building and the landscape below it.

The IAAM building is a servant of the site—a silent yet significant presence with minimal design gestures animating its essential shape. Few openings punctuate the facades, which are clad in handmade bricks of pale yellow. Only the two ends of the building facing the water and downtown Charleston are carved out, hosting four terraces and large openings screened by large-scale exterior sunshading structures built from sapele wood.

The museum's interior plan was conceived around a forty-eight-by-forty-eight-foot structural grid. The long-span structural system, which reduced the number of interior columns, and the placement of the few service elements on the main floor (they are, with the administrative offices, on the upper level) provide great flexibility as the IAAM and its exhibits evolve over time. The museum's spaces are organized around a central unobstructed visual axis that traverses the building, allowing visitors to easily orient them-

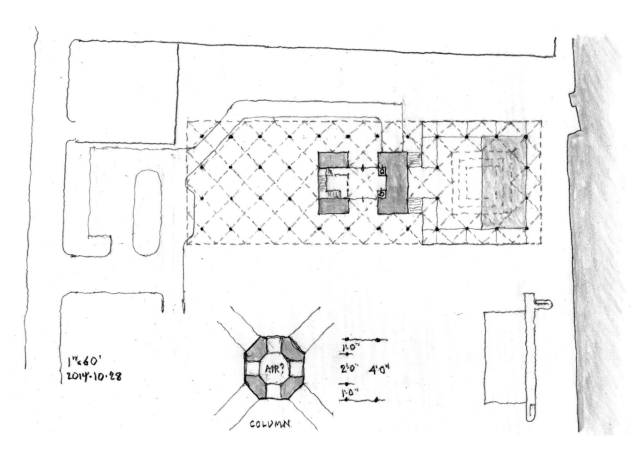

1"=60'
2014·10·28

AIR?

COLUMN

1'0"
2'0" 4'0"
1'0"

Above and right: structural grid
and blow-up poche of large
columns.

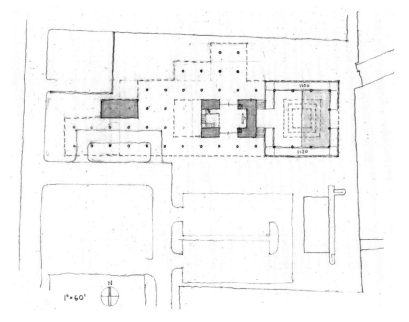

1"=60'

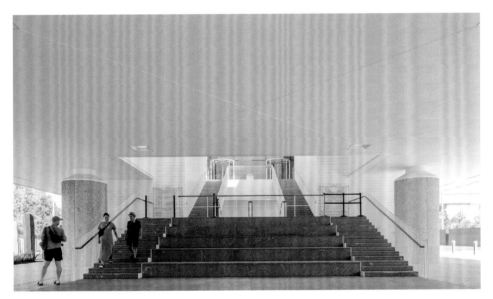

Top: Other than the massive support columns, the monumental stair is the only element that touches the ground of this site, serving as the interface between the Ancestors Garden and the museum itself.

Bottom: The stairwell proceeds to rise through a skylit atrium to the main level of the museum.

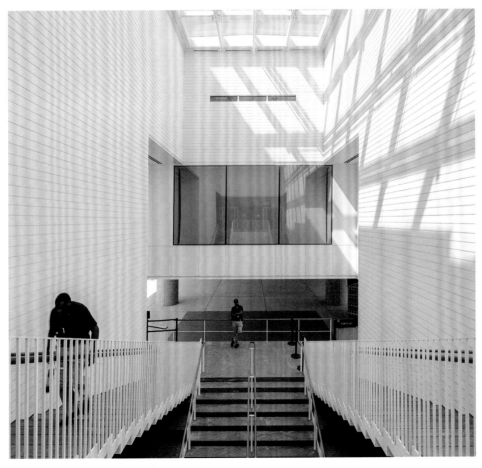

The stairs act as a transitional space between the
landscape and exhibition interiors of the museum.

selves. We made these planning choices with the exhibit designers, Ralph Appelbaum Associates, who have imagined an open, multifaceted visiting experience.

The essential simplicity of the planning and the minimalistic design approach for the architecture of the building were intentional from the concept's beginning. Because the history of the site is the essence of the IAAM, we wanted nothing to overshadow it. As exemplified by the building's columns, the architecture converses with the landscape design, which interprets the site with deep, broad, and multiple meanings that consider the point of arrival to the Lowcountry landscape as experienced by our African ancestors. The landscaped site engages visitors emotionally by revealing historical traces and ancestral memories. The museum then connects the site's history with the African Diaspora through informative exhibits inside the IAAM.

Within this context, the building stands on the site but barely touches it. It is the elevated background for a nonhierarchical experience of the outdoor public space that welcomes all. Although it is oriented along the east-west axis, visitors can walk across it in all directions. The space beneath the museum shelters outdoor activities and provides a stage for social events, and landscape features enrich the ground. The monumental stair of the museum—the link between the building and the ground—provides tiered seating on the west side for audiences to watch spontaneous and planned performances under the building. The open and flexible ground floor directly under the building, while surrounded by a richly designed landscape, serves as a blank canvas for the community and the IAAM to host public and private events in a unique, meaningful setting. In a way, it is a plaza—a social and public space—where each individual engages with the site's history, whether walking, meditating, resting, or playing.

At the scale of the city, the architectural gesture reveals something more. The building, a 426-by-85-foot rectangular object, is a visible, distinctive, thick line in tension between the Atlantic Ocean and the city of Charleston. It is a clear symbol, a figure standing out from its surroundings. It is an incision in the body of the city, right at the edge of Gadsden's Wharf. It is a mark, a passage through a history and across a geography whose stories could not stay silent and hidden any longer. It wants to be a new beginning; it is a *threshold*.

Spectral Nature: Building an African American Memory Garden

Mabel O. Wilson

Our entrance to the past is through memory—
either oral or written. And water. In this case salt
water. Sea water. And, as the ocean appears to be the
same yet is constantly in motion, affected by the tidal
movements, so too this memory appears stationary
yet is shifting always. Repetition drives the event and
the memory simultaneously, becoming a haunting,
becoming spectral in its nature.
— M. NourbeSe Philip, *Zong!*

Charleston has always felt haunted to me, ancestral
ghosts saturating its salty humidity. Here, Black his-
tory has been silenced by marble and bronze erected
to forget its landscape of racial tyranny. Charlesto-
nians built monuments to a Lost Cause for which
America never lost its taste; its appetite for rendering
Black bodies less than human has never subsided.
From the 1670s till the outlawing of the transatlantic
slave trade in 1808, hundreds of thousands of en-
slaved men, women, and children passed through the
Port of Charleston, and eventually through Gadsden's
Wharf, on their way to plantations and businesses
that profited from the violent transformation of hu-
mans into property.

When the international slave trade turned inward and became a domestic market, Charleston's infrastructure of barracks, jails, and auction houses adapted, continuing the transport of slaves across land and by sea and river, to corn and cotton plantations that sprouted on territories stolen from sovereign Native American nations. The "amber waves of grain" and "fruited plains," signatures of America's landscape, are saturated with the blood, sweat, and lives of Africans and their descendants. How can a garden tell these difficult histories?

Walter Hood's landscape for Charleston's International African American Museum creates a threshold between land and sea, between past and future. Beneath the new museum dedicated to the journey of Africans to the Americas, Hood Design Studio has crafted the African Ancestors Memorial Garden. Through the sonic textures of seagrass in the wind, the fragrance of varietal flowers, and the turn of the seasons, the garden cultivates memories of the diverse cultural contributions of food, music, dance, art, and knowledge that peoples of African descent made to the Lowcountry region and across the Americas. This poetic landscape of plants, water, textures, smells, colors, sounds, and cycles reverberates with the aquatic flows of time, remembering the Middle Passage and the slave trade that brought Africans to the Americas and to Charleston. The two main design elements of this landscape—the expansive fountain with its imprint of a slave ship and a series of gardens—provide moments for visitors to reflect on the violent trade of enslaved Africans that built personal wealth and national fortunes, a debt that has never been repaid to their descendants. The landscape functions as a rich commemorative counterpoint to the exhibition narratives unfolding in the museum's galleries above and converses with the architecture to further encourage contemplation and memory. Designed by Harry Cobb, the museum—a large, neutral, elevated box—floats above the ground plane, in part to avoid flooding during hurricane season. In the large swath of terrain below, amidst a field of six-foot-diameter columns, Hood created a series of commemorative public spaces for individual and collective reflection.

From the early sixteenth century onward, the transatlantic slave trade formed an elaborate network connecting the African coast to ports in Europe, the Caribbean, and South and North America. The trade conducted its odious business in slave forts and castles, docks, warehouses, barracoons, auction

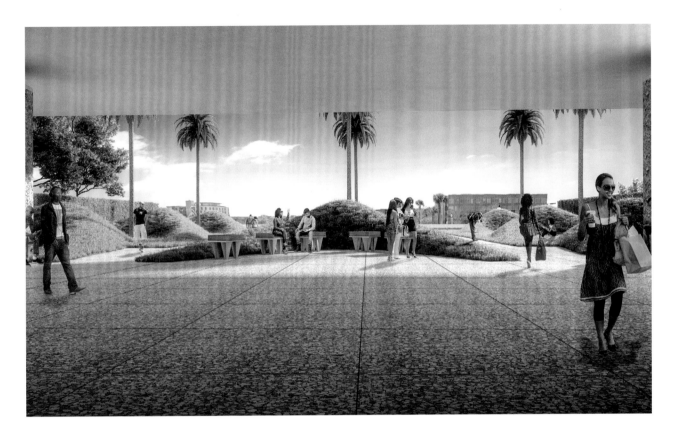

halls and auction blocks, slave jails, taverns, offices, kitchens, and morgues. Hood marks the threshold of Charleston's port—which had eventually become Gadsden's Wharf, a landing dedicated solely to the trade of human flesh—in the museum's landscape by embedding a stainless steel curb at the western end of the fountain, which expands some forty yards on the east side of the promenade to the edge of the dock. Recessed into the concrete surface of the fountain and traced in shells are the silhouettes of enslaved people packed into the hold of the slave ship *Brookes*. The horrific and inhumane conditions of a slave ship's hold, with its "tight packing" of 454 people—mostly men, but also women and children—whom traders had bartered or sold into slavery, was recorded in an infamous 1787 engraving of the *Brookes* and circulated by the Plymouth chapter of the Society for Effecting the Abolition of the Slave Trade. It's a rare documentation of the spaces where slave traders stole the lives of people from different tribal groups, transforming them into chattel for sale and profit.

View west toward the city of Charleston through the Dune Garden and tabby ground plane.

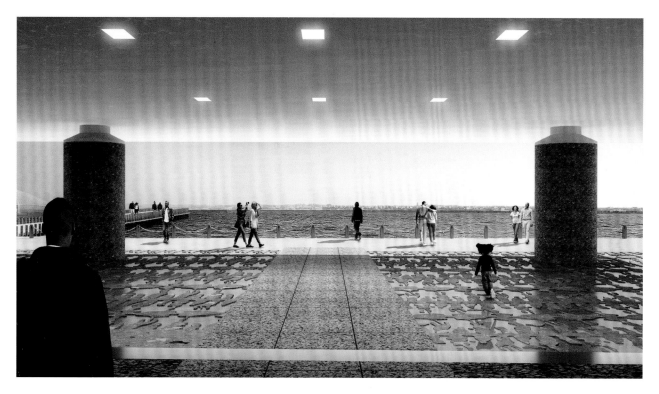

Above: Tide Tribute Fountain at low tide.

Right: The African Origins Garden honors the botanical diaspora of African Americans through its carefully selected plantings such as the South African Tree Fern.

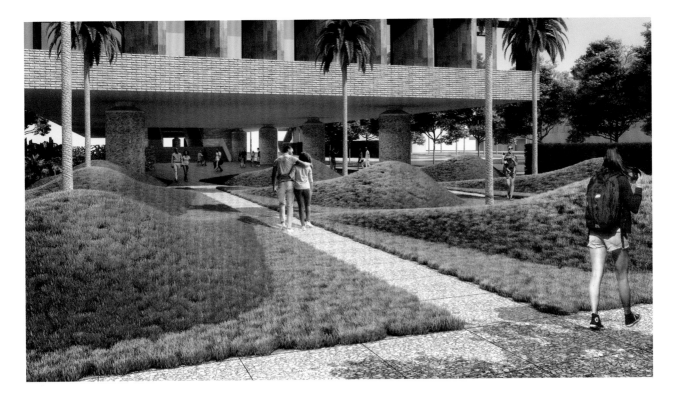

The slave ship continued the violence initiated on the African continent that dehumanized the African into the American Negro, primed for work in the fields of cane, for labor in manufactures of indigo, and for erecting the architecture of cities like Charleston. In the claustrophobic confines of the hold, slave traders chained people to strangers, paraded them on deck for exercise, and fed them strange foods to keep them alive for market. People were wracked with fear of retribution from strange men with pink skin who spoke a different language. Sickness and death stalked everyone in the hold during the months-long Middle Passage crossing. Some Africans refused life in bondage and sought freedom in death by jumping overboard in the cold waters of the Atlantic. Now, in the museum's garden, the ebb and flow of the fountain, calibrated to the tide, hides and exposes the *Brookes* plan. As the public walks by and through the fountain, they will either see a sheet of water reflecting the sky or the slow exposure of enslaved bodies—a poignant reminder of lives lost, of cultures lost, of languages lost, of families lost, of memories lost.

On the north side of the site, as visitors arrive at the museum from the city, Hood's design leads them along a journey through the African Garden,

Procession to the entrance of the International African American Museum through the Dune Garden.

the Stele Garden, the Formal Garden, and, finally, the Lowcountry Garden. Silver date palms welcome visitors and trace a geography of colonial transplantations that brought people, plants, and cultures from Africa to the Caribbean and the United States. In the African Garden, visitors encounter plants from Africa as well as local species. Here, the public experiences an ethnobotanical account of the different knowledge bases and cultural practices that Africans brought to America. The textures, colors, and fragrances of plants that thrive across the African continent, in places where peoples were captured and enslaved, tell the origin stories of these peoples—umbrella plants from Madagascar, *Agapanthus africanus* "Queen Anne" from South Africa, hibiscus from Tanzania and Kenya, and the delicate African iris, found from Ethiopia to South Africa.

In the area designed as the Stele Garden, Hood Design Studio planted stone as the medium of remembrance. The surfaces of the stelae are inscribed with African languages that were also transplanted, hybridized with languages of other cultures—European and Indigenous. Language bears the traces of where enslaved peoples came from. The echoes of these histories can be found in the dialects of the Gullah communities who populated the coastal Sea Islands of the Carolinas, Georgia, and Florida. Their connection to various parts of the African continent from where slave traders captured and enslaved their ancestors resonates in cultural practices, as well as in the local Gullah dialect. The traditions of making baskets from sweetgrass merged western African aesthetic practices and forms with materials found in the Americas. During slavery and after, people used those baskets to winnow rice, removing the husk by tossing the kernels into the air and swirling them over the surface of the basket.

From sweetgrass plantings to serpentine paths, Hood's African Ancestors Memorial Garden offers an homage to that history. And the Lowcountry Garden, with its pod-shaped planters filled with common rushes, evokes the region's marshlands, where people once harvested rice. (The Lowcountry's European colonists eagerly sought enslaved peoples who were knowledgeable about wetland rice cultivation.) Hood also recognizes the importance of that marshy ecology, whose insects, animals, and birds are also attracted to the museum's landscape. Novelist, writer, and theorist Sylvia Wynter writes that like the Lowcountry of South Carolina, the Caribbean was planted with

enslaved peoples to produce singular crops like rice, sugarcane, indigo, to-
bacco, and cotton for markets in the metropoles and colonies. But on those
largely monocultural plantations, "African peasants" tended their own plots,
continuing traditional rituals that honored the "Earth Goddess" for suste-
nance, and that "around the growing of the yam, of food for survival, [they]
created on the plot a folk culture—a basis of a social order—in three hundred
years." The series of gardens at the International African American Museum
acknowledges the landscape as the origin of Black culture in the Americas.

Scholar Christina Sharpe asks a difficult question about our current com-
memorative practices. "If museums and memorials materialize a kind of repa-
ration (repair) and enact their own pedagogies as they position visitors to have
a particular experience or set of experiences about an event that is seen to be
past," she writes, "how does one memorialize chattel slavery and its afterlives,
which are unfolding still?" The African Ancestors Memorial Garden takes this
charge by crafting spaces that highlight the cultural practices of an American
Black culture. Throughout the landscape, the use of tabby—a cement of lime
and ground seashells often made by enslaved peoples in tropical climates—
reminds visitors of the labor and knowledge Black peoples have contributed
to building the United States. The fluctuation of the fountain's water level
acknowledges those lives unaccounted for in the depths of the ocean and the
lives stolen by the slave trade. The wake of the slave ship still haunts the lives
of Black peoples descended from the millions enslaved through the unrelent-
ing violence of police and white vigilantism, the lack of decent and affordable
housing, the polluted air and water in Black neighborhoods, and the under-
funded educational and health care systems in the United States. By drawing
on the cycles of growth and the turn of the tide, Hood's landscape crafts a
different rhythm of time, one that works against the forgetting that monu-
ments and memorials often enact, to achieve a cadence in which, as poet M.
NourbeSe Philip describes, a "repetition drives the event and the memory
simultaneously, becoming a haunting, becoming spectral in its nature."

NaNHISTORY AND MEMORY AT THE IAAM

In the Spirit of the Garden: A Reflection on Nature, Culture, and Reconciliation

by Paul Peters

Charleston

Charleston is a utopian idea of colonial success. It is a carefully crafted narrative through the curation of architecture and public space that showcases the American success story of the South, and, by extension, the world. It boasts in full brilliance the accomplishments of settlement, colonialism, trade, agriculture, and war. The constructed city's air of timelessness—passed on through materials, semiotics and craftmanship—allows us to see America in its own reflection as it displays beauty, triumph, integrity, and liberty.

The reflection, however, is unreal. Within the landscape lies its heterotopias: Sullivan's Island, Middleton Place, Philips, Mother Emanuel Church, and the International African American Museum, among others. Within the city limits, these differences are concealed, but they reveal themselves to those who look closely. For Foucault, utopias were unreal places, representing an inverted society, an idealized version of perfection. In contrast, heterotopias are real places, embodying difference and contrast, which allow us to perceive the true meaning of a place. Foucault argued for a society composed of numerous heterotopias to escape state repression.

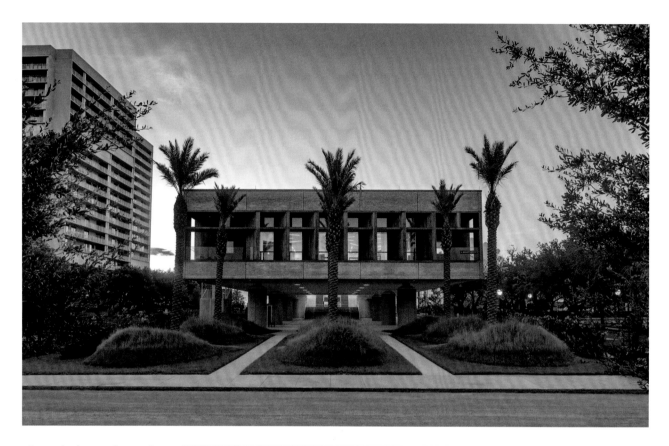

Above: The dunes reference the ecological history of Sullivan's Island and call reference to the sacred ground.

Right: The African Ancestors Garden's design draws inspiration from the local Low-country landscape and the broader African Diaspora.

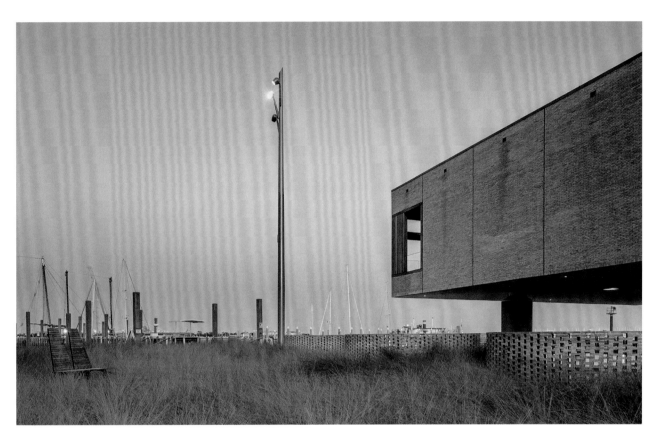

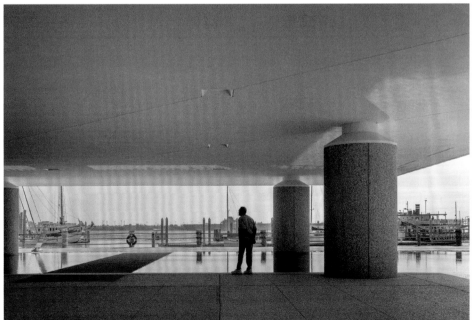

Above: Sweetgrass is integral to the time-honored African American tradition of basket weaving, an artform introduced to the U.S. by enslaved Africans.

Left: A museum patron stands stares out to Gadsden's Wharf, a pivotal entry point for nearly half of enslaved Africans brought to America.

Exploring Charleston compels us to confront its diverse and layered history, moving beyond the dominant narrative to unearth deeper and durable truths. By acknowledging the existence of these heterotopias and embracing their inherent differences, we can work toward creating a more inclusive and authentic representation of our shared history.

During the design team's initial visits to Charleston, I would wander through the streets and marvel at the city's architectural beauty, ornate gardens, and the palpable history that seemed to permeate every corner. The colonial narrative was evident in the landscape, a testament to the accomplishments of settlement, agriculture, and trade. Yet, Charleston's history is not solely Eurocentric; beneath the surface lies a rich, diverse cultural tapestry that has left an indelible mark on the land and its people. Beneath this picturesque facade, there exists a more complex, layered history of resilience, cultural richness, and untold stories.

The Garden

The garden serves as a unique heterotopic space, seamlessly uniting nature and culture while offering an opportunity for personal and societal evolution. In 1845, Ezra Watson astutely observed that those who cultivate gardens simultaneously cultivate their own nature. This idea highlights the transformative power of gardens, both on the land and on the individuals who tend to them. The act of gardening enables us to connect with the earth, fostering appreciation for the natural world and encouraging personal growth.

However, despite the universality of gardening, cultural preferences and biases remain. American gardening, for instance, continues to be dominated by Anglophilia, reflecting the cultural history that has shaped the nation. By examining the gardens we create, we gain insights into the values, beliefs, and traditions that inform our collective understanding of nature. Cultivating our nature, as Watson suggested, is a crucial aspect of our relationship with the environment, and it is through culture that we learn to observe, remember, and share our experiences, allowing us to develop a deeper understanding of our place within the natural world.

Wendell Berry, the American author and environmental activist, once said, "Culture teaches us to restrain ourselves," emphasizing the importance of our relationship with the environment in shaping our values and beliefs.

Gardens serve as spaces where we can examine the intersection of nature and culture, and gain insights into our collective understanding of the world around us.

Throughout history, gardens have been expressions of cultural values, ideologies, and aspirations, carrying the imprint of their societies and reflecting the social, political, and economic conditions of their time. Nature may indeed be an indispensable source of guidance for a garden ethic, but culture holds equal importance. As Berry astutely observed, it is through culture, not nature, that we acquire the ability to observe and remember, learn from our errors, and share our collective experiences.

The African Ancestors Garden

Charleston, with its deep colonial roots, serves as an ideal setting for contemplating the role of gardens as a bridge between nature and culture. The International African American Museum exemplifies an endeavor that aims to carve out an authentic Black space by unearthing the varied and rich cultural history hidden beneath Charleston's colonial veneer. It is a testament to the potential of creating distinctively Black spaces that not only celebrate African American history but also foster dialogue and provide a platform for the multitude of voices that have shaped society.

At the edge of the Cooper River, the African Ancestors Garden, alongside the museum building, asserts itself as a deliberate pause in Charleston's historical narrative, a narrative long dominated by the echoes of colonialism. Here, in this space, the garden seeks not only to interrupt that narrative but to weave a new story, one rooted in truth—the truth of Gadsden's Wharf, a truth that begins a journey toward reconciliation within this country.

Crafted as a tapestry that lies at the river's edge, the garden's design is punctuated by its archaeological memory, while the building hovers above. To the north, an expansive field of sweetgrass nods to traditional basket weaving crafts. This field is bordered by a perforated, serpentine brick wall that meanders its way through the field delineating a series of gardens. Along the wall a series of gardens provide spaces of contemplation, offering visitors a moment of respite in the shade of the site's history. The gardens symbolize the Lowcountry landscape and the African Diaspora. Among the gardens a set of sculptural planters allows visitors to sit among wetland reeds as water

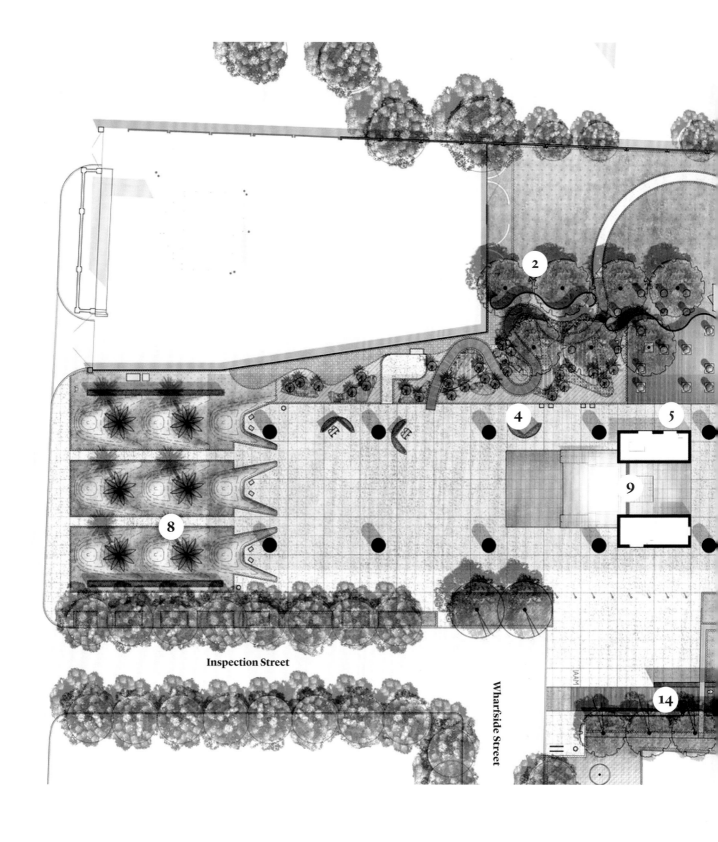

Inspection Street

Wharfside Street

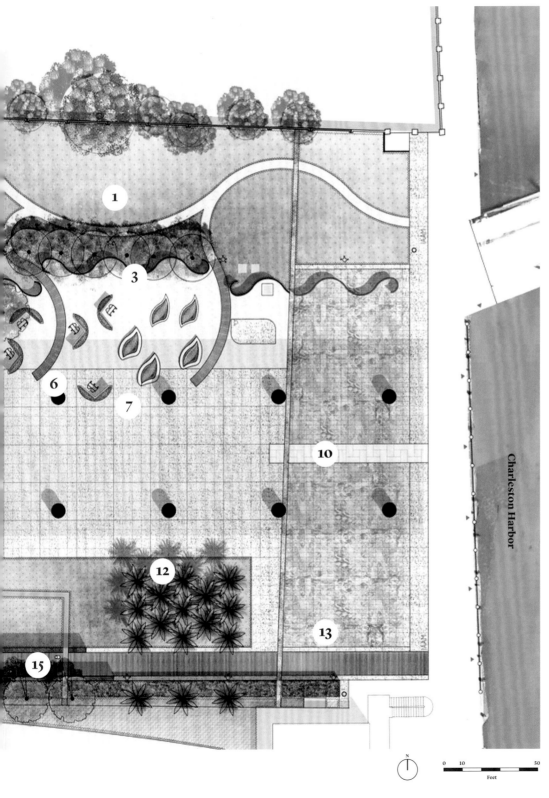

The African Ancestors Garden
1. Sweetgrass Field
2. Oak Grove
3. Serpentine Wall
4. African Origins Garden
5. Stele Garden
6. Badge Garden
7. Lowcountry Garden
8. Dune Garden
9. Entry Atrium
10. Atlantic Passage
11. Old Storehouse
12. Palm Grove
13. Tide Tribute Fountain
14. Storehouse Walk
15. Kneeling Figures

Charleston Harbor

N

0 10 50
Feet

The plantings in the Lowcountry Garden, commonly seen across the gardens of the South, all originate from various regions of Africa, symbolically illustrating how plant migration echoes the historical trade and movement of people.

infiltrates and heals the site. Stone columns emerge from the ground in the Stele Garden, as symbols of commemoration, with wood decking at their feet catching shadows. The African Origins Garden features plants indigenous to Africa that have become ubiquitous and synonymous with the American garden in the South.

In stark contrast to the respite of the gardens, the southern boardwalk compresses space, guiding visitors from the city to the river, flanked by thick granite walls. Here, as the visitor passes through the archaeological site of the old storehouse, their reflection is cast amongst kneeling figures emerging from the ground—confronting one with past and present.

At the river's edge, with the building docked above, the reflecting pool ebbs and flows. Along the western edge of the water Gadsden's Wharf is marked with a stainless-steel band. From here, one can look across the water to Sullivan's Island. The water flows across the pool, and the surface ripples in the wind and reflects the sky above. As the water recedes, a series of figures emerges as the water pools within their bodies. The relief of the pool's

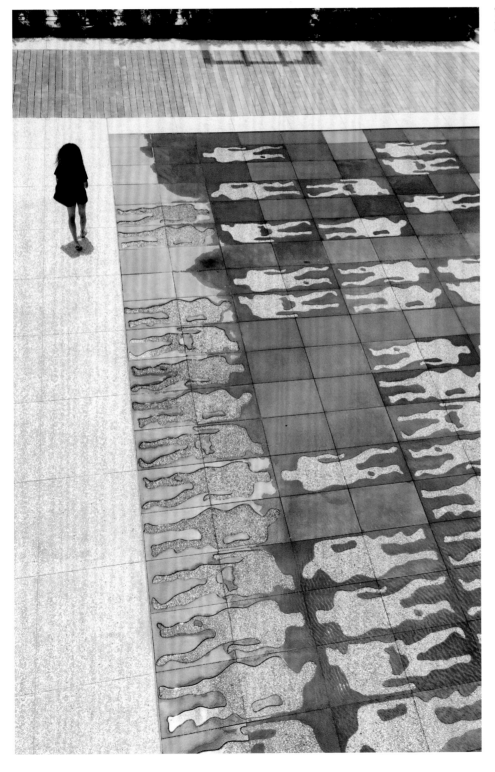

The Tide Tribute Fountain at low tide.

Above: A woman seeks solitary respite in the Dune Garden.

Right: Embrace at low tide of the Tide Tribute Fountain.

base is composed of a serialized composition referencing figures depicted in the Brookes map, an eighteenth-century diagram that depicts how enslaved people were inhumanely packed into a ship for their transatlantic journey. Throughout the day, the water reveals and conceals those figures.

At the International African American Museum, the landscape itself becomes a medium for storytelling, where the echoes of Gadsden's Wharf are woven into the fabric of the American garden, and where the sacred and the historical converge to inspire reflection, understanding, and, ultimately, healing.

In the African Ancestors Garden, we encounter a confluence of nature, culture, history, and truth, and an invitation to reconcile our worldviews. The IAAM exemplifies the potential of landscapes to embrace diversity by grounding garden designs in the authentic narratives of the land. Challenging traditional landscape semiotics allows us to question and redefine Eurocentric historical narratives prevalent in our public spaces.

The IAAM encourages us to reimagine Charleston and similar environments through a lens of heterotopias. This approach can transform our public spaces into reflections of our collective history's richness, celebrating the diversity that defines us. Thus, we not only honor the myriad voices of our shared history but also forge a path toward a future enriched by a deep appreciation of the interconnection between nature and culture.

In Charleston, as elsewhere, gardens symbolize our collective human experience as spaces for exploring the interplay between nature and culture, and how our histories and values shape our worldviews. Cultivating such spaces nurtures a deeper connection to our environment and the diverse narratives that shape our shared existence.

Facing Africa, Facing America

*Matteo Milani, Guy Nordenson,
and Walter Hood, moderated by
Grace Mitchell Tada*

How did you all come to work together?

GUY NORDENSON: Harry Cobb was very deliberate about the people with whom he wanted to work. Conceptually, Harry thought there was an opportunity to integrate the engineering and the architecture, but the truth is, for Harry, that was never really a high priority. The quality of feeling and the friendship he felt with everyone on the team were more important than technical expertise. This was a very special project for him. I feel like he just wanted to have old colleagues around—people he was at ease with and could brainstorm with.

WALTER HOOD: Harry called me—I didn't even know Harry then—and he said, "Walter, this is Harry Cobb. I'm doing this project in Charleston; it's a very significant project. It's all about structure and landscape. I have Guy, and I need you." That's as much as he said. And then he talked about how important the project was, and trying to build the team, a set of relationships. For Harry, the project was less about a kind of formal expression, because he didn't want to do a rhetorical building. It was about the ground and about the place. I had never heard that from an architect before. It was basically saying, "I'm going to set this thing up for you guys to operate in." And it was a very giving way to think about a team.

NORDENSON: That's an important point about Harry. One of the lessons I learned from him—there were a couple projects that we did together after 9/11—was the extraordinary ability he had as an architect to step back and make room for others to play. In this sense he was like a great jazz musician who knows how to make space for his partners to improvise. Harry would, with tact and self-confidence, make a space for what you wanted or could do. That was a gift—both in the possibility of the kind of relationships one can have among designers, but also at a personal level, just feeling like this man, whom I admired so much, had the confidence to let us play our instruments freely.

HOOD: That's a great way to think about Harry. Early in the project, the memorial aspect was proposed as part of the building. There was an oculus. At a certain point, the discussion came up for my studio to do the memorial. And I was—how can I say? It was kind of weird. I didn't know how to approach Harry. Because I knew there was already this idea. And I remember Harry saying, "Oh, that was just a placeholder."

And he said it in a way that was very gracious: "Oh, that's just a place-holder; you go ahead and do your thing."

And we went through this process. Not once did Harry push to hold on to those ideas. He allowed new ideas to develop. I don't think I've ever experienced that with another architect, where they developed something and didn't hold on to it. Then, when the idea emerged, he had this way of bringing that to the locus of the project. I remember him saying, "This is like the Atlantic Crossing, coming into the building." It was a powerful turning point for me because my team and I felt encouraged by Harry to push to make this thing come true.

How did you start to meld the architectural and landscape elements?

MATTEO MILANI: That moment was one of the key design discussions and decisions for this project. From the beginning, Harry wanted to make clear that something had happened here, at this precise point, because it was of the essence of the site, of the history of the site, and of the museum. He had a lot of critics. Even the exhibit designers were not confident about having the memorial in one single point, and "memorial" was an ambiguous terminology for many people, and so on—he didn't care, because he knew the concept would evolve over time.

He encouraged these more open processes to take place and offered guidance. He was totally confident, because the purpose of those early sketches was just to have a placeholder—there for something to happen. During those three days [of the charette], instead of making that circular shape [of the oculus] a destination, as it was as a placeholder, it became more like a threshold, an experience, a passage. It was wonderful to hear all these different people have their own vision, and I like the way Harry encouraged all voices to come up with different themes. And then came the resolution: that circular-shaped moment became a threshold—with the reflecting pool, its hard and soft edges, the passage.

Also, the idea of the memorial evolved and became the whole African Ancestors Garden; in a way it was spread into different landscape elements. It became more an archipelago of different events.

HOOD: And I love that you guys developed the section. And I think you drew it, right, Matteo? And the axon of the reflecting pool. Again, this ability of Harry's—I love the idea of him as the jazz ensemble conductor—to move things in a certain way, and then when things settle, take it another way. Harry was really good at that.

Like the columns—the way he talked about these columns, these two-meter-wide columns that came to a point. This notion that the column is not just a tectonic piece, but is part of the experience. I was blown away listening to Harry talk about a column.

NORDENSON: Some of that was conversation about the proportions of the space underneath the building. You know, thinking about Oscar Niemeyer's Great Canopy at Ibirapuera Park in São Paulo—the key is how you calibrate the width and height of that space in relation to the light and climate. In a place like São Paulo, you want the shade, and the same is true in Charleston. To me, the way those columns evolved, and the way that they hold the ceiling at that height, gives it a sense of levitation that increases your feeling of spaciousness. It was all part of this discussion among everyone about how to proportion that space—and how it related to the site along the sides as well, which was really important.

Could you talk about some of the other challenges—in addition to the hot climate, the site is vulnerable to hurricanes, sea level rise, etc.—and how they affected the design?

NORDENSON: The building section is a direct expression of the future of hurricanes, flooding, and sea level rise. The building is there to stay. It's built to last through storms and earthquakes, too, as Charleston also has a history of earthquakes. There's a toughness embedded in the form. To me, that's a big part of the message.

HOOD: So, is there a huge mat slab holding things up?

NORDENSON: No, the foundation underground is a network of grade beams and pile caps resting on bundles of piles that go deep down into the mud. It's like a pier—a wharf, of course. It's perched, and even if the ice caps melt, it will remain.

MILANI I remember this discussion with both of you and Harry. Guy, you were discussing with Harry the column shapes and the shape of the soffit. Harry debated the direction to take, torn about the feeling below this space. He reminded me of a metaphor about a cat with two legs for running and two for breaking. He first considered a hypostyle, then decided the space was most about the proportions: the very wide span between the columns and the calmness of that proportion. And the cantilevers giving the feeling of the levitation. If you remember, we found the balance together through many iterations.

NORDENSON: I came up with a lot of shapes and ideas for the columns that are in a shoebox that I keep. In the end, simple was best.

MILANI We still have it, too! I like that of Harry: he never stopped meditating about design options. He always wanted to see more, to see if there was another perspective, a new point of view to consider. And then he would come back to the original idea, but he was always so curious to see the whole evolution of design ideas.

The same was true for the reflecting pool. Walter, if you remember, all this started a long time ago with Harry.... We went together to Mexico City for business, and we visited Luis Barragán's San Cristobal Stables, with that beautiful pool. Harry became obsessed with the soft edge of that pool, and he thought the same solution for our water feature in Charleston could symbolize the infinity of the ocean. Visitors could understand the deep meaning of crossing the IAAM pool by stepping on the Gadsden's Wharf line. He was always building up the concept step-by-step. And then we came up with the axon, and you, Walter, liked the idea and developed it further.

I like how every single design component was so deeply discussed in a collective manner and always with reference to other built design projects. Harry had in mind two projects since the beginning. One was a Louis Kahn project, never built: Palazzo dei Congressi, in Venice, the suspended building. And then Mario Fiorentino's Fosse Ardeatine Mausoleum in Rome. Both were in his mind, because of their gravitas.

HOOD: When did the columns become tabby? The tabby came later, right?

MILANI Initially the concrete columns were five feet in diameter, and we were struggling to decide on their surface finish. Later, when you started working with the tabby for the exterior flooring, Harry decided to match that finish, so the columns would appear to emerge from the ground, rather than sit on the ground—again, highlighting the concept of levitation. The tabby came from you.

NORDENSON: The columns are thick also so they can withstand the impact of floating debris in a flood, giving the base the strength and resilience to deal with anything slamming into it.

You mentioned Harry didn't want to build a rhetorical building. Could you talk about that?

HOOD: Harry didn't want to design a rhetorical building, a building that was a metaphor or that was allegorical. I've heard from different people that they don't like the building. I think it's because of that. And I wonder what you think, Matteo, or how Harry thought about these issues, and why he chose that stance.

I remember our competition with Diller Scofidio + Renfro for the National Museum of African American History and Culture (NMAAHC) in DC. When I saw David Adjaye's project, I was like, "They won." I mean, I saw it going through the room. And it was a crown. It's interesting that the expectation, I think for a lot of museums—whether the National Museum of the American Indian in DC that is a big circle or other institutions that deal with race and culture—there's an expectation that they have to somehow *look* like it versus being a great piece of architecture. That's always been my critique. But it'd be interesting to hear if Harry ever had that larger conversation, Matteo.

MILANI: I don't think we did explicitly talk much about this, but I had the feeling that the two museum conditions are so different. On the National Mall, you are on the right stage for that type of move. And you also, with a design move, must symbolize something that is not there. In that sense, I think the autonomous design and the symbol are welcome in that setting, because all the buildings along the Mall are within a monumentalized system. There is a certain expectation for the design to bring more than what is there—to symbolize, to express something in a different scale.

For our work in Charleston, the difference is a site that speaks of the history. There is enough happening on the site announced by the landscape design. So Harry decided to have a much simpler building to let the landscape and the site speak. The difference between the two is

the stage where they're telling the story. Harry said the challenge was to build on the site without occupying it. He wanted to leave the site intact because it is a hallowed ground, a sacred ground.

NORDENSON: You're right, Matteo. But I think that the NMAAHC was present in Harry's mind, because he had done that competition. There was pressure there to create a form that was as symbolic and autonomous as Gordon Bunshaft's circular Hirshhorn Museum. But it isn't hallowed ground in the same way as in Charleston. It is a different site and a different kind of building, for sure. In some ways, speaking as the engineer of both buildings, Harry's building is comparatively calmer and simpler.

Between the opening of the two museums, there have been a lot of changes in our national conversation about race. Can you talk about what it means for the museum to come to life in 2023?

NORDENSON: These two museums will bookend the Trump administration. The NMAAHC opened in Washington weeks before the 2016 election. It was a moment, at least for me, that felt exhilarating but also peaceful, with George and Laura Bush warmly welcomed by Michelle and President Obama, and Justice John Roberts speaking eloquently about the bad and the good history of the Supreme Court and civil rights. There was a feeling there that this was a moment for the American family. And then we got Trump, and everything that has come since.

HOOD: It's interesting that you say that, because, for me, it's been a return to the South, by Harry bringing me on the team. I had completely disengaged with my Southern roots. Going back and spending time in Charleston made me recover a lot of that. The museum, in a way, gave me a way to deal with a lot of shit that I hadn't been dealing with by having conversations in Charleston.

And, more recently, to have the Calhoun statue come down has been really, really transformative. It brought a different way of thinking about this experience with the building, which might allow for Charleston to actually have a reckoning of all the white supremacist *stuff* that's been allowed to just sit there in this passive way.

I was taken by Michael Kimmelman. When he came down for the *New York Times* to write about the museum, he asked Mayor Riley—he didn't say anything about the building—his first question was: "You were mayor for more than thirty years. How is it possible for these monuments to still exist?" Kimmelman was immediately drawn to the city's context and its relationship with its past.

I wish Harry were around to see the context in which this building is going to open. I think we are in a moment that is transformative in a different way than when the NMAAHC opened in DC. This project has the power to speak for something that we haven't been able to talk about in this context. Those three days, Matteo, that we hung out—we talked about some really deep subjects. The tour ended at Mother Emanuel, then we worked through the various design concepts. Many of the more polarizing design ideas sifted down. Hopefully they can rise back up now. Again, the Calhoun removal is huge. I thought that would never come down.

NORDENSON: Of course, Joe Riley shares many of the same qualities of equanimity, wisdom, generosity, and resilience that we saw in Harry.

HOOD: He stayed with it for so long. And, particularly, with Harry and Joe, two older white gentlemen, leading this project for a museum for people of color—that's why I brought up the rhetorical aspect. I do think a lot of the critique is coming from Black architects, because, to be blunt, there is some animosity for Harry designing this building. I know that's something Harry thought about; I know he was conscious of that.

The Tide Tribute Fountain at high tide. The visibility and reflections of the human forms change as light and water interact over the course of a day.

NORDENSON: Harry, coming from an old WASP Boston family, was quite aware and moved, I think, by the difficult parallel of Plymouth Rock and Gadsden's Wharf and the complexity of his position. I am also now helping with the Studio Museum in Harlem and the Emanuel Nine Memorial, and while I am grateful to have the opportunities, I'd gladly give way to the Black voices we need in these roles. Yet, Harry nonetheless served as a model for me, leading the project with grace in spite of cultural differences.

HOOD: I've never met an architect like Harry Cobb. For me, Harry embodies this kind of old-school quality of—*he's an architect*. There's a kind of gravitas with that. He was always going to make a great building. When people critiqued it, I was like, "It's going to be a good building." It's not just the gesture—it's actually *a good building*. That's what we're talking about—being able to assemble a team and also knowing when to push and when to pull back. But to also want to make something *great*. Not just something to look at, but something that is going to stand the test of time.

MILANI: And also—the attention to the public space. Since the beginning, he wanted this ground floor to be a space for performance, for public life, for the community—the African American community—making the public space the protagonist of the design. This is why we have fought to have no fencing around it. We want people coming from any direction. This attitude is not common among architects. They want to overcontrol what is going to happen in their building. Instead, Harry said, "I want to set the stage for this to happen in the future."

Did this come from Harry's own vision, or from conversations with the Charleston community?

Harry Cobb demonstrating to his granddaughter Julia Speed, the model of the International African American Museum at the American Academy of Arts and Letters Ceremonial Exhibition, 2017.

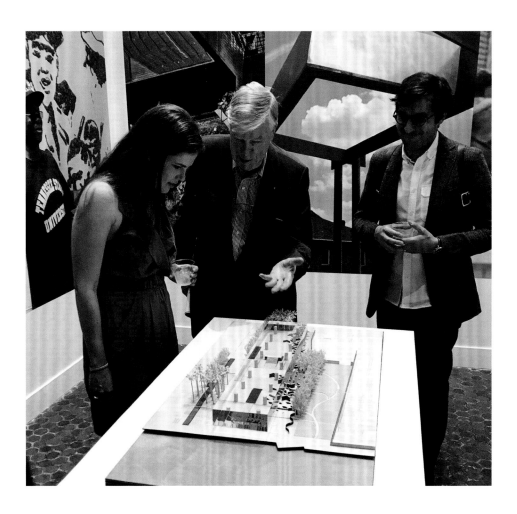

MILANI: I think it came from his own vision. It was his way to deal with those issues of his identity that have been touched upon by Guy and Walter.

NORDENSON: The phrase "keeping the space open" is key. That encapsulates what it's all about.

MILANI: No gates, no fencing, because then more people will be engaged with this site, more people will gather here, and more of the site will be safe and alive.

HOOD: It works like the other sites in Charleston. The cemeteries are open—the city is basically this porous public space—and to all of a sudden say "This space can't be like the other spaces" is marginalizing. We must have this openness and porosity—so the ghosts can be there. You know, they lead the ghost tours in other places in the city; they'll be leading the ghost tours here, I hope—of a different kind. And the lighting scheme that we came up with is powerful, so the entire underbelly of the building will just glow.

You know, slaves couldn't be out at night. Charleston had this rule that a bell would go off, and all the slaves would have to scurry. Charleston was described as the Blackest city by day and the whitest city by night. There's something really powerful about talking about these kinds of spaces—not just in the light of day, but at night. I don't think there's any other space in the city where you could have this conversation.

What were your experiences with the community during the design process?

MILANI: This project went through different public processes to get the design approved. There was an architectural review open to the public, and there were community meetings where we presented the design to

the community. They made comments; there was some concern. It was a very modern building by Charleston standards. But everything got approved.

HOOD: The way Harry talked about the building sitting up, this space being open, giving credence to the hallowed ground—there were very few people pushing back. Overall, those meetings were not as challenging as I thought they would be.

During the memorial charettes, some people were like, "We can't have that." I had a scheme where I wanted to put figures on the soffit, just hanging everywhere. It was too much. But for us, those meetings were less about the design, and much more about trying to spark a conversation about slavery. You'd be surprised, in these public meetings, people talk *around* this whole idea. We were trying to get people to actually talk about the reality of this place. I think we were able to with the fountain piece and the *Brookes* map—talking about the body in space at that moment. There were some concerns, particularly from elderly African American women, that by putting bodies on the ground, people would be stepping on them. So we put in a walkway to traverse the fountain. I had never led a process in this way, dealing with these sticky issues. Touring Middleton Plantation, going through Gullah communities, and then ending up at Mother Emanuel—I think it gave people on the memorial committee a larger view of what the place could be.

So people wouldn't talk about slavery in the community meetings. How do you think the IAAM could change this?

HOOD: I think the educational component makes it different. And I think the building works in two different ways. One is with the Atlantic Crossing. The building is elevated, looking back toward the Atlantic. But the other piece of the building is the side facing the city. That's

where you can trace your descendants. To me, that's the difference between the museums in Charleston and DC. The one in DC is a collection of a lot of things across the nation. Here, it's about this place, Charleston, and the diaspora that moved through this space. It's a space that will always be becoming. This space is about looking forward. Where people can come in and engage their heritage—look back but also look forward.

NORDENSON: Maybe this is too optimistic, but it seems there is an opportunity for Charleston to be transformed by this project and by what they'll do at Mother Emanuel into a different kind of community that really embodies that history, that moves us into a better future. I'd like to hope that. This is an opportunity for the city of Charleston to become a different kind of symbol for the country.

HOOD: And in a way, through the genealogy, it's a way to validate the existence of the other. We spent the twentieth century diminishing the existence of the other. The museum offers something much more progressive in how we think of identity. You're going to find the diaspora—people are going to come and see that they're mixed with a lot of different people. It's not this singularity that people like to imagine.

NORDENSON: It faces to Africa, and it faces to America.

MILANI: The shape of the building itself is conceptually a line in tension between Charleston and the ocean, between Charleston and Africa, America and Africa. This speaks horizontally, making this what I hope is a bridge—a connection, between the United States and Africa, between Charleston and the water.

Overleaf: The eastern facade of the International African American Museum overlooking Charleston Harbor at twilight. The east and west ends of the building face the water and the city, and are enclosed in clear glass shaded by angled wooden louvers.

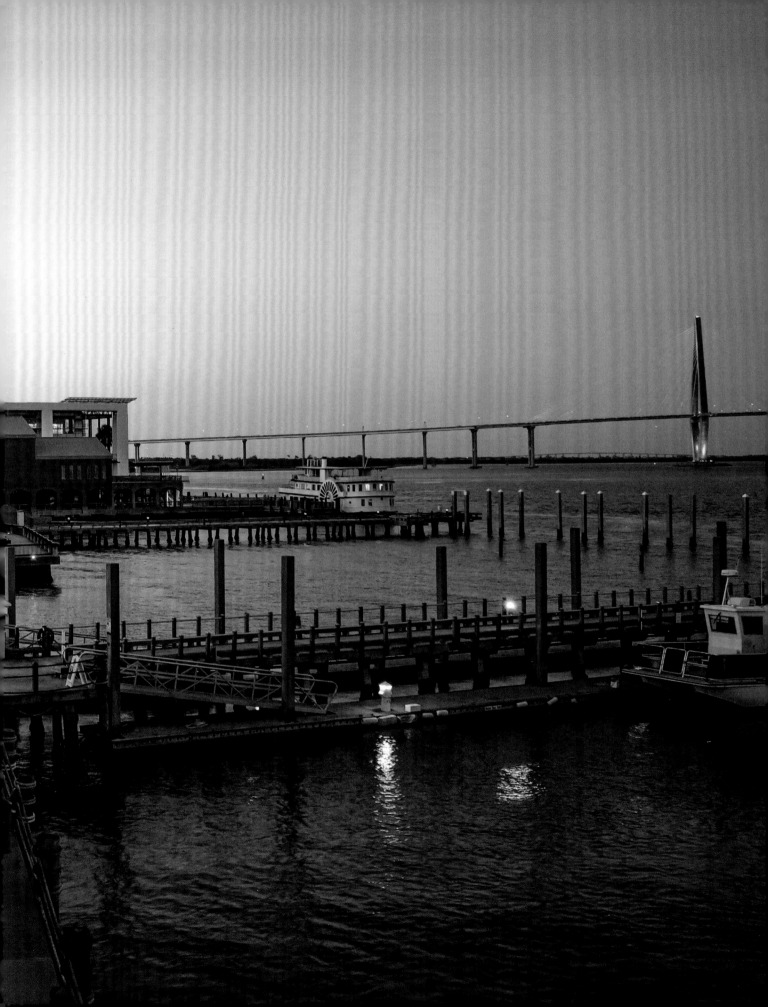

EPILOGUE

Epilogue
Walter Hood

Most of my career I have viewed nostalgia's presence in design as a weakness. Seen narrowly through its restorative meaning, the replication of history or of artifact never interested me. Particularly, what was preserved and monumentalized had nothing to do with me. Coming of age in the South, there were many reminders of the past around me. Remembrance of the Confederate soldier was a common installation at court buildings, county courthouses, and public squares. The buildings' neoclassical aesthetic and stature monumentalized the past; and, for African Americans, it indicated control and domination.

Years later, I encountered J. B. Jackson's writing on the county courthouse: "This courthouse place of assembly, as a kind of city, had its social hierarchy too; those who could not vote and those who could; those who held office and those who did not. It had its group of the rich and powerful, and its majority of poor and ignorant." And this evocation of hierarchy still resonates for so many motivated by nostalgia—as somewhere to return to, something to restore. When I moved across the Mason-Dixon Line from where I grew up in North Carolina to work for the National Park Service in Washington, DC, I encountered two projects that remained dormant in my consciousness for years to come: the Frederick Douglass House and Harpers Ferry.

Both presented the problem associated with restoration: the phenomenological aspect of memory is overlooked and ignored. Instead, the artifacts—the house and a town, respectively—are preserved and restored around a single time and place. Nothing at either site attempts to suggest that many other experiences occurred in these places, or that these experiences offer different, multidimensional views of the past.

And now, over the past few years, I've grown nostalgic. The longing I felt was not like most who longed to return to pre-pandemic "normal." During the Covid-19 shutdown I, like others in the world, had a lot of time to think. As I witnessed a world breaking down and reckoning with race and justice issues, I thought of my childhood, particularly my Black and segregated past. I didn't even know about segregation as a kid; I lived in a Black world. Not until desegregation did I see there was this other world.

During the pandemic, I began longing for that space I grew up in—not the larger segregated space my parents had to navigate, but the space in which they allowed me to develop. My neighbors were doctors, librarians, teachers, insurance agents, preachers, stay-at-home moms, garbage collectors, cooks. There were fish fry every week in the neighborhood, we walked everywhere, we moved freely.

What made many of these experiences incredible was the "terrain vague" that we inhabited and played within. Some families did not fence their yards, allowing the neighborhood children to play unconstrained. There were electrical line rights-of-way, sewer rights-of-way, and unburied creeks, all forming linear spaces we moved through. There were overgrown landscapes with briars and blackberries, and wood lots adjacent to the neighborhood elementary schools. The Halloween scene from Harper Lee's *To Kill a Mockingbird* in which Scout and Jim are accosted in the woods has always resonated with my own experiences. Although there were static elements like a park and recreation center and school ballfields, the landscape itself remained in a dynamic state full of possibilities.

This nostalgia I yearn for today is not restorative but reflective. I want to go there, but I don't want to recreate it. I want to draw on its memory, and I want to give that memory power for a future. I want to create and experience spaces of Black joy. And I want to create and experience spaces that are also full of Black sorrow.

In *The Future of Nostalgia*, Svetlana Boym writes of two types of nostalgia, restorative and reflective. Reflective nostalgia gives shape and meaning to longing. What might these spaces look and feel like? This idea suggests spaces need to be unresolved, open to multiple interpretations. She states that restorative nostalgia gives you reconstructive monuments of the past, while reflective nostalgia lingers on ruins, the patina of time and history, in the dreams of another place and another time. Reflective is more concerned with historical and individual time—with the irrevocability of the past, with human finitude. It is concerned with new flexibility, not the reestablishment of status. Rather than recovering what is perceived as the absolute truth, it focuses on the mediation of history and the passage of time. Reflective nostalgia creates a context to return to powerful memories and to the intervals of joy. It also provides a context for the preservation of place, cherishing shattered fragments of memory and temporalizing space.

Frederick Douglass National Historic Site, administered by the National Park Service, Washington, DC.

Hood Design Studio,
Lafayette Square Park,
Oakland, California, 2002.

I encountered an example of this context twenty-five years ago at Lafayette Square Park in Oakland, California. Unbeknownst to me while we designed it, I was nostalgic for a particular time—a time when public space could point to class issues, when its design was less about race and more about the community. Created in a reflective manner, our design attempted to meld a collection of memories within the typological investigation of the square. We harnessed the classical composition of the square and utilized the golden mean as the framework for the diverse collective elements. This decision reinforces the square's formal expression, a cross-axial set of walkways stretching from corner to corner. The corners in the final design remained spatially open, evoking the memory of this pattern.

Lafayette Square Park is a meditation on history. Early in its day, the square featured the seventy-two-inch lens Chabot Observatory, which our design educed by creating a perfect circular hillock seventy-two feet in diameter and five feet tall at its center. The historic palm, redwood, and oaks are the only trees our design featured prominently, reinforcing their hundred-year legacy. Hood Design established restrooms and a shade structure as nods to the contributions of the Women's Club contribution in the 1950s. Barbecue smokers, horseshoe pits, and checkerboard tables create an ironic, culturally specific programmatic use—none of which relates to the new growing gentry. Yet in the past few years, the restorative nostalgic fervor for change has emerged as more people living transiently populate the space.

Irony, humor, and abstraction can help us address the longing for familiar things lost and missing in today's context. Claes Oldenburg's *Needle and Button* in New York City's Garment District comes to mind, as that district and the neighboring Meatpacking District gentrify and disappear in identity. Another example is Hank Willis Thomas's *All Power to All People,* a monumental Afro pick installed in various locations, perhaps foreign to many people except to those who have sported an Afro. Longing and critical thinking don't need to be in opposition.

Reflective nostalgia utilizes the conceptual space between identity and resemblance. Hood Design Studio's *The Shadow Catcher,* at the University of Virginia in Charlottesville, attempts to fill this space by abstracting an archeological site into a phenomenological space. The physical form of the homestead of Kitty Foster, a free Black woman, is constructed of steel and lifted in the air

to create a shadow play on the ground. The inner surface of the steel form is rendered in reflective stainless steel, creating a dualistic experience of light. When the sunlight strikes the building form, a shadow is cast on the ground, shifting throughout the day and year, never cast in the same spot. Whereas the archaeological site merely constructed a scaled datum over the ground to accurately locate and exhume findings, *Shadowcatcher* nods with nostalgia to cultural mythologies—specifically, to the "flash of the spirit," a tradition traced to the Yoruba and other cultures. By some understandings in the US South, when African Americans pass away, they need a ride to heaven. In some places, this conviction is marked by turning back the colored foil on potted plants left at burial, revealing the reflective side. When light hits the foil, there is a flash, indicating this passage to heaven. In Charlottesville, like at those burial plots, each visitor has an individual experience with the site. And likewise, a visit on a cloudy day is different than one on a sunny day.

Reflectively, I want to go back to my grandfather's wake: kids playing in the back room, adults gathered in the kitchen eating and drinking as Grandpa's body lay in the living room. We were evincing that ability to walk and chew gum; that ability to carry our history with us even though we don't want to go back. These thoughts were with me as the International African American Musem work progressed and galvanized over a two-day period in 2018 with a group of colleagues as we experienced sites within the Lowcountry. I felt the pain, *algia*, I felt as the group convened, and struggled to articulate what we have been longing for: spaces and landscapes that remember and evoke, in myriad ways. We came to understand that, yes, we can tell the story of enslavement and death at Gadsden's Wharf, but as fragmentary memories—unresolved—and more, importantly, revealing the temporality of space.

In the aftermath of the massacre at Mother Emanuel Church in Charleston in 2015, people carved sincere dedications and condolences on the trunk and limbs of the tree standing out front of the church entry. Over time they will disappear, becoming a fleeting memory of the community and national outpouring of sympathy. This temporal expression, coupled with the surviving family members' empathy and forgiveness toward the killer, set the context for broader discussions and reconciliations in Charleston.

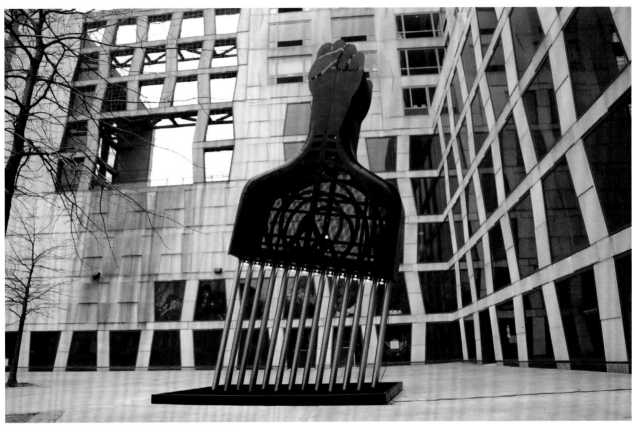

Above: Hank Willis Thomas, *All Power to the People*, East Harlem, New York, 2019.

Left: Hood Design Studio, *Shadowcatcher*, University of Virginia, Charlottesville, Virginia, 2012.

The statue of John C. Calhoun being removed from the monument in his honor in Marion Square in Charleston, South Carolina June 24, 2020.

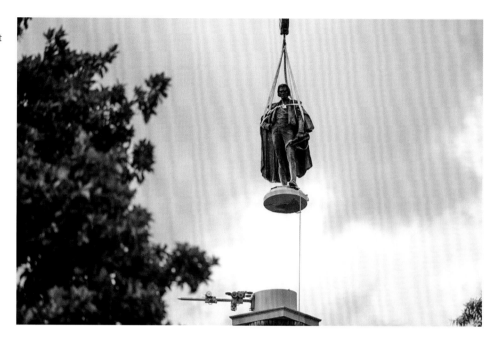

Eight years after this horrific event, the dream of a museum on the Gadsden's Wharf site materialized on that very land. Charleston chose to preserve an ostensible past, excluding a group of citizens, deciding not to represent its enslaved past in its historic core, and denying proposals featuring those who led emancipation efforts. Then, at that post-colonial moment, in 2020, many Charlestonians witnessed what they thought would never happen: the toppling of the John C. Calhoun statue in Charleston's Marion Square.

As these social and political events have unfolded during the museum's creation, the museum has helped map the city's attempts to deal with its racist past while trying to remain the "white citadel." It seems fitting to mention that the museum's first director, Michael Moore, descends from Robert Smalls, the first revolutionary. Mayor Joseph Riley—the longest-termed mayor of Charleston, a civil rights champion, and IAAM advocate—characterizes from where the city has come. But even during these times of change, the Black landscapes of Charleston and the Lowcountry are still under threat of being erased. We still have a much to do to preserve and maintain this geography. This is where we may see the mission of IAAM serve a broader role. The small hamlets and settlements facing threats of erasure through the development of wetlands and rural lands tenure now have an advocate. Gullah Geechee communities like

Walter Hood, *The Wake*, oil on canvas, 48" × 72". exhibited at Jule Collins Smith Museum of Fine Art at Auburn University, Auburn, Alabama, 2023.

Snowden, Ten Mile, and Phillips remain the only link to a collective past of the Lowcountry, a story that will be documented and presented at the new museum.

I find it short-sighted that the recent outpouring for social justice can be simultaneously blind to a culture's history in plain sight. These hamlets and settlements challenge the Lowcountry's fabricated ostensible past. They are the breadcrumbs that lead back to the enslaved people, the plantation, back to Carolina Gold rice, back to Africa. It has been sixteen years since Congress established the Gullah Geechee Corridor, the 12,000-square mile corridor stretching from North Carolina to Florida with Charleston and the Lowcountry at its center. If now is not the time to reckon with this past, when is? The more reflective we can be in our longing, whether collective or individually, we can shatter the idea of the simple, clean and unadulterated past, and move to one more complex, enmeshed.

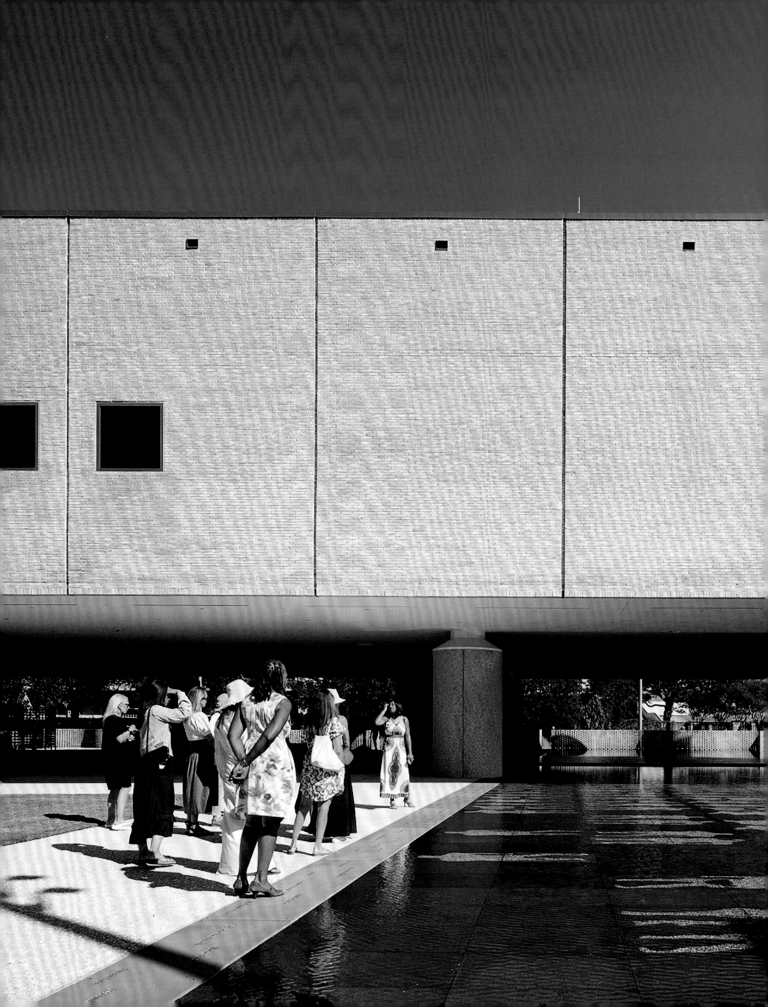

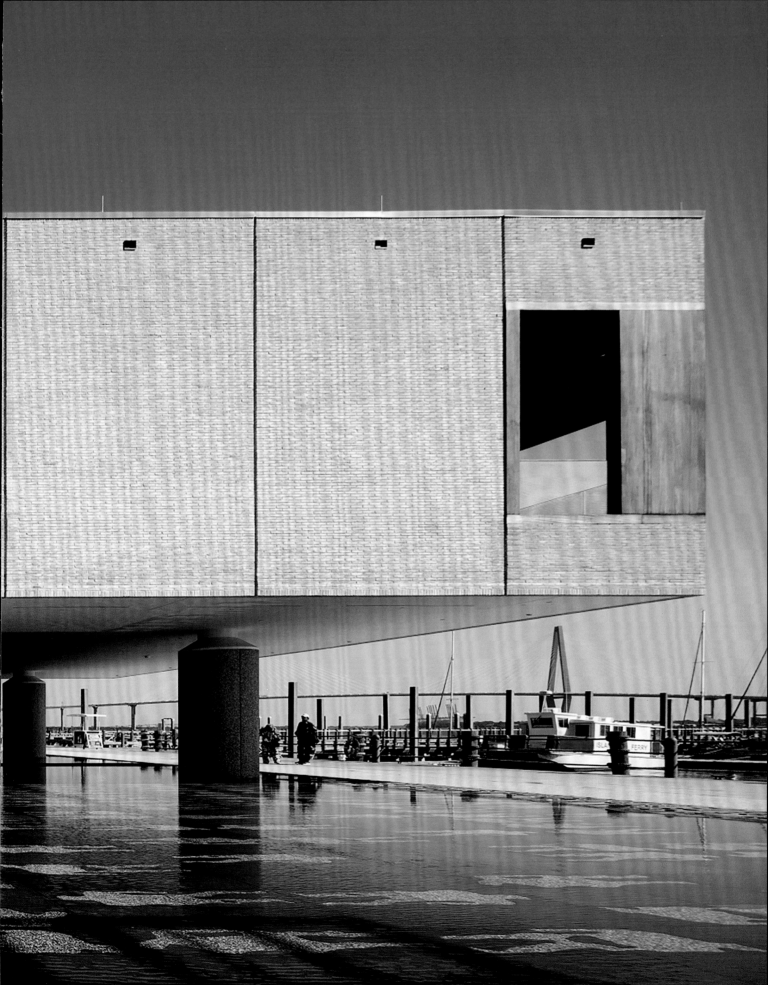

CONTRIBUTORS

WALTER HOOD is a landscape designer, artist, and educator. His innovative work integrates architecture, landscape, art, and urbanism to create spaces that reflect and enhance the social and historical contexts of their environments. Born in Charlotte, North Carolina, Hood's early experiences of the built environment and nature deeply influenced his career. He earned a bachelor's degree in landscape architecture from North Carolina A&T State University, a master's degree in architecture and landscape architecture from the University of California, Berkeley, and a master of fine arts from the School of the Art Institute of Chicago.

In 1992, Hood founded Hood Design Studio in Oakland, California, where he leads a multidisciplinary team dedicated to crafting spaces that resonate with and enrich their communities. His work reflects a deep passion for the democratic potential of landscape and urbanism, providing inclusive experiences that transcend traditional architectural constraints. By infusing African American cultural arts into his design philosophy, Hood has established a distinctive voice in the field of landscape architecture, transforming spaces to meet contemporary needs while honoring their historical context.

Hood's exceptional contributions to landscape architecture and urban design have earned him numerous accolades, including the prestigious 2019 MacArthur Fellowship, the 2021 Architectural League's President's Medal, and the *Wall Street Journal Magazine's* 2023 Innovator Award in Design.

MICHAEL ALLEN grew up in Kingstree, South Carolina. He is a 1978 graduate of Kingstree Senior High and a 1982 graduate of South Carolina State College with a degree in history education. He began his career with the National Park Service in 1980. He served as a park ranger, education specialist, and community partnership specialist for the Gullah Geechee Heritage Corridor, Fort Sumter National Monument, Charles Pinckney National Historic Site, and Reconstruction Era National Monument. Throughout his career, Michael was involved in designing exhibits and presenting interpretive programs to attract non-traditional audiences and to help them understand and appreciate African and American history. He is a founding board member of the International African American Museum.

LOUISE BERNARD is the founding Director of the Obama Presidential Center Museum. As a Senior Content Developer and Interpretive Planner at Ralph Appelbaum Associates, she helped develop the Smithsonian's National Museum of African American History and Culture, along with other national and international projects. She previously served as Director of Exhibitions at the New York Public Library, as Curator of Prose and Drama at the Beinecke Rare Book and Manuscript Library at Yale University, and as Assistant Professor of English at Georgetown University. She received an MA in Theatre History and an MA in English Literature from Indiana University, Bloomington, and a Joint PhD in African American Studies and American Studies from Yale.

JONATHAN GREEN is a renowned painter celebrated for his vibrant depictions of Sea Island Gullah culture, rooted in the history of descendants of enslaved Africans in the coastal regions from northern Florida to North Carolina. Raised in Gardens Corner, South Carolina, Green creates work that reflects the maritime aesthetics of his upbringing. A U.S. Air Force veteran, he earned a BFA from the School of the Art Institute of Chicago in 1982. He has served as Ambassador of the Arts for Florida and Charleston and received numerous accolades, including two Order of the Palmetto Awards. Green's art is featured in prominent museums, and his contributions to preserving Gullah culture are honored by the upcoming Jonathan Green Maritime Cultural Center in Beaufort, South Carolina.

RHODA GREEN is a Barbadian who has resided in Charleston, South Carolina, since 1989. She was president of the now-defunct Carolina Caribbean Association from 1991 to 2005 and worked with the Barbados Ministry of Tourism and South Carolina groups and organizations to explore shared history and heritage. In 2000, the Barbados Government awarded her its Silver Merit of Award. In March 2008, Barbados commissioned her as its Honorary Consul to South Carolina. Rhoda founded the Barbados and the Carolinas Legacy Foundation in 2005, which was registered and certified as a nonprofit corporation "to highlight, research, archive, facilitate and promote opportunities for Barbados/Carolina collaboration" in 2012. In the 1990s, former Mayor Joseph Riley invited her to serve on the International African American Museum Steering Committee.

CHINWE OHAJURUKA is an architect who is passionate about sustainability, social equity, and justice, especially in sub-Saharan Africa. She has more than 35 years of experience in architecture and has been working in the green building and sustainable design space since 2006, with green professional accreditation in three continents (LEED USA, Green Star South Africa, and BREEAM UK). Chinwe is founder and CEO and Comprehensive Design Services (CDS), with which she pioneered the first affordable Eco-Village in Nigeria, and is the recipient of several prestigious awards and recognitions, including the 2015 sub-Saharan Africa Laureate of the Cartier Women's Initiative Awards. She lives in the United States with her family and works on the African continent through teamwork, technology, and travel.

ROBERT R. MACDONALD is the Director Emeritus of the Museum of the City of New York and former president of the American Association of Museums. He has spent more than five decades as an innovative museum leader, executive, and consultant responsible for directing large- and medium-sized public and private museums in Pennsylvania, Connecticut, Louisiana, and New York City. He has developed acclaimed national and international exhibitions, award-winning educational programs, and noted publications, as well as professional exchanges and museum training programs with museums in France, Russia, Great Britain, Germany, Korea, Japan, Australia, and Cuba. Robert has also published extensively on museum policy and operational issues. He has served as vice chair of the South Carolina Aquarium, and a consultant to and a member of the board of the International African American Museum.

TONYA M. MATTHEWS is president and CEO of the International African American Museum, located in Charleston, South Carolina at the historically sacred site of Gadsden's Wharf, one of our nation's most prolific former slave ports. As a champion of authentic, empathetic storytelling of American history, IAAM is one of the nation's newest platforms for the disruption of institutionalized racism as America continues the walk toward "a more perfect union." A thought leader in inclusive frameworks, social entrepreneurship, and education, Matthews has written articles and book chapters across these varied subjects. She is founder of The STEMinista Project, a movement to engage girls in their future with STEM careers. Matthews is also a poet and is included

in *100 Best African American Poems* (2010) edited by Nikki Giovanni. Matthews received her PhD in biomedical engineering from Johns Hopkins University and her BSE in engineering from Duke University, alongside a certificate in African/African American Studies.

MATTEO MILANI is associate partner at Pei Cobb Freed & Partners. He has been practicing, teaching, and writing about architecture for more than two decades, first in Milan and then in New York, where he has lived since joining PCF&P in 2006. As one of the firm's leading designers, he has contributed to many of its most important recent projects. He worked closely with Henry Cobb on the design of the International African American Museum from its earliest stages. Other projects he collaborated on with Cobb include Palazzo Lombardia in Milan and Soyak Kristalkule | Finansbank Headquarters in Istanbul.

JONATHAN MOODY is CEO of Moody Nolan. Driven by a passion to continue his father's legacy, Jonathan D. Moody has entrenched himself in firm leadership, driving growth and innovation. Moody Nolan has grown to over 340 employees and twelve offices across the nation. The firm's designs have now won over 350 design citations including forty-seven from the American Institute of Architects (AIA) and forty-four from the National Organization of Minority Architects (NOMA). Jonathan has helped continue and extend the firm's position as the largest African American–owned architecture firm. Moody Nolan continues to garner national attention by promoting "diversity by design."

GUY NORDENSON is a structural engineer and professor of architecture at Princeton. He was the engineer for the National Museum of African American History and Culture in Washington, DC; the International African American Museum and Emanuel Nine Memorial in Charleston, South Carolina; and oversaw the design and engineering of David Hammons' Day's End sculpture in the Hudson River. Nordenson is the author of books on climate adaptation and engineering design. He was Commissioner of the NYC Public Design Commission from 2006 to 2015 and a member of the NYC Panel on Climate Change. He is fellow of the American Academy of Arts and Sciences and member of the National Academy of Engineering.

PAUL PETERS is a principal at Hood Design Studio, where he has honed his expertise in the nuanced relationships between cultures and their environments. With a background in geography, Paul skillfully employs the tools of history, culture, and evolving ecologies, creating landscapes that serve as conversations rather than mere spaces. Since his start at Hood Design in 2016, Paul has led several groundbreaking projects. Including the International African American Museum in Charleston, South Carolina; the renovation of the Oakland Museum of California including an immersive outdoor performance area set within four acres of vibrant gardens. Presently, Paul is overseeing the development of a two-acre outdoor performance park at Lincoln Center in New York City, and a 16-acre expanse of gardens and forest trails at Discovery Place Nature in Charlotte, North Carolina.

BERNARD E. POWERS JR. earned his PhD in American history at Northwestern University. He is professor emeritus of history at the College of Charleston and the College's founding director of the Center for the Study of Slavery in Charleston. Powers has also served as the interim CEO of Charleston's International African American Museum. His *Black Charlestonians: A Social History 1822-1885* (University of Arkansas Press, 1994) was designated an "Outstanding Academic Book" by *Choice Magazine*. Powers is coauthor of *We Are Charleston: Tragedy and Triumph at Mother Emanuel* (Thomas Nelson, 2016), which contextualizes the city's racially motivated murders of 2015. Most recently he has edited *101 African Americans Who Shaped South Carolina* (USC Press, 2020).

DELL UPTON is Distinguished Research Professor of Architectural History in the Department of Art History at UCLA. He earned his PhD and MA at Brown University and a BA at Colgate University. His books include *Another City: Urban Life and Urban Spaces in the New American Republic* (2008; winner, Society of Architectural Historians Spiro Kostof Book Prize); *What Can and Can't Be Said: Race, Uplift, and Monument Building in the Contemporary South* (2015) and *American Architecture: A Thematic History* (2019). He was a 2019 Resident of the American Academy in Rome and 2020–21 Kress-Beinecke Professor at the Center for Advanced Study in the Visual Arts, National Gallery of Art.

NATHANIEL ROBERT WALKER is professor of architectural history in the School of Architecture & Planning at the Catholic University of America in Washington, DC. Previously he taught at the College of Charleston, after earning his PhD at Brown University. Nathaniel specializes in the history of urban form, public buildings, and shared spaces such as squares and streets, with a special focus on the ways in which people have used architecture to imagine and shape dreams of a more beautiful, fairer, and healthier world. His publications include *Victorian Visions of Suburban Utopia: Abandoning Babylon* (Oxford University Press, 2020); he is coeditor with Elizabeth Darling on *Suffragette City: Women, Politics, and the Built Environment* (Routledge, 2019), and is currently coediting a book with Rachel Ama Asaa Engmann entitled *Architectures of Slavery: Ruins and Reconstructions* (University of Virginia Press).

LEWIS WATTS is a photographer, archivist/curator, visual historian and Professor Emeritus of Art at UC Santa Cruz. He also taught at UC Berkeley, and served as college professor for over forty years. His research and art practice center around the "cultural landscape" and the inhabitants of that landscape primarily in communities of the African Diaspora. He is the coauthor of *Harlem of the West: The San Francisco Fillmore Jazz Era* (Chronicle Books, 2006; Heyday Books 2020). He is the author of *New Orleans Suite: Music and Culture in Transition* (UC Press, 2013) and *Portraits* (Edition One Books, 2019).

MABEL O. WILSON is the Nancy and George E. Rupp Professor of Architecture, Planning and Preservation and a professor in African American and African Diaspora Studies at Columbia University, where she also serves as the director of the Institute for Research in African American Studies. With her practice Studio&, she was a member of the design team that recently completed the Memorial to Enslaved Laborers at the University of Virginia. Wilson is author of *Begin with the Past: Building the National Museum of African American History and Culture* (2016), and *Negro Building: Black Americans in the World of Fairs and Museums* (2012); she coedited the volume *Race and Modern Architecture: From the Enlightenment to Today* (2020). For the Museum of Modern Art in New York City, she was cocurator of the exhibition *Reconstructions: Architecture and Blackness in America* (2021).

ABOUT THE INTERNATIONAL AFRICAN AMERICAN MUSEUM

The International African American Museum (IAAM) stands as testament to the profound contributions and enduring legacy of African Americans throughout history. Located in Charleston, South Carolina, the museum is intentionally placed on the historically sacred site of Gadsden's Wharf, where many enslaved Africans first set foot on what is now American soil. This museum serves as a bridge, connecting the present with the past and offering an immersive journey through the African American experience.

After a twenty-year journey of powerful and powerfully challenging conversations on design, content, and authentic storytelling, the IAAM broke ground in late 2019. Already rooted in its "power of place" and centuries of global and domestic history, IAAM continued building through 2020 and the aftermath of a worldwide pandemic and national reckoning with racial discord crystallized the importance and necessity of the museum. The museum finally opened its doors in June 2023, dedicated to exploring and showcasing the rich history, culture, and impact of African Americans and the African Diaspora from origins on the African continent to determined creation and preservation of its culture across the world to impacts on the present-day United States. The museum achieves its mission of honoring these untold stories through a combination of permanent and rotating exhibits, educational programs, and community outreach initiatives.

The museum's architecture is a modern marvel, designed to evoke both reflection and inspiration. The structure is elevated on pillars in recognition of the sacredness of the ground it hovers above. Beneath it lies the African Ancestors Memorial Garden, a serene and contemplative space dedicated to the memory of the millions who were enslaved and brought to the Americas. This garden serves as a poignant reminder of the museum's deeper purpose: to remember, honor, and educate through the history of trials and triumphs of the African American journey.

Inside, the IAAM offers a multifaceted experience through its various galleries and interactive exhibits. Visitors can explore the African roots of African American culture, the brutal realities of the transatlantic slave trade, the struggle for civil rights, and the numerous achievements in arts, science, politics, and more. The museum also features the Center for Family History, a world-class genealogy research center that helps individuals trace their ancestry and uncover personal connections to the past.

The IAAM is not just a museum but a hub for dialogue, learning, and community engagement. It hosts lectures, workshops, and cultural events that foster a deeper understanding of African American history and its relevance today. Through authentic and empathetic narrative, the International African American Museum empowers visitors to recognize the resilience and contributions of African Americans and inspires future generations to continue the journey towards equality and justice.

ACKNOWLEDGMENTS

This book is a celebration of the design team's vision and ten long years of hard work to imagine a new space that commemorates and speaks to the long absence of blackness in the spatial memory of Charleston, South Carolina. From the shores of Africa to the Lowcountry, the African Ancestors Garden is a space that was lost to an ostensible past, but today is awakened so that the community—regional, national, and international—could form and participate in the living memory of the region. Special acknowledgment to the Dorothy and Lillian Gish Prize and the MacArthur Foundation. Without their support this effort would have never materialized.

I would like to thank Mary Jane Jacobs for introducing me to Charleston . . . even though I was born and raised one state away, in North Carolina, to know Charleston is to understand that the American South is not monolithic. And to Nigel Redden for supporting our participation in the Spoleto Festival USA and our work with the local Gullah Geechee communities, particularly the Phillips community, which is now on the historical register. Thanks to Richard Habersham for welcoming us to the community and sharing its lifeways. Unbeknown to me at that time, these experiences would be fodder for my later design work at the International African American Museum.

Thanks to the honorable Mayor Joseph P. Riley, for his mentorship diligence and more than two-decade commitment to building the IAAM. Over the past twenty years his invention and leadership of the Mayors' Institute on City Design, as well as his constant advocacy for inclusion, have been unsurpassed. And to the late Henry N. Cobb, who entrusted the care and vision for the Ancestors' landscape in my hands. I wish I had the chance to walk the finished gardens and building with Harry, to see that smile and sparkle in his eyes. And special appreciation to Matteo Milani of Pei Cobb Freed & Partners, who shepherded Harry's vision to reality.

Great appreciation for the leadership of former director Michael Moore, and current director Dr. Tonya Matthews. And congratulations to Michael Allen for his commitment to the Sullivan Island story.

Appreciation to the content collaboration with Melanie Ide and Louise Bernard of Appelbaum and Associates. I learned so much from you and the craft of storytelling.

The collaboration between structure and architecture is readily apparent at IAAM, and thanks to Guy Nordenson's contribution, this collaboration extends to the landscape, in the form of the two-meter diameter tabby columns. We were blessed with the local knowledge of SeamonWhiteside, Landscape Architect of Record, especially that of Gary Collins.

Special thanks to all of the essay and photography contributors to the book, and to Grace Mitchell Tada for her organization and editing skills in bringing all of these elements together. And to Alan Rapp and Jenny Florence at Monacelli for their energy and dedication to bringing this book to fruition, and to Kelly Walters for reflecting the layers of history and memory into the graphic design. And to Lewis Watts, thanks for allowing your images to coexist with my work, ever since our initial collaboration in Blues and Jazz landscapes. And special thanks to Regine Ramos, for assisting us at the finish line.

My appreciation goes out to the design team at Hood Design Studio, for working through all the iterations and assisting along the way; Tim Mollete-Parks, Megan McLaughlin, Lan Ly, Andrea Valentine, Hester Tittman, Remi Pulice, and Tamara Kalo. And in particular, Paul Peters for his thoroughness and commitment to excellence in design and implementation, particularly with the Tide Tribute. And thanks to art coordinator Sarita Schreiber for assisting with the kneeling figures

and concrete coordination work with QCP Corp—and special thanks to them as well: Neil Elenzweig, Peter Bustin, Guillermo Fernandez, and the rest of the team.

And those whose conversations and collaborations nurtured this work . . . thanks to artist Ernesto Pujol, Francis Whitehead, and Kendra Hamilton, Jonathan Green, and Rick Lowe. And a big thanks to then local architects Ray Huff and Mario Gooden for the collaboration at our first museum project, Virginia Key Museum, and later at Charleston's Memminger Auditorium.

It was a special honor to work with two construction managers that graduated from my alma mater, HBCU, North Carolina A&T State University: Bobby Teachy, Brownstowne Construction and Bri'Shae Anderson, Turner Construction. Aggies represent!

Finally, I would like to thank all of those who participated on the Ancestors Garden committee for their guidance and support. The International African American Museum (IAAM) stands as testament to the profound contributions and enduring legacy of African Americans throughout history. Located in Charleston, South Carolina, the museum is intentionally placed on the historically sacred site of Gadsden's Wharf, where many enslaved Africans first set foot on what is now American soil. This museum serves as a bridge, connecting the present with the past and offering an immersive journey through the African American experience.

After a twenty-year journey of powerful and powerfully challenging conversations on design, content, and authentic storytelling, the IAAM broke ground in late 2019. Already rooted in its "power of place" and centuries of global and domestic history, IAAM continued building through 2020 and the aftermath of a worldwide pandemic and national reckoning with racial discord crystallized the importance and necessity of the museum. The museum finally opened its doors in June 2023, dedicated to exploring and showcasing the rich history, culture, and impact of African Americans and the African Diaspora from origins on the African continent to determined creation and preservation of its culture across the world to impacts on the present-day United States. The museum achieves its mission of honoring these untold stories through a combination of permanent and rotating exhibits, educational programs, and community outreach initiatives.

The museum's architecture is a modern marvel, designed to evoke both reflection and inspiration. The structure is elevated on pillars in recognition of the sacredness of the ground it hovers above. Beneath it lies the African Ancestors Memorial Garden, a serene and contemplative space dedicated to the memory of the millions who were enslaved and brought to the Americas. This garden serves as a poignant reminder of the museum's deeper purpose: to remember, honor, and educate through the history of trials and triumphs of the African American journey.

Inside, the IAAM offers a multifaceted experience through its various galleries and interactive exhibits. Visitors can explore the African roots of African American culture, the brutal realities of the transatlantic slave trade, the struggle for civil rights, and the numerous achievements in arts, science, politics, and more. The museum also features the Center for Family History, a world-class genealogy research center that helps individuals trace their ancestry and uncover personal connections to the past.

The IAAM is not just a museum but a hub for dialogue, learning, and community engagement. It hosts lectures, workshops, and cultural events that foster a deeper understanding of African American history and its relevance today. Through authentic and empathetic narrative, the International African American Museum empowers visitors to recognize the resilience and contributions of African Americans and inspires future generations to continue the journey towards equality and justice.

IAAM BOARD MEMBERS
Wilbur Johnson, Board Chair
Dr. Bernard Powers,
Programming Committee Chair
Lucille Whipper
Jonathan Green
Dr. Antonio Tillis
Mayor Joe Riley,
Building Subcommittee, Chair
Melissa Lindler

EXTENDED SUBCOMMITTEE
Dan Littlefield

COMMUNITY ADVISORS
Queen Atterberry
Mary Battle
Rhoda Green
Marlene O' Bryant-Seabrook
Rev. Joseph A. Darby
Emory Campbell

COMMUNITY RESOURCE SPECIALISTS
Rebecca Shumway
Nathaniel Walker
Leo Twiggs
Valinda Littlefield

IAAM STAFF
Lauren Crawford

CITY OF CHARLESTON
Edmund Most

CONSULTANTS
Bob Macdonald, IAAM Consultant
Michael Allen, National Parks Service

CONTENT DEVELOPER / EXHIBITION DESIGNER
Melaine Ide, Ralph Appelbaum & Assoc.
Louise Bernard, Ralph Appelbaum & Assoc.

DESIGN ARCHITECT
Matteo Milani, Pei Cobb Freed

ARCHITECT OF RECORD
Robert Larrimer, Moody Nolan
Chinwe Ohajuruka, Moody Nolan

LANDSCAPE ARCHITECT
Walter Hood: Artist/Designer,
Hood Design Studio
Tim Molette-Parks, Hood Design Studio
Paul Peters, Hood Design Studio

CREDITS

Every reasonable effort has been made to identify copyright holders and obtain their permission for reproduction. Any additions or corrections will be incorporated in subsequent printings or editions of this book, given timely notification to the publisher. Courtesy *Charleston Magazine* 206; courtesy city of Charleston 120; © Sahar Coston-Hardy / ESTO 10, 13, 34, 180, 181, 192–93, 195 (top), 213, 240, 248 (bottom), front and back cover; courtesy Julie Dash 80, 81; courtesy Gibbes Museum of Art 106; Google Earth (map data: Google, Airbus, Data SIO, NOAA, U.S. Navy, NGA, GEBCO) 25; courtesy and copyright © Jonathan Green 169–74; courtesy Fernando Guerra 2, 14, 16–17, 36–37, 178, 179, 182, 183, 187, 188–89, 190 (top), 191, 194, 227, 228, 241, 259, 264–65, 276–77; courtesy of Foundation for Spirituality and the Arts 26 (middle two images, bottom two images); courtesy Gaillard Center, Charleston 138; courtesy Mike Habat 184–85, 195 (bottom), 196–97, 246; photo by Carol M. Highsmith 22 (bottom); courtesy HOOD DESIGN STUDIO 30, 207 (top), 208–09, 211, 212, 233, 234, 235, 244–45, 270, 273 (bottom); courtesy Walter Hood 21, 33, 59, 183 (top), 186, 190 (bottom), 203, 204 (bottom), 207 (bottom), 248 (top), 260, 275; courtesy International African American Museum 6; courtesy Suzanne Lacy 29; Library of Congress, Geography and Map Division 44, 122 (top); Library of Congress, Prints and Photographs Division 73; photo by Warren LeMay 155; photo by MacFawlty 22 (top); courtesy Middleton Place Foundation 204; courtesy Moody Nolan 219; courtesy National Park Service 269; courtesy Pei Cobb Freed + Partners 225, 226; courtesy Paul Peters 247; photo by Sean Rayford/Getty Images 274; photo by Soniakapadia 23 (bottom); © Olga Stavrakis 52, 53; courtesy Hank Willis Thomas 273; photos by Dell Upton 105, 112–13; photos by Nathaniel Robert Walker 125, 133, 134 (used with permission of Fletcher Williams III), 137, 139, 140, 141, 142; © Lewis Watts 24, 26 (top left and top right), 54, 84–99; photo by Kenneth Zirkel 23 (top).

Copyright © 2024 Walter Hood and Monacelli. All text contributions are copyright © 2024 the individual authors.

All rights reserved. No part of this book may be reproduced, stored in a retrieval system, or transmitted in any form, by any means, including mechanical, electric, photocopying, recording or otherwise, without the prior written permission of the publisher.

Library of Congress Control Number is available.

ISBN 978-1-58093-584-5

10 9 8 7 6 5 4 3 2 1

Printed in China

Design by Kelly Walters | Bright Polka Dot

Monacelli
A Phaidon Company
111 Broadway
New York, New York 10006

www.monacellipress.com